the BLUE RIDGE TUNNEL

A Remarkable Engineering Feat *in* Antebellum Virginia

MARY E. LYONS

THE
History
PRESS

Published by The History Press
Charleston, SC 29403
www.historypress.net

Copyright © 2014 by Mary E. Lyons
All rights reserved

First published 2014

Manufactured in the United States

ISBN 978.1.62619.421.2

Library of Congress CIP data applied for.

Dedicated to Donald Harrington, a Blue Ridge Tunnel descendant who represents the spirit of Irish American generosity.

Contents

Contents

Preface

Newspapers in the 1850s invariably referred to the Blue Ridge Tunnel by that name. Burial records kept during the 1850s at Thornrose Cemetery in Staunton, Virginia, contain the same phrase. Most important, Irish immigrants writing to or from the Virginia Blue Ridge Railroad while searching for lost relatives referred to the Blue Ridge Tunnel in newspaper advertisements. For historical accuracy, then, I use the original name rather than the more recent names of Crozet Tunnel or Afton Tunnel.

I also designate 1860 as the completion year for the Blue Ridge Tunnel. True, the first train steamed through the passage in 1858, but work was incomplete. Irish laborers continued to blast away rock in 1859, and one died in a tunnel explosion that same year. The last known person who worked on the Blue Ridge Tunnel's construction was Irishman Tim Callaghan, as reported in the 1860 Nelson County, Virginia census.

I know of no extant photographs of the tunnel construction or the workers. I have included examples of similar scenes so that readers can understand the difficulty of life at the tunnel and along the tracks. These are representational images, not actual photographs of the Blue Ridge Tunnel or the laborers.

Dean Merrin in *America Transformed: Engineering and Technology in the Nineteenth Century; Selections from the Historic American Engineering Record* states that the Blue Ridge Tunnel was the longest railroad tunnel in the world upon completion. However, William Lowell Putnam writes in *Great Railroad Tunnels of North America* that the first bore of the Woodhead Tunnel, completed in England in 1845, was almost three miles long.

The summit of the mountain at Rockfish Gap is 2,418 feet above sea level. The Woodhead summit in the United Kingdom, where a mountain is defined as 2,000 feet or more above sea level, is 966 feet. I have concluded, then, that the Blue Ridge Tunnel was the longest mountain railroad tunnel in the world upon completion.

The following good souls helped in a variety of ways as I researched and wrote this book. I thank Paul Collinge, Jane C. Smith, Arthur Collier, Allen Hale, Margaret and Molly Ryther, Jane Harrington, Nancy Sorrels, Linda Petske and her marvelous students, Katherine McNamara, Mary Lee Dunn, Gene Carlson, Myra Horgan, Michael Aukofer, James E. Gage, Gary Rogers, Mac Beard, Debra Weiss, Vesta Gordon, Mardi Brownell, Pam Hardy, Sam Towler, Bob Vernon and Jim Kauffman.

To my research colleagues in Ireland, I offer special thanks for their encouragement, curiosity and generous sharing: Flan Enright, Pat O'Brien, Denis Callahan and Charlie Coughlan.

I am especially grateful to the Virginia Center for the Humanities for a residential fellowship that allowed me to complete a draft of the book in the fall of 2011. The staff and other fellows were supportive at all times, especially Ann Spencer, Susan McKinnon, Jamie Ross, Bill Freehling, Jerry Handler and Hilary Holladay.

To all, *go raibh maith agat*. Thank you.

Mary E. Lyons
Charlottesville, Virginia
December 2013

PART I

A Narrative History of the Blue Ridge Tunnel

Prologue

Ticks. Mosquitoes. Chiggers. Snakes. It's a sticky hot day in 1976. Two men are battling the beasts of summer as they hike along a grassy trail. This is no ordinary path through the forest. It's an old railroad track bed, built between 1850 and 1860 at Rockfish Gap, Virginia. Made of blasted rock, the track bed is 135 feet high and 700 feet long.

Minutes later, the men round a bend. They come upon an eye-popping sight: the east portal of the Virginia Blue Ridge Tunnel. The opening looks like the gaping jaws of a sleeping giant. Its mouth is smeared with more than one century of locomotive soot. Water from mountain springs drools down both sides. Vertical drill holes in the rocky approach to the portal are long and smooth, like teeth.

The visitors to the tunnel on this sweltering day are members of the American Society of Civil Engineers. The society has recently decided that the Virginia Blue Ridge Tunnel was one of the "greatest engineering marvels of the nineteenth century." It has declared it a National Historic Civil Engineering Landmark.

Other winners of this prestigious award are the Statue of Liberty, Washington Monument, Panama Canal and Eiffel Tower. The society plans to erect a bronze plaque in honor of the historic tunnel. That's why the engineers are here today—to inspect the passage and decide where to put the plaque.

The body of the Blue Ridge Tunnel is 16 feet wide, 20 feet high and 4,237 feet long. The longest mountain railroad tunnel in the world when finished,

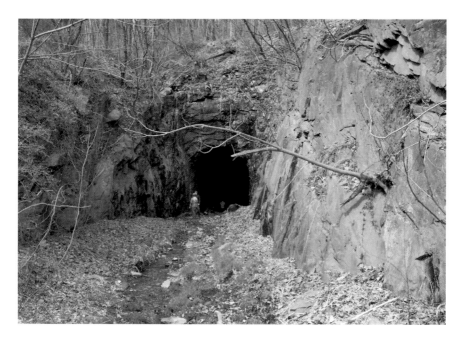

East portal of the Blue Ridge Tunnel. No arch was necessary to support the granite at the east portal. *Author's collection.*

it's a Goliath in American railroad history. The passage slices through the belly of the mountain, straight as a knife. The inside is inky dark, with a chilly temperature of fifty-five degrees. A steady stream of cold water runs along the floor.

As the men slosh through it, their flashlights cast an eerie glow on the ceiling. One engineer shines his light on the tunnel walls. Layers of bricks cling to them like scaly skin. "I'll bet there aren't three men in this country," he says with awe, "who could do that kind of work now."

There aren't many people who would do that kind of work now. But back in the 1840s and 1850s, almost two million Irish men and boys were desperate for jobs, no matter how difficult they might be. When railroad construction exploded across America, railroad companies needed people willing to work for a beggar's pay, and they knew just where to find them.

Tragically, a catastrophe in Ireland called the Great Hunger brought American railroad companies great luck. Without the Great Hunger, the Blue Ridge Tunnel would never have been built.

1

1845–49

Ireland's Great Hunger began when a plant fungus blew in on the wind in 1845. The fungus withered the stalks of potato vines and scorched the leaves, as if someone had lit a match to the plants. When Irish farmers dug up the potatoes, they found black tubers that smelled like raw sewage.

During the first year of the blight, parts of some potatoes still looked healthy. Children had the task of finding edible sections. "They first peel off the skin," one witness wrote, "then they scoop out the black or spots on all sides. It has a rather curious appearance when cleared of all the black spots, and even looks much worse boiled than raw."

An Irish brother and sister who ended up at the Blue Ridge Tunnel can help us understand the horror of the Great Hunger. Catherine Brennan and her brother, John, lived in Bantry Town on the west coast of County Cork. Both held positions as gentleman's servants. They probably worked for Lord Bantry, an English landlord who owned most of the town.

Catherine would have cooked and served Lord Bantry's meals. She might have feather-dusted his priceless hand-stitched tapestries or buffed his huge leather doors stamped with gold. Horsewhip in hand, John would have driven Lord Bantry around the countryside in a fancy carriage or rowed him across the bay to inspect his property on the Berehaven Peninsula.

Lord Bantry's many-roomed mansion overlooked Bantry Bay. The mountainous, wind-swept Berehaven Peninsula was in plain sight across the bay's clear waters. Lord Bantry owned most of Berehaven, too, including the mud cabins where his Irish tenants lived.

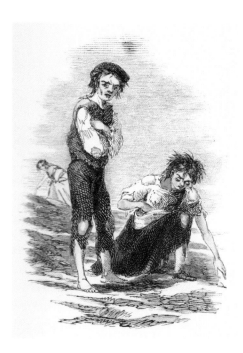

Famished children in Caheragh, County Cork, Ireland, search desperately for a healthy potato. *From* Illustrated London News, *February 20, 1847.*

Berehaven's soil is thin. Tenants could grow only enough crops to sell for the rent that Lord Bantry charged. They survived on what was left—potatoes from the field and seaweed, shellfish and mackerel from the sea. The only available jobs were at copper mines that dotted the peninsula. Wages at the mines, some of which Lord Bantry owned, were indecently low.

A Protestant minister once inspected Berehaven. "I have frequently visited the log shanty of the slave on the cotton plantations in South Carolina, and chatted with the inmates," he wrote, "but never till I came to the Berehaven mines did I witness such wretchedness of eye-revolting poverty."

Men at the Berehaven mines labored underground with picks and shovels, while women and children worked above ground at the mouths of the mines. "We come to work at six in the morning," said one woman who washed and sorted the raw copper ore, "and leave off as the bell rings at six in the evening. Many of us only have one meal whilst at work."

A girl of eleven toiled for a blacksmith at the mines for five cents a day. "It is rather hard work," she said, "and sometimes rather hot."

CAPTAIN ROCK

For decades before the Great Hunger, Bantry and Berehaven folks rebelled against their poverty by joining a violent secret society. It operated throughout County Cork and in parts of bordering counties. The leader was a mysterious, perhaps mythical, figure named Captain Rock. To identify each other, Rockites memorized a secret question, such as, "What distance is there between the

OUR LAND OF IRE

We met as desperadoes whose every act was watched, and the ferocity which at first only existed in the suspicions of our rulers, began gradually to find room in our breasts, from the consciousness of our being suspected. At the time of which I write, party spirit was just as high in Ireland as ever it was, and as ever it will be: and the little town in the neighbourhood of which I lived, was the focus of, perhaps, the fiercest and most ungovernable factions that existed then in our land of ire.

From "Reminiscences of a Rockite," Dublin Penny Journal, *1835.*

Sun and Moon?" The answer: "A square foot and an Irish heart in the Full Bloom."

Rockite mischief took place at night. If a landlord raised the rent or evicted someone who could no longer pay, Rockites posted a threatening notice on his door and signed it "Captain Rock." Arson was common; Rockites often burned outbuildings on landlords' estates.

Hundreds of Rockites roamed the countryside, stealing muskets, clubs and swords. When Lord Bantry organized soldiers to stop them on a road near Bantry Town, the Rockites fought back but lost the battle.

Revolt against Lord Bantry's iron-fisted control was a major Rockite objective. Keeping jobs was another. When a mine owner hired Irish miners from outside the region, the Berehaven Rockites called them "strangers." They burned the newcomers' lodgings and made sure that no one sold them potatoes.

For Rockites, fighting for jobs was the same as fighting for their lives, and violence against landlords equaled justice. They would use similar survival techniques later at the Blue Ridge Tunnel. But no Rockite could fight the potato fungus that devastated the fields in 1845. The threatening notices and burnings stopped as blight destroyed the people's main source of food.

When Lord Bantry's tenants became too weak to raise the crops they sold for rent money, they fell behind in payments. Though he traveled across the world every year buying antiques for his mansion, he claimed that the loss of rental income was a burden. As a cost-cutting measure, he laid off some of his employees. John and Catherine Brennan may have been among them.

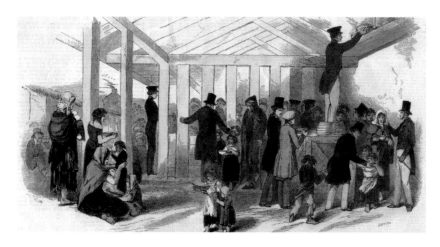

A soup kitchen in County Cork, Ireland. *From* Illustrated London News, *March 13, 1847.*

Grown children in Ireland were expected to help their families. John and Catherine's parents must have been frantic. If their children couldn't work in Ireland, they had to leave. John was twenty. Catherine was seventeen. Surely they could find jobs in America and mail enough money home to keep the family alive.

Catherine and John were caught in one of the early surges of immigrants who fled Ireland during the Great Hunger. They boarded a ship called the *Lord Ashburton* in the spring of 1846. Weeks later, it landed in New York City.

Catherine's great-grandson remembers a family story about the pair. "Catherine came to the U.S.A. with her brother," the story goes, "and worked in a railroad camp where he protected her from the men."

The brother and sister escaped just in time. The wind blew its poisonous breath again during the snowy winter of 1846–47. Fungus blighted every potato plant in every field. By March 1847, hundreds of thousands of men, women and children across Ireland were starving. So many perished, and so quickly, that it was impossible to bury them all in coffins. On Lord Bantry's estate, one thousand people were dying every week.

Protestant England had controlled Catholic Ireland's land and people for centuries. The English government could have helped Ireland when the Great Hunger began. Instead, it ignored the disaster for two years.

English lawmakers finally found a conscience and ordered landlords to provide soup kitchens. These open-air, makeshift shelters provided enough watery broth for only a few of the famished tenants. Lord Bantry donated 20 shillings, or about $100 in present-day money, for the Bantry soup kitchen. Then he gave nothing at all. Furious, the tenants dug two large pits in front of his mansion,

burying 650 people without coffins. The corpses were silent reminders of Lord Bantry's greed. Friends or relatives of John and Catherine Brennan would have been among the dead or those who buried them.

Harbor of Tears

Early in the spring of 1848, a ship called the *Albion* left the harbor in Cork City. Aboard was a clan of twenty-eight people with the last name of Harrington, including twenty-six-year-old Michael Harrington. Fifty-four people named Sullivan were also aboard.

Some of the Harrington and Sullivan passengers were skilled miners from the Berehaven Peninsula, where copper mines were closing. Eventually, they ended up at the Blue Ridge Tunnel area. It made sense. Men used to the dark, cold depths of a mine would work just as fearlessly in a tunnel, and they would do it for low pay—for a while.

Other ships leaving Ireland were packed with County Cork men who had worked in marble, lead, zinc and coal mines. Some of these miners found their way to the Blue Ridge Tunnel, too. No doubt, all the County Cork miners were familiar with Rockite methods.

Between 1846 and 1855, two million Irish as desperate as the Brennans, Harringtons and Sullivans escaped from Ireland. Homeless as hobos, they packed their ragged clothing in bags, boxes, bundles and trunks. Many owned so little that they carried only one paper-wrapped package as they walked to the nearest seaport town.

Berehaven Peninsula Names at the Blue Ridge Tunnel

Names are ranked by order of frequency.

Sullivan
Murphy
Harrington
McCarthy
Leary
Shea
Kelly
Crowley
Lynch
Dwyer

From the "Virginia Blue Ridge Railroad Datasets," Mary E. Lyons, 2009–13.

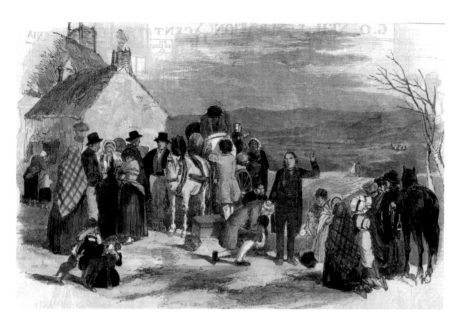

Survivors of the Great Hunger receive a priest's blessing before leaving their homeland. *From* Illustrated London News, *May 10, 1851.*

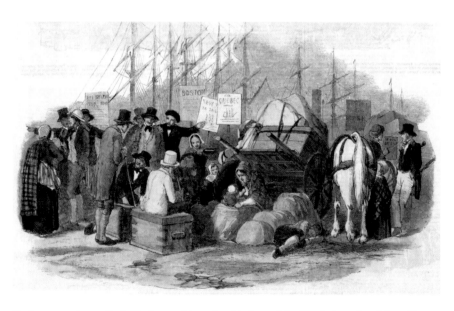

Emigrants arrive at Cork Harbor and board a ship bound for North America. Many Blue Ridge Tunnel workers sailed directly to Baltimore, Maryland. *From* Illustrated London News, *May 10, 1851.*

Wharves at the seaports were sadder than cemeteries. While wind filled the ships' sails, family members who stayed behind wept. A newspaper reporter in Galway heard grown men on the docks "bellow and roar like bulls." The harbor at Cork City was the scene of so many tearful farewells that people called it the Harbor of Tears.

Passage across the stormy Atlantic Ocean could take two months. First-class passengers slept in cabins on deck while the Irish huddled together in the bowels of the ship. This cheap class of travel was called steerage because it was near the noisy rudder, or steering mechanism, for the vessel.

At best, the Irish slept on bunks that were thirty-three inches wide. At worst, they slept on the floor in seawater that seeped through the bottom of the ship. When the journey ended, most landed in ports along the East Coast of North America: Quebec in Canada and the United States cities of Boston, Massachusetts; New York, New York; Philadelphia, Pennsylvania; and Baltimore, Maryland.

The *Albion*, with its load of Harrington and Sullivan families, arrived in New York on May 15, 1848. The picture of what happened to them next is fuzzy. Irish families often split up to find work in America. Sometimes they even lost each other in the confusion of landing in a strange country.

Where the Brennans, Harringtons and Sullivans first lived in America is a mystery. Still, we can make a good guess. The Baltimore and Ohio Railroad Company, or B&O, was located in Baltimore, Maryland. It hired thousands of Cork immigrants in the 1840s and 1850s. Like many Blue Ridge Tunnel workers, John and Catherine Brennan—and the Harrington and Sullivan clans—probably worked for the B&O first. The B&O knew exactly what to do with the newcomers: send them to Cumberland, Maryland, in the mountainous, western part of the state.

RACE TO THE RIVER

The Appalachian Mountains were an immense barrier between eastern states and the Midwest. Travelers crossing the range had two miserable choices. They could ride in a painfully slow boat that traveled four miles an hour along a hand-dug canal, or they could sit in a bone-rattling stagecoach drawn by horses on bumpy plank roads. By the late 1840s, Americans clamored for a faster way. Trains were the answer.

From New York to Georgia, railroad companies were punching through the Appalachians as fast as they could find Irish men to blast tunnels and lay tracks. Their prize was the Ohio River on the other side of the mountain

range. The Ohio River was a pot of gold at the end of two iron rails. Companies that reached the river could move goods across bridges and connect with tracks on the other side. Those same companies would make piles of money from merchants eager to ship their products east and west.

More important, the Ohio flows into the Mississippi River. The Father of Waters, as Native Americans called it, is 2,360 miles long and runs north to south. East to west, north to south—the potential for making money along this watery highway system was enormous.

By 1849, it looked as if the Baltimore and Ohio Railroad would win the race to the Ohio. Contractors signed agreements to build sections of the B&O. They hired Irish immigrants straight off the ships, supervised their labor and paid them at the end of the month.

Years of heavy lifting and digging take a toll on even the strongest body. Men could expect to live only another seven to ten years after starting work on the railroad. One witness who saw Irish laborers on B&O tracks was deeply moved by their emaciated faces and "patched and tattered garments"—sure signs that they had suffered great privations.

Most of the men labored without complaint, while others organized strikes and demanded higher wages. Some men refused to strike. The nightmare of the Great Hunger still haunted their dreams. If they gave up their pay, their families would go hungry again. On the other hand, Irish miners from County Cork were familiar with Rockite tactics. The Cork men, called Corkonians, turned against their Irish countrymen. They assaulted Irish nonstrikers on the job during the day and burned their houses at night. They also attacked newly hired Irish, Germans and enslaved workers.

Tempers along the B&O railroad line were torch-hot in the fall of 1849. One group of Irish workers in Cumberland, Maryland, was from the midland counties of Ireland. Called Fardowners, they defeated the Corkonians in a conflict along the railroad. The Corkonians had long memories. They would soon take revenge at the Blue Ridge Tunnel.

BRIDGE TO BRIDGE

That same fall of 1849, a tall, stout Frenchman named Claudius Crozet won an argument. Crozet was the chief engineer for the state of Virginia. He convinced the board of public works in Richmond that the state should join the railroad dash to the Ohio River.

PLANK ROADS

Plank roads were also called corduroy roads. Builders cleared a path and placed small logs across it side by side. The planks were covered with a protective layer of earth that often washed away. A typical plank road was single track and eight feet wide.

After all, the James River and Kanawha Canal that ran from Richmond partway through the Blue Ridge Mountains had broken in one hundred places in 1843. And plank roads going over the mountains flooded in low spots, or "miry" places—Crozet's term for muddy quagmires. Other states had already figured out that trains were a better way. It was time for Virginia to catch up, and only fools would turn down the chance to make money on the venture.

Take oysters, for instance. Americans adored the fleshy treat inside this mollusk's shell. Oyster saloons, oyster bars and oyster parlors served them raw, boiled, pickled, stewed, broiled or fried. The largest oyster beds in the world were off the coast of Virginia, but oysters spoil quickly. Trains would be the fastest way to deliver the delicacy to drooling customers west of the Blue Ridge Mountains.

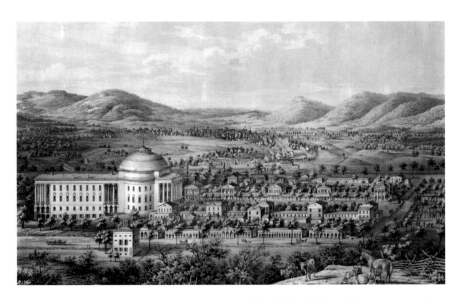

Charlottesville was the western terminus when the Blue Ridge Railroad began construction in 1850. *Center right:* A train passing by the University of Virginia in Charlottesville. *Courtesy of Library of Congress.*

With a beaver hat on his head and a compass in his coat pocket, Crozet made several trips on horseback through the Blue Ridge Mountains. He discovered a narrow pinch in the mountain chain and told Richmond lawmakers that the "most favorable pass" for a railroad was at Rockfish Gap.

The Richmond officials agreed. The railroad would start at a bridge over Mechum's River on the east side of Rockfish Gap in Albemarle County. It would end at a bridge over the South River on the west side, near the village of Waynesboro. From bridge to bridge, the tracks would stretch for eighteen miles through four tunnels and some of the roughest terrain in the eastern United States.

The project was so massive that the state of Virginia formed its own company, the Blue Ridge Railroad, to pay for it. Crozet estimated that he could finish by 1853. At the same time, the privately owned Virginia Central Railroad would lay tracks east of the bridge at Mechum's River, connecting it with the village of Charlottesville. More tracks would run between the bridge over the South River at Waynesboro and the city of Staunton.

And still more Virginia Central Railroad construction would occur simultaneously from Staunton west through the Alleghany Mountains. When all the tracks, tunnels and bridges were finished, they would form an unbroken line to the Ohio River.

The race was on.

1850

Now that Virginia was committed to the railroad, Claudius Crozet could advertise for contractors for the four tunnels. John Kelly, a well-educated Irish man known for his hospitality, was one of many who responded with a bid for the Brooksville and Greenwood Tunnels. These passages would be built east of the main Blue Ridge Tunnel.

Kelly had been in the United States at least six years. In 1844 and 1845, he led construction of a tunnel and tracks for the Maryland Mining Company in Cumberland, Maryland. In the mid-1840s, he oversaw canal construction for a different company, and in the late 1840s, he completed railroad work for the Baltimore and Ohio in Sykesville, Maryland.

Kelly's letters of recommendation from his supervisors noted that he was an "efficient manager" who "prosecutes his work in a satisfactory manner" and that he was "industrious, high-minded, energetic, and honorable." The praise must have impressed Crozet. He chose Kelly to build the Brooksville and Greenwood Tunnels and eventually the monster Blue Ridge Tunnel.

When railroad contractors moved to a new job, they brought reliable workers along. It's likely that the men who followed John Kelly to Virginia were Corkonians who had worked for him in Maryland. They had earned his trust by following his directions, and he had earned theirs by paying them on time.

Kelly's group left Maryland sometime after December 1, 1849. He brought heavy construction tools. The Corkonians packed typical Rockite

The first page of Claudius Crozet's specifications for building the Blue Ridge Railroad. *Author's collection.*

weapons—pistols, clubs and swords. They reached Rockfish Gap around January 1850.

Claudius Crozet and John Kelly knew how impossibly hard the work would be. Forty-two train tunnels had been built in the United States by this time. None passed through a mountain as steep as at Rockfish Gap. Anyone who has set up a model train understands that tracks have to climb or descend a slope gradually. If the uphill climb over Rockfish Gap were too abrupt, the locomotive and train cars would slide backward and tumble off the rails.

If the downhill tracks were too steep, brakes might not be strong enough to maintain a safe speed. Either way, the result would be a runaway train, smashed cars, spilled freight and bloody passengers.

The west side of the future Blue Ridge Tunnel was easy enough. A locomotive would roll out of the Blue Ridge Tunnel and steam two miles down a long slope. When the train reached the bottom of the hill, it would cross a bridge over the South River at Waynesboro and continue west on flat land to Staunton.

The east side of the Blue Ridge Tunnel was a different story. Crozet admitted that the first few miles of land beyond the east portal were the most rugged he had ever seen. The mountainside was too narrow for a track bed. He needed an embankment at least twelve feet wide, built of piled-up rocks blasted from the tunnel. Train tracks would run along the top. (The two engineers mentioned in the Prologue walked this same track bed in 1976.)

The next two miles heading east were even more complicated. If you crumple a piece of paper, you'll see empty spaces between the folds. In the mountains, these are called hollows. The Blue Ridge Railroad would span three hollows more than 1,000 feet wide. Workers had to construct embankments across them, building from the bottom up. One embankment would be 130 feet wide at the bottom—the width of a ten-lane highway—and 80 feet high. Stone walls hundreds of feet long would hold up the sides.

Steep mountain ridges lay before, between and beyond the three hollows. Shorter tunnels would pierce these ridges and connect them with tracks running on top of the embankments. It was as if Crozet planned to make this part of the railroad out of rock and sky. And it would all be built by hand. In the meantime, the Irish needed a place to live.

NEWLYWEDS

A cluster of shanties sprang up between trees at the top of the mountain, near the future openings of the Blue Ridge Tunnel. The Irish first collected thick, flat fieldstones and then wedged them in the mountainside as foundations. Shanty walls were made of scrap timber—rough boards that likely protruded at the end. Empty barrels with the top and bottom removed served as chimneys. Building a wooden shanty in America was much like building a mud or stone cabin in Ireland. Friends and relatives helped one another and finished a dwelling in one day.

It's hard to picture building a shanty in the dead of winter. The summit of the mountain at Rockfish Gap is 2,418 feet above sea level and windy all year round. In January, air temperatures at the mountaintop can be twenty degrees colder than at the base. The Irish wore whatever they could afford,

which wasn't much. It's doubtful they had more than a wool jacket for outerwear as they lifted fifty-pound rocks in howling winter gales.

A typical shanty was around twelve feet by twelve feet—the size of a small bedroom. It might hold six single men or two sets of parents with small children. Shanty living was uncomfortable and unhealthy. Still, it was better than sleeping in water on a ship's floor.

About 150 Irish lived in the west side shanties. The occupants of one dwelling included newlyweds. John Brennan could protect his sister, Catherine, from rowdy railroad men for only so long. Michael Harrington, who was single when he left the Berehaven Peninsula in Cork, married Catherine Brennan in early 1850. The couple may have known each other in Bantry Town, or perhaps they met in New York or Baltimore. Either way, it's nice to think that marriage provided them some comfort after the tragedies they had witnessed in Ireland.

Michael and Catherine shared a shanty with Mark and Anna Sullivan and their three-year-old daughter, Mary. The Sullivans were also from the Berehaven Peninsula. Both families would have spoken Irish and English. If we close our eyes, we can almost hear Anna singing a lullaby in the Irish language to little Mary as dusk tiptoed around the shanty each night.

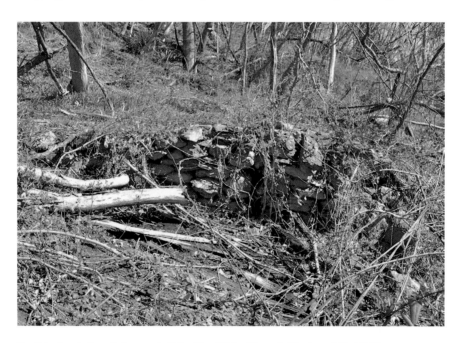

Possible shanty foundation east of the Blue Ridge Tunnel. *Courtesy of Paul Collinge.*

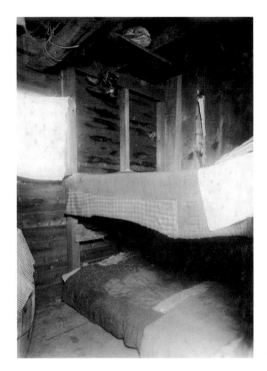

Shanty interior, New Jersey, early twentieth century. Nineteenth-century drawings of Irish cabins often pictured a cloth-covered barrel, seen here on the far left. *Courtesy of Library of Congress.*

Housing was the same going down the east side of Rockfish Gap. Overcrowded shanties near the east side of the tunnel housed another 150 Irish: more Harringtons and Sullivans from County Cork and families from every other corner of Ireland.

Irish Bull

Trouble started soon after the Corkonians settled in their shanties on the mountain. On February 7, 1850, a parade of picturesque carts made its way through the streets of Staunton, Virginia. The carts were driven by Fardowner men and piled high with luggage. Women and children were perched on top. Soaked to the bone from a rainstorm, the group rode cheerily through town. They headed east toward the western base of the mountain, where they moved into boardinghouses, rented rooms in farmhouses or built shanties.

The Fardowners had arrived to lay tracks between the bridge over the South River and Staunton. They were the same group that had defeated

<div style="border: solid">

PRE-FAMINE IMMIGRANTS

A handful of Irish Catholic families were already settled in Staunton when the famine immigrants arrived in 1850.

- Owen Kivlighan from County Sligo and his wife, Mary, from County Limerick
- Peter Crickard from Downpatrick in County Down and his wife, Rose
- Mary and Patrick McAleer from County Tyrone
- Edward Dooley from County Limerick and his wife, Johanna, from Cork City.

From the "Virginia Blue Ridge Railroad Datasets," Mary E. Lyons, 2009–13.

</div>

Corkonians in a labor conflict in Maryland a few months earlier. The Corkonians up at Rockfish Gap were still nursing their wounded pride, and they must have worried that the newcomers might work for less pay, just as so-called strangers had done back in Ireland. According to Staunton newspapers, the Corkonians warned the Fardowners to leave. Apparently the Fardowners refused.

The thought of lower pay disturbed Corkonian women as much as it did the men. On a Monday night one week later, 250 Corkonian men and women marched to a large farmhouse rented by twelve Fardowners. About seven were home. The others were out, possibly planning a counterattack on the Corkonians.

Filled with Rockite spirit, the avenging Corkonian leader wielded a sword. Fourteen others carried pistols or clubs. They burned down the two-story house, and though no one was hurt, police arrested fifty Corkonians in the morning. Everyone except fifteen identified leaders was released that day. Six remained in jail for four months.

A local newspaper reporter described the "bull" he heard when police questioned Corkonians present at the commotion. "One witness said he last saw a prisoner on Monday," the amused reporter wrote, "but did not see him again until tomorrow."

"Bulls" were a sly trick the Irish often played on English police and lawyers back in Ireland. The Corkonian witness was using language to have a laugh on the policeman, but the reporter didn't understand the mockery. Nor did

he understand the true cause of the disturbance. It was a conflict over wages that stretched back to B&O tracks in Maryland and to Ireland before that. Now it had reached the Virginia Blue Ridge Railroad.

A SMALL ARMY

When the worst of winter was over in 1850, the energetic John Kelly and his partner, Irishman John Larguey, put their men to work at the Blue Ridge Tunnel. Twenty-two of the laborers were from the Harrington clan. Forty-seven were Sullivan men. Many hundreds more Irish built the remaining tunnels.

A prodigious amount of protein was necessary for the tasks ahead. John Kelly made sure that the men ate well. In 1850 alone, they consumed more than seven thousand pounds of beef that he purchased from a nearby general store, though they probably had to pay Kelly for the meat, and the effect of a suddenly rich diet on famine survivors who had been reduced to eating chickweed in Ireland is unknown.

JOHN KELLY'S WORKFORCE AT THE BLUE RIDGE TUNNEL, MAY 1850

- Foremen: 4
- Drillers: 25
- Quarry men: 28–57
- Pick holders: 14
- Blacksmiths: 4–18
- Carpenters: 2
- Drivers: 7–9
- 7 horses and carts and some wheelbarrows

Total men: 84

About three thousand Irish workers, family members and enslaved laborers lived along the Blue Ridge Railroad between 1850 and 1860. Sixty percent were from County Cork. Surviving payroll records show that about eight hundred Irishmen in all labored on the Blue Ridge Tunnel. The entire workforce was the size of a small army, and like members of an army, they each had a job to do.

Most tunnels in those days were built by drilling shafts straight down from the mountaintop. Rope pulleys lowered men in carts down to the tunnel floor. The Blue Ridge Tunnel was seven hundred feet below the mountain's peak and too deep for shafts. Workers could only blast sideways into the granite guts of the hill.

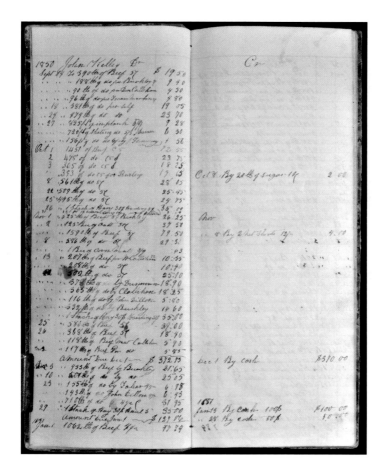

John Kelly's purchases were charged to the railroad and listed in this general store ledger. Presumably the amounts were deducted later from the men's pay. *Courtesy of Clann Mhór.*

Plus, the passage was fifty-seven feet uphill, east to west. Mountain springs fed by rain and melting snow constantly leaked into the work area. Laborers in the tunnel were usually soaking wet. Most important, dynamite hadn't been invented yet. Unpredictable black gunpowder was the only explosive available at the Blue Ridge Tunnel.

Two-man teams first created long cuts, or approaches, leading to the future portals. A driller balanced a steel rod on his shoulder and crouched down on the cleared mountainside. The tip, or bit, of the rod was star shaped. A striker stood behind the driller. While the driller twisted the rod, the striker pounded it into the rock with a sledgehammer. The hands and arms of both workers quivered with every blow.

When the drill hole was ready, a blaster wrapped loose gunpowder and a long fuse in slow-burning brown paper. He shoved the deadly package down the tube-shaped hole and lit the fuse while everyone ran. If a stray spark

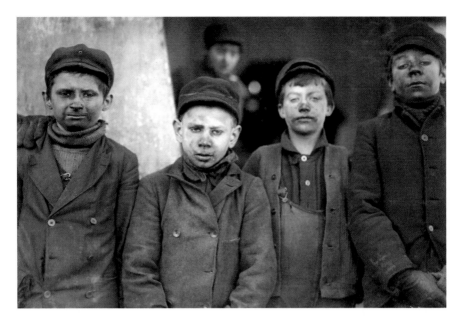

Boys at work, early twentieth century. *Lewis Hines photograph, courtesy of Library of Congress.*

from the match landed on the gunpowder, the blaster was blown to bits of flesh and bone. Only a person desperate for wages would work such a job.

About fifty-two Irish boys between the ages of seven and sixteen also toiled inside the Blue Ridge Tunnel. None of them attended school. They worked eleven-hour shifts just as the men did. Eventually, Crozet called for three eight-hour shifts. Men and boys often worked two of these shifts in one day.

Daniel Harrington Jr. was one of the youngest boys. Only nine years old, he carried tools for the men, who would have included his father, Daniel Harrington Sr. Other boys loaded and unloaded rock debris from carts and drove the mule teams that pulled the carts. Payroll records suggest that the eldest boys worked alongside men near the blasts, earning a boy's pay for doing a man's hazardous work.

Seven boys helped make 168,000 bricks for the tunnel walls and ceiling. They cut hundreds of cords of wood, loaded them into horse-drawn wagons and drove the wagons to kilns, or ovens. Night and day, the boys fed wood into the kilns, where high heat hardened the bricks.

None of these laborers could have done their exhausting tasks without help. About six hundred Irish women and girls lived along the Blue Ridge Railroad. The wives gave birth, nursed newborn babies, cooked meals

and surely raised chickens and pigs. The youngest children would have slopped the pigs with food scraps and hauled buckets of drinking water from mountain springs.

Elizabeth Sullivan from County Cork was a maid-of-all-work in a local home near the Blue Ridge Railroad. Though her age is unknown, she could have been as young as twelve—a common age for Irish servant girls in America. She would have risen at 5:30 a.m. seven days a week to sweep, dust, set the table, cook and serve breakfast, make beds, scrub floors, shake carpets, answer the front door and run errands. Bedtime was 10:00 or 11:00 p.m. It was mind-numbing drudgery. As one Irish servant girl wrote to a friend, "'T'sn't fair."

Unmarried or widowed sisters and aunts at the Blue Ridge Railroad earned extra money as washerwomen. One woman worked as a seamstress. Another may have run a railroad kitchen that cooked and served the thousands of pounds of beef, mutton and fish to the famished laborers.

BLACK VIRGINIANS

When southern railroad companies needed a contractor for a section of track, they often hired a plantation owner who lived nearby. Planters might not know much about building a railroad, but the lure of money gave them a reason to learn quickly. About ten local contractors worked for the Blue Ridge Railroad. All of them owned slaves—a convenient source of free labor for the project. At the end of each month, the planters pocketed most or all of their salaries.

Thomas Jefferson Randolph, grandson of the third American president, Thomas Jefferson, was one of the local contractors. His 1850 contract with the Blue Ridge Railroad called for three miles of construction. It covered a level section of land midway between the Greenwood Tunnel and Blair Park plantation. Randolph's crew included at least twenty-seven slaves. His bid for the contract hints that he avoided placing them near potentially dangerous tasks such as cutting trees or building high bridges. A healthy male slave was worth $1,200 at the time. Randolph wouldn't risk losing his investment in human flesh.

Instead, the men leveled land along the path of the tracks. They may have laid wooden crossties, then placed the rails along the crossties and pounded them in place. The last step was adding ballast between the rails for stabilization. Randolph's workforce shattered large rocks with sledgehammers,

African American railroad workers, 1862. *Courtesy of Library of Congress.*

THOMAS JEFFERSON RANDOLPH'S WORKFORCE, MAY 1850

Overseer: 1
Quarry men: 8–9
Negroes: 22 (5 not at work)
27 [men] *with 5 carts*

Quoted from Claudius Crozet's letter to the president and directors of the Blue Ridge Railroad Company, May 6, 1850.

making two-inch pieces the size of large gravel. They spread and rammed the ballast—1,800 cubic feet per mile— in the ground between the rails and leveled it.

The crew also helped build fifteen culverts. A miniature tunnel made of stone, a culvert channels rainwater through the bottom of an embankment and prevents flooding of the tracks on top. To build the culverts, the men would have broken chunks of rock into roughly rectangular slabs with sledgehammers. Then they lifted the slabs by hand and set them in place. It would have been an exhausting process.

Contractor Mordecai Sizer used a mixed-race workforce, with an average of

Double culverts at Goodloe Hollow, east of the Blue Ridge Tunnel. *Author's collection.*

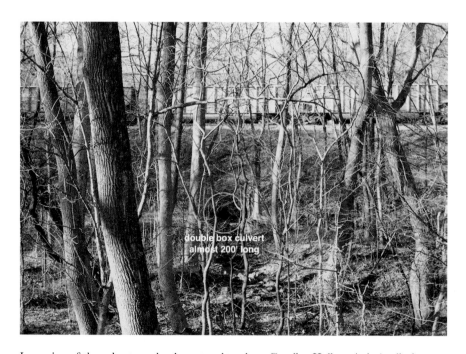

Long view of the culverts, embankment and tracks at Goodloe Hollow. *Author's collection.*

one hundred Irish and forty-two enslaved men. They worked on three sections of the railroad east of the main tunnel. One section included a double culvert and embankment at Goodloe Hollow.

Sizer's crew first constructed a box culvert almost two hundred feet long. The roof and walls were built with slate that the men excavated and roughly shaped on site. When Crozet worried about leaves and brush blocking the culvert in a heavy rain, he directed the men to build a twin culvert alongside the first to catch overflow water.

Next the crew excavated and hauled rocks for the embankment. Sixty feet high, it still covers the double culvert and stretches thousands of feet east and west. The man-made mound now looks like a natural part of the mountain landscape. Trees hide the culvert openings, which are still in use. Sunlight flashes off the metal sides of coal cars that roll along tracks on top of the embankment. Nothing about the scene today suggests the laborers—their backs straining with every lifted rock—who created it in 1850.

PROWLING ABOUT THE MOUNTAIN

THE ROAD TO UNREST

Rockites and other secret Irish societies paved the way for labor unrest in America. Their rebellions, including strikes at the Blue Ridge Tunnel, were small steps on a path that led to a widespread 1877 railroad strike. By that time, American workers were ready for a full-scale revolt against their oppressive employers.

As the Irish shouted over the roar of blasts that spring of 1850, a whispered message made its way through the work area. Railroad workers up and down the East Coast of America were planning to strike for higher wages.

Men on the B&O Railroad in Maryland left the tracks in early March. In a matching move, one hundred Irish at the Blue Ridge Railroad walked off the job on March 26. Claudius Crozet nervously wrote to officials in Richmond that the Irish men were "prowling about the mountain."

The Blue Ridge Railroad Company paid the owner of a team of mules seventy-five cents a day for hauling rocks. The average daily wage for a man working like a mule

Irish graves at Thornrose Cemetery in Staunton, Virginia. Many Irish who died during the railroad construction decade are buried at Thornrose. *Author's collection.*

on the Blue Ridge Railroad in 1850 was also seventy-five cents. Boys earned about fifty-four cents a day. The wages were well below usual railroad pay.

The Irish struck for more money in April. When Crozet refused, some left. They had suffered too much from landlords in Ireland to let one man govern them in America. Only death could control them now.

Thomas Devine was blown up in an explosion in June 1850. That same month, a local railroad foreman shot and killed an Irish foreman. A jury decided that the local man was innocent. Four people died from dysentery in July. They included a five-year-old Sullivan boy. More explosions at the Blue Ridge Tunnel killed two men in September.

For every mile of progress along the Blue Ridge Railroad in 1850, an Irish person died. Their burial places are unknown.

3

1851–53

Time and again, the mountain let the men know that it was boss. When the portal approaches were complete, drillers and headers cracked open the tunnel's two mouths. They first blasted a hole large enough to stand in. Now that rock surrounded them on three sides, the danger tripled. Two men were blown up in January 1851.

Blasting forward, the crew created the tunnel ceiling and a rock shelf, or heading, fifteen feet long. As work progressed, the shelf became hundreds of feet long. At the same time, other men drilled and blasted into the face of the shelf, or bench. Men at the face of the shelf were called floorers because they worked on the tunnel floor. Men on top of the shelf were called headers because they worked farther ahead, into the black vault of the mountain.

At first, only nine men could fit inside the west opening of the Blue Ridge Tunnel. The ghostly glow of whale oil lamps lit their way day and night. Imagine twelve yardsticks laid end to end. That's how little progress the men made on the west side each month of 1851. Some rock was so soft that large masses of it fell from the ceiling as they worked.

Men on the east side of the mountain had the opposite dilemma. The greenstone there was so hard that it dulled the drill bits before they could dent the rock. These teams made only nineteen feet of progress each month—about six yardsticks laid end to end.

Though John Kelly pushed his men hard, Crozet's letters indicate that both he and the contractor were discouraged. At this rate, the Blue Ridge Tunnel would take eight years. Meanwhile, the B&O Railroad was shoving

through the mountains at Wheeling, Virginia, on the east side of the Ohio River. The Kingwood Tunnel under construction at Wheeling had three vertical shafts and two portals. Workers blasted away in eight places at once and were making three hundred feet of progress every month.

Crozet was falling well behind in the race to the Ohio River. Culverts offered the only encouraging news.

A SINGULAR SCARCITY OF STONE

Claudius Crozet reported in a letter that an expensive culvert under the widest embankment was "creditable work," thanks to John Kelly's direction. Crozet failed to credit the stonemasons who built the culvert, perhaps because there was no shortage of them. But finding enough easily cut limestone near the masons' work sites was a constant headache. Crozet noted with irony the "singular scarcity" of usable stone in a mountainous, rocky area.

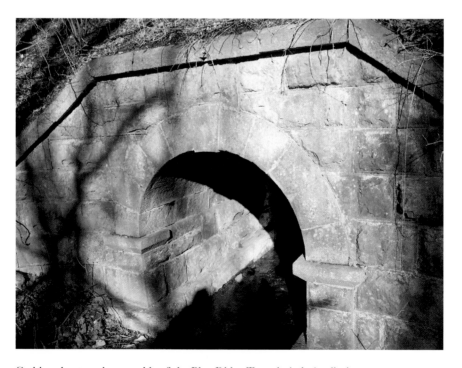

Gothic culvert on the west side of the Blue Ridge Tunnel. *Author's collection.*

Irish Stonemasons on the Blue Ridge Railroad

Cornelius Collins
Richard Collins
Thomas Collins
Daniel Croghan
John Croghan
Thomas Croghan
Peter Crowe
Thomas Cullen
Thomas Cullinan
John Daly
Charles Duggan
Pat Flannery
Michael Keefe
John Kelley
Florence McCarthy
John McCarthy
Michael McCarty
Michael McGinty
Dennis Mullins
Michael Mullins
William Mullins
Dennis Murphy
John Murphy
Michael O'Keefe
John Quinn
Daniel Sullivan

From the "Virginia Blue Ridge Railroad Datasets," Mary E. Lyons, 2009–13.

Construction of a viaduct—a railroad bridge—over the Rockfish Gap Turnpike on the west side of the mountain was especially troublesome. The viaduct required a tall stone support, or abutment, on both sides. An embankment next to the viaduct needed a culvert to channel rainwater and melted snow. Both structures would be built of limestone.

After exhausting a limestone quarry near the viaduct, skilled Irish stonemasons moved to a quarry several miles distant. They would have worked in cutting sheds where they transformed rough pieces of limestone into precisely measured rectangular blocks. A gritty mix of water and sand was poured over the rough limestone as the masons worked. The sand provided abrasion while the men sawed the blocks with toothless iron blades, and the water washed away stone dust. The finished stones were smooth as a sidewalk, but the cost of paying a local hauler who moved them by wagon to the viaduct was high.

The railroad hired about twenty-four men, including five stonemasons, to build the viaduct and culvert. The first worker listed on the payroll was thirty-seven-year-old Peter Crowe, a master mason from County Clare, Ireland. His brothers-in-law, Daniel and Thomas Croghan, were also from County Clare. Both were probably Peter's apprentices; Daniel later became a qualified mason.

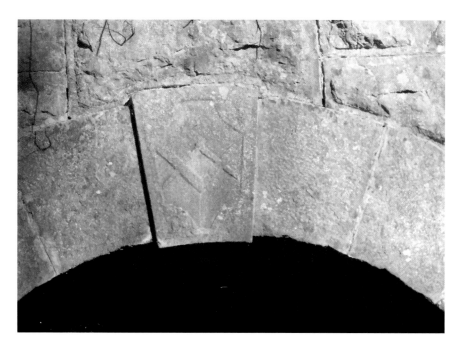

A master stonemason—possibly Peter Crowe—inscribed the ancient tools of his trade on the culvert keystone: an open compass and a T-square ruler. *Author's collection.*

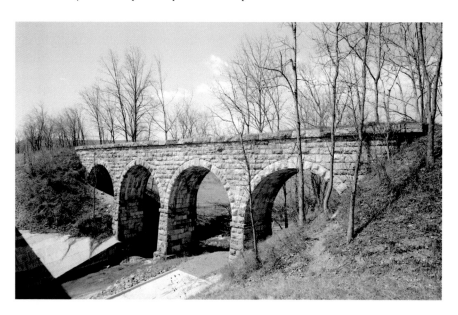

This abandoned railroad viaduct south of Staunton, Virginia, gives a sense of how the Blue Ridge Railroad viaduct may have looked. *Courtesy of Library of Congress.*

Peter's crew would have gradually removed pieces of a supporting timber frame as they assembled the stone abutments and the culvert. When they withdrew the last piece of timber on the culvert, they inserted the keystone—a central block at the top of the arch—to lock all the stones together. The culvert was about 150 feet long, 5 feet wide and 8 feet high. Crozet called it and others like it along the railroad "stupendous structures."

Peter Crowe was descended from a family of noted Irish stonemasons. One of them, "Black Johnny" Crowe, helped build an impressive bridge in 1804. It runs beside Bunratty Castle in County Clare and is still in use. Though the original abutments at the Blue Ridge Railroad viaduct are gone, the Crowe-Croghan culvert is also still in use. More than 160 years have passed since Peter Crowe and his men eased the stones in place. The timeless tinkle of water can still be heard as it courses over the culvert floor.

Double-Barreled Chimneys

Outdoor photography was rare when the Blue Ridge Tunnel was built. Luckily, the diary of one teenage traveler gives us a snapshot of how the Irish fought for survival at Rockfish Gap.

In June 1851, a lively but naive young woman named Mary Jane Boggs was living near Richmond, Virginia. Eighteen years old and fond of fashion, she packed her prettiest dresses in a trunk and her finest bonnets in a hatbox. Her father strapped them on the back of a horse-drawn carriage, and the pair set off with two cousins for a vacation in the Blue Ridge Mountains.

The next day, their carriage climbed Stagecoach Road at Rockfish Gap. When it reached the top of the mountain, Mary Jane glanced back at the scenery that stretched out behind her. "I was indebted to an Irishman for one of the prettiest views of the Valley," she wrote in her diary. "One of the poor men who works on the railroad had made a clearing among the trees in order to plant his potatoes.

"There are a great many Irish cabins on each side of the mountains," Mary Jane remembered, "which reminded me of descriptions I have read of the manner of living of the lowest class in Ireland. They are mere hovels, & most of them have one or two barrels on top of the chimney, but in some of them, we saw muslin curtains, a strange mixture of dirt & finery."

Then Mary Jane parroted stereotypes she had read in newspapers: "The people are real Irish, wretched, miserable & dirty in appearance, but they hold on to Irish fun & Irish potatoes as well as Irish tempers. Father called to a man

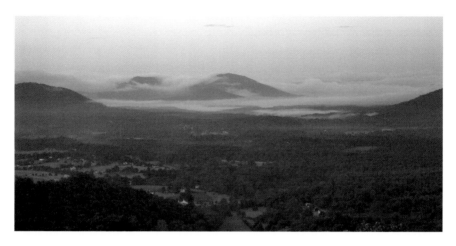

View from Rockfish Gap. *Courtesy of Jim Kauffman.*

who was at the door of one of the cabins & told him he had often seen double barreled guns but had never before heard of double barreled chimnnies [*sic*]."

The word play amused the Irishman, but the next joke wasn't so funny. As the carriage rolled a bit farther up the road, Mary Jane's cousin made a crack about the "queer way the Irish had of washing their clothes at sunset."

An Irishman overheard the cousin and answered with a sharp reply. (Mary Jane didn't hear what he said). You can't blame the fellow. Men and boys at the tunnel worked in constant clouds of gritty smoke from gunpowder explosions. The thick, bitter fumes reddened their eyes and coated their lungs; the stink polluted their hair, skin and clothes.

UP IN THE CLOUDS

I don't know how it happened, but I never heard much about Rockfish Gap, & when [we] *reached it, we were all struck with admiration. We were, both literally & figuratively, up in the clouds. The vapor around us was so thick that it made our clothes damp & it was almost oppressive to breathe it, but the sun was shining brightly upon the little valley below us, which looked like a green garden spot…On one side was some peaks of the Blue Ridge on one of which a cloud was resting, like a crown.*

From the Diary of Mary Jane Boggs, *June 1851.*

WHAT THE IRISHMEN WORE

Irish laborers along the Blue Ridge Railroad purchased the following items of clothing from the Wallace general store, which was centrally located between the Blue Ridge Tunnel and Mechum's River Bridge. Blue pinstriped hickory shirts, so called because the heavy denim is as tough as hickory wood, are still produced for manual labor such as logging.

- Hickory shirt: $0.62
- Two pair of drawers: $1.75
- One pair of mitts: $0.75
- Check shirt: $0.62
- Flannel shirt: $1.25
- Boots: $3.75
- Coarse boots: $3.50
- Fine boots: $3.75
- Pants: $4.75
- Suspenders: $0.25
- Cotton handkerchief: $0.19
- Pocket handkerchief: $0.25
- Silk handkerchief: $0.75
- Vest: $2.75
- Black hat: $1.00

From a ledger book kept at the Wallace general store in Greenwood, Virginia, January 1852.

Staying clean in such an isolated spot was a challenge for the Irish, yet they won the battle. They regularly bought pounds of soap from local merchants. They also had plenty of water from mountain springs that bubbled up near shanties on both sides of the mountain.

No doubt, the man who snapped at Mary Jane's cousin had just finished a long shift at the tunnel. Maybe he was on his knees, scrubbing a pair of coarsely woven pants and a heavy work shirt. If so, he was in no mood for a snobby remark. And no matter how clean he got them, he would still be dirty in the minds of people like the Boggs family.

Mary Jane admitted in her diary that the tunnel was a "stupendous undertaking & will require a great amount of labor to complete it. Some of the embankments & deep cuts of the railroad too must have required a great deal." But like the rest of America, she seemed unable to connect a "great amount of labor" with smoky clothes and sooty faces. To her, Irish railroad workers were simply, as she put it, "dirty" people with no need for curtain finery.

LOST HISTORY

Michael Harrington often worked two shifts a day as a header or floorer at the Blue Ridge Tunnel. So did his brother-in-law, John Brennan. Sunday—their only day off—was a welcome relief. In July 1851, the two men had a special reason to enjoy Sunday. Catherine Brennan Harrington had given birth to a daughter that month. Now it was time to baptize the infant.

The only Catholic Church in the area, Saint Francis of Assisi, was fifteen miles away in Staunton. Father Daniel Downey was the pastor at Saint Francis. He asked the Irish to build a wooden chapel on the mountaintop. Located midway on the railroad construction route, the chapel allowed Downey to say Mass for families who were unable to reach Staunton on Sunday. He probably baptized Michael and Catherine Harrington's daughter in the wooden chapel.

We know only two facts about the baptism: the baby's name was Margaret Jane, and John Brennan, her uncle, was her godfather. Time hides everything else about that day from us. Irish Americans are often frustrated by how little they know of their immigrant ancestors. They use phrases such as "lost history" and "hidden memories." It's as if the Irish who fled during the Great Hunger developed amnesia once they reached America. They didn't, of course. It was just easier to suppress memories of walking corpses and mass burials if they never wrote or talked about them.

As one Irish American daughter said, "I used to ask my father about Ireland when I was growing up. He'd say, 'Ah, don't ask me that. I can't talk about it now.'"

The same is true for the Irish who built the historic Blue Ridge Railroad. So far, we have no photographs of the workers and no diaries or journals. Out of their meager salaries, Irish living along the railroad mailed an average of $4,000 home to relatives each year. They probably sent the money with letters describing life on the Blue Ridge Railroad. Those letters may no longer survive.

The past does not easily give up its secrets. Sometimes we have to help it along. We can be sure that Margaret Jane's baptism was a joyful occasion for her parents. On that day, their daughter became a member of their religious community—a reason for celebration in any faith. Perhaps the Harringtons invited Father Downey back to their shanty. Maybe their shanty mates, Mark and Anna Sullivan, brewed a pot of precious, expensive tea and passed around a plate of buttered bread. Irish men along the railroad routinely bought plugs of tobacco and clay pipes. After the modest feast, fragrant pipe smoke would have sweetened the air.

Irish Shanties at Walden Pond, Massachusetts

In a small and secluded dell that opens upon the most beautiful cove of the whole lake, there is a little hamlet of huts or shanties, inhabited by the Irish people who are at work upon the railroad. There are three or four of these habitations, the very rudest, I should imagine, that civilized men ever made for themselves,—constructed of rough boards, with the protruding ends. Against some of them the earth is heaped up to the roof, or nearly so; and when the grass has had time to sprout upon them, they will look like small natural hillocks, or a species of ant-hills,—something in which Nature has a larger share than man.

These huts are placed beneath the trees, oaks, walnuts, and white pines, wherever the trunks give them space to stand; and by thus adapting themselves to natural interstices, instead of making new ones, they do not break or disturb the solitude and seclusion of the place. Voices are heard, and the shouts and laughter of children, who play about like the sunbeams that come down through the branches. Women are washing in open spaces, and long lines of whitened clothes are extended from tree to tree, fluttering and gambolling in the breeze…

The household pots and kettles are seen at the doors; and a glance within shows the rough benches that serve for chairs, and the bed upon the floor. The visitor's nose takes note of the fragrance of a pipe. And yet, with all these homely items, the repose and sanctity of the old wood do not seem to be destroyed or profaned.

From The American Notebooks, Volume 2 by Nathaniel Hawthorne, October 6, 1843.

As in Ireland, the shanty door would have stood open as a sign of welcome. Other Irish might have stopped by to play a medley of tunes, dance a few jig steps and tell a story or two. Father Downey would have been an honored guest at the party. He was also from Ireland. More than anyone, he understood the loneliness of the Irish at the Blue Ridge Railroad.

Whereas most of Ireland was Catholic, most of Virginia was Protestant. Protestants in the state and across the country were often critical and fearful of Catholic immigrants. The first Catholic Church in Staunton was built in 1851, shortly after the famine immigrants arrived. No doubt, they erected it. The structure was more than four brick walls with green shutters and a steep roof. It was a protected place where families could escape Protestant eyes while praying for better times.

Father Downey held his isolated Irish flock together with the familiar and comforting rituals of the Catholic Church. He performed marriage ceremonies, baptized infants and, sadly, presided over frequent funerals as deaths increased along the Blue Ridge Railroad.

SHANTY POWDER AND BALL

Late in 1852, two floorers named Michael Powers and Michael Curran were wounded in a gunpowder blast. Curran lost both hands. The board of public works in Richmond approved one month's full pay for the injured men.

Michael Powers was back on the job by February 1853, working as a floorer. But Michael Curran was fully disabled and perhaps dying. Contractor John Kelly felt responsible for him. In March, Kelly wrote a letter asking the board to continue Curran's wages. Their curt reply: "The Board have no authority to apply the public funds in the manner desired."

Michael Curran then disappeared from the payroll and all other public records. We can assume that he died from his severe injury. Whether he was dead or alive, the railroad company's unfeeling neglect must have enraged his fellow workers. Their anger boiled over when they heard a rumor the following month: a header could make $1.50 a day in Cincinnati, Ohio, and a floorer could earn $1.25 a day.

BLUE RIDGE RAILROAD PAYROLLS

Extant payrolls begin April 1852 and end September 1857. Some months are missing. The payrolls contain a total of 10,011 names, or about 900 different names written again and again, month after month, year after year. Each page lists men's names, jobs, exact days worked, daily wages and total monthly pay. The payrolls are housed at the Library of Virginia.

Payroll page for the Blue Ridge Tunnel. *Author's collection.*

A total of 160 men immediately went on strike for higher wages. Naturally the boys did, too. Everyone had to join the strike, or it would fail. An east side shanty dweller posted a notice on the blacksmith's shop at the west portal of the Blue Ridge Tunnel. He or she didn't sign it "Captain Rock," but it contained a typically anonymous Rockite threat: "Let no man go to work in this Tunnel without a dollar and a half in the heading and dollar and twenty-five cent in Bottom: take notice, young or old, married or unmarried, let them look out for shanty powder & ball."

Three long weeks passed. Wives in the shanties must have been anxious. They knew their families would have only six or seven dollars to live on after payday at the end of the month. The strike was a risk for people with so little money; yet working in the tunnel was a frightful risk, too. No woman wanted to send her man to the tunnel in the morning, only to see his shredded body carried home at night.

The strike caused Crozet serious trouble. Local citizens were fed up with the unfinished Blue Ridge Tunnel. A group of sixty wrote and signed seventeen pages of complaints. "If left to the management of Col. Crozet," they sniped, "God only knows when it will be completed."

Crozet's critics must have known about the steady progress on the Pennsylvania Railroad, where Irish men were thrusting their way through a tunnel. When finished, it would connect with Pittsburgh on the other side of the Appalachian Mountains. And the Baltimore and Ohio Railroad had recently reached the Ohio River near Wheeling. At 4,173

feet, the Kingwood Tunnel at Wheeling was shorter than the planned Blue Ridge Tunnel. For the present, though, Kingwood was the longest in the world.

Building the longest mountain railroad tunnel in the world was the least of Crozet's worries at this point. If the Blue Ridge Tunnel strike continued, Virginia would have to drop out of the race to the Ohio River altogether. Crozet stood firm. He asked the governor of Virginia to send civilian soldiers in case violence broke out. And he told the board in Richmond that it should advertise for two hundred Irish workers in northern newspapers. "If, at last, we have to go up so high," he wrote, "let it be with newcomers, who have not been guilty of embarrassing us and stopping work without warning."

Meanwhile, contractor John Kelly offered his men a compromise. The Blue Ridge Railroad Company would pay headers $1.25 a day, not $1.50. Floorers would earn $1.12½ a day, not $1.25. The workers refused.

A large group left for Cincinnati. Michael Harrington may have been one of them. He disappeared from the Blue Ridge Tunnel payroll around this time, and once again, John Brennan was left to watch over his sister, Catherine.

The labor crisis seemed unsolvable until Father Downey stepped in and urged the men to take the compromise wages. The Catholic Church was the one authority in America the Irish thought they could trust. Reluctantly, they accepted John Kelly's deal and returned to the wet, smoky tunnel. A boy's daily wage of $0.54 also jumped. Young Daniel Harrington now carried tools for $0.62½ a day.

CONSTANT DREAD

Catherine Harrington welcomed Michael Harrington back home in June 1853. Their son, John Patrick, was born nine months later. Apparently Michael refused to work in the Blue Ridge Tunnel and probably labored elsewhere on the Blue Ridge Railroad. Meanwhile, young Daniel Harrington Jr. worked twelve-hour shifts while the men bored steadily through the passage that summer.

As the Irish went farther in, they found harder rock. Progress slowed. Crozet was anxious to find extra workers. A local plantation owner promised he would hire out sixty slaves for work at the tunnel, but Crozet would have to pay them an Irish floorer's wage of $1.12½ day.

AN EVIL

The aggregate number of men 185, is even more than a full complement; But you will perceive that the number of laborers, each day, falls short of the whole force; Because, every day, some of the men fail to go to work, an evil without a remedy that I could suggest; and which is likely to increase, with the improvident, as wages rise— Before the present year, we had numerous applications for work and could enforce discipline; But now, those men must be taken on their own terms, or else they will leave without ceremony.

From Claudius Crozet's letter to the board of public works, August 2, 1853.

Contractors elsewhere on the Blue Ridge Railroad also needed more workers. They upped the ante and offered slaveholders $1.25 a day for a slave's daily wage. When Irish at the Blue Ridge Tunnel heard the news, they demanded another raise. Crozet well knew that the Irish would strike if need be. Though the pay raise pained him, every man's daily wage rose by $0.12½.

As danger increased in the tunnel, so did Irish demands. The pressure of rock at the east portal crushed one-foot-square wooden braces. Then blasting at the center of the passage opened up two hundred feet of red clay in August. It was streaked with veins of water. If the gooey mix gave way, rock would tumble down and shatter men's skulls. Eleven headers working at this dangerous spot insisted on yet another pay raise.

Pneumonia was raging through the shanties—the men requested oilskin suits that would keep them dry. Crozet agreed to the raise and the suits.

Three headers were hurt when a platter of roof fell in on the east side in November. Their frightened fellow workers walked off the job for a week, and Crozet allowed the injured men two months' full pay. An accident on the west side of the tunnel nearly killed two men in December. Shoving timber up against the ceiling and walls was expensive, but Crozet instructed workers to brace that side of the tunnel, too.

Rock slides and cave-ins became so common that Crozet was near despair by January 1854. He urged the headers to drill holes only one foot deep. Any

Looking out the west portal of
the Blue Ridge Tunnel. *Courtesy
of Library of Congress.*

deeper and the blasts might set off an avalanche. "The excavation on the
west side continues to be very dangerous," Crozet wrote. "I am in constant
dread of a serious accident which would disperse the hands. Those who are
now engaged on this hazardous work are entitled to high credit, and I have
advanced their pay to $1.50 during this danger."

By now, the feuding Corkonians and Fardowners had learned a crucial
lesson in labor negotiations. United, they could strike for safer working
conditions and higher wages, and they could win. Crozet seemed willing to
employ them on their terms at last. He would even reward the riskiest work
at the tunnel center with higher pay.

Unfortunately, the truce didn't last long. Even as Crozet raised headers' wages
to $1.50, he schemed to get rid of them and all other Irish working in the tunnel.

4

1854

The Blue Ridge Tunnel, Claudius Crozet reminded the men in Richmond, "is not the work of a day." The project was well behind schedule and over cost. Blaming the Irish work strike of the previous year, Crozet devised a manipulative plan. First, he wanted only slaves working deep inside the passage. Second, local slaveholders must agree to lease the slaves at a pay rate lower than Irish wages. Then, he could lower pay for Irish who worked on the embankment leading to the east portal. The "troublesome" Irish, as he called them, could quit if they wished.

"For drilling & blasting," Crozet wrote to the board, "we must have all negroes, or none; that is, we must have at once 120 hands for both sides, or else the number hired would have to mix with the white hands."

We can only guess why Crozet wanted to separate Irish and enslaved workers. Four contractors on the Blue Ridge Railroad project used a mixed-race laborforce. If Crozet knew of problems between the two groups, he never mentioned them to the board in Richmond.

True, Irish railroad workers in America had a reputation as ruffians. As in Ireland, they would fight anyone in America—black, white, German or other Irish—for jobs and fair wages. And it's possible that Crozet thought the Irish would blame the slaves and retaliate if his coercive plan worked. Yet Irish men on the Blue Ridge Railroad apparently never attacked African Americans. Court records show that the few fights involving arrest were between local white citizens and Irish or Irish and Irish.

African American railroad workers in northern Virginia, 1862. *Courtesy of Library of Congress.*

Soon Crozet had to give up his dream of an all-slave laborforce in the passage. "Every master made it a condition," he told the board, "that his negroes should not go into the tunnel."

Three slaveholders finally agreed to lease forty slaves to work at the Blue Ridge Tunnel in 1854. The contract stated that the men would receive Irish wages but could perform only safe jobs, such as blacksmithing or pumping water from the passage. Cramming gunpowder down a drill hole or setting off blasts was forbidden. Disappointed, Crozet settled for the forty slaves, but even that agreement turned sour. "When brought to the tunnel, 10 of them ran away," he wrote, "and were withdrawn by their masters: for, at present, in hiring, it appears that negroes have become masters of their masters."

Thirty-one enslaved men ended up working at the tunnel in 1854. We know that five were blacksmiths. We also know that all thirty-one worked as floorers in May 1854, clearing rock debris from the tunnel floor. And we know that the railroad company provided beef for them to eat on occasion.

When the 1854 hiring agreement was over, most of the men returned to their plantation quarters at the bottom of the mountain. Three of the skilled

Enslaved Men Working at the Blue Ridge Tunnel in 1854

Abel Smith, blacksmith
Abraham, blacksmith
Albert Gallon
Albert Hartshorn
Arthur
Benjamin
Bob Mickums, blacksmith
Dan Paldox
David Davenport
Elias
Fleming
Harry Abell
Henry Groves, blacksmith
Henry Jones
Joe Champ
Jordan Nables
Larus Pacing

Lenn
Lewis Hartshorn
Lynn Bruce
Oddy Abell
Randal Powers
Randolph
Reuben Hailstock
Samuel Carter
Sandy White
Shadrach Taylor
Stephen Walls
Thomas Barns, blacksmith
Washington
Wesley Carter
William Shanklin
William Spears

From the "Virginia Blue Ridge Railroad Datasets," Mary E. Lyons, 2009–13.

blacksmiths worked at the tunnel until mid-1856. The others would have gone back to raising wheat and corn in fields that the planters owned.

Little else is known about the captive laborers at the Blue Ridge Tunnel. As with the Irish, time has dropped a veil over their day-to-day lives.

Rails Through the Heavens

Despite the shortage of enslaved workers, Crozet was relieved when March 1854 arrived. By that time, two of the four tunnels on the Blue Ridge Railroad—the Greenwood and Little Rock—were complete.

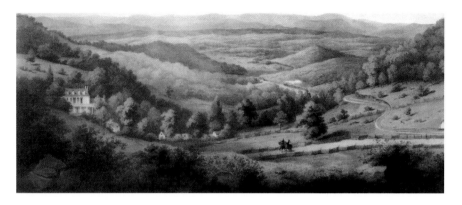

A train steams down the temporary tracks on the west side of Rockfish Gap. Reproduction of an 1857 Edward Beyer painting. *Author's collection.*

The Blue Ridge Tunnel was well behind schedule, but the Virginia Central Railroad was building discrete sections of temporary tracks around it and the incomplete Brooksville Tunnel. After enslaved men finalized sections of Blue Ridge Railroad temporary tracks that linked with the Virginia Central Railroad tracks, the line was complete. Though the rails lacked ballast, engineers in charge of the temporary tracks declared they were safe enough for a train. Passengers were eager to ride that train, even if it meant risking their lives.

On March 13, forty guests of the railroad boarded two train cars on the west side of Rockfish Gap. The interiors were probably furnished in the same manner as other Virginia Central Railroad cars. Ladies sat in plush red chairs in a separate compartment. The gentlemen perched on benches covered with horsehair cloth. Drab cotton curtains hung at the glass windows. A water cooler, wood stove and oil lamps completed the décor.

Excitement in the cars must have been intense. The locomotive began its slow trip up the western slope, climbing at seven and a half miles an hour—about the pace of a very fast runner. Passengers gaped at the grand view of mountaintops that seemed level with their noses. It was as if they were riding rails through the heavens.

Fifteen minutes later, the train reached the peak of the mountain. The curve at the top was so tight that the locomotive barely had room to stay on the tracks. Now came the very steep journey down the other side. In one place, the slope plunged six hundred feet per mile. Each car had six wheels, and every wheel had brakes on it. Would they hold?

The locomotive chugged down the east side of the mountain at a cautious six miles an hour. The wheels hugged the iron rails around three short, tight

A Dreadful Road

All railroads and any other kind of travelling [is] *very dangerous, yet I think that railroads over mountains are* most dangerous...*I had no idea when I used to admire that high mountain that I should ever find myself in a railroad car* mounted high on it *making curves around. Oh! It is a dreadful road.*

From a letter written by Elizabeth Valentine Gray about riding on the temporary tracks over Rockfish Gap in 1856. Quoted by Gregg Kimball in American City, Southern Place.

curves, and the train safely reached flat land twenty-five minutes later.

Trains didn't actually make the world smaller, but it seemed that way. For the first time, any white person with fifty cents could buy a first-class ticket and cross the Blue Ridge Mountains in minutes rather than hours. Before the temporary tracks, farmers west of the mountain paid $1.10 to ship a barrel of flour by wagon to Richmond. Shipment on the temporary tracks cost $0.80, and the barrel arrived two days sooner. Staunton residents were thrilled when daily trains delivered oysters from the coast. Those who

The 1855 Timberlake locomotive was similar to the one that first crossed the temporary track in 1854.
Courtesy of the Chesapeake and Ohio Historical Society.

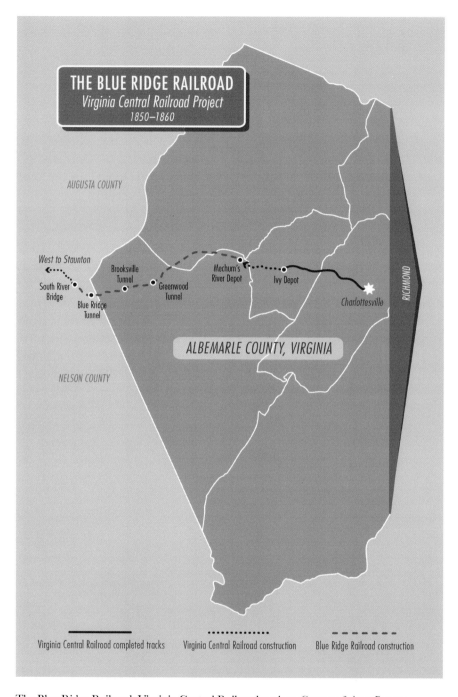

The Blue Ridge Railroad–Virginia Central Railroad project. *Courtesy of Anna Burrous.*

could afford the salty delights slurped them down for $0.25 a plate at a local oyster saloon.

For others, the trip was tragic. In April 1854, a runaway car killed two enslaved railroad workers named Jerry and Thomas. Jerry was twenty-one. A slaveholder who had known him all his life remembered that he was of "good character" and "good health." Thomas was twenty. One of Crozet's slave agents said he was of "fine appearance excepting a small scar on his temple where he had been burned." The burial places for Jerry and Thomas are unknown.

Forty thousand people rode across the mountain on the temporary track over the next two years, but Americans have always wanted to go faster and faster. Pressure on Crozet to finish the Blue Ridge Tunnel increased, as did newspaper articles blaming him for the high cost and slow pace. Crozet made a new pledge to the board of public works in Richmond. It was now the spring of 1854. The Irish would finish the Blue Ridge Tunnel by the end of the next year. When Crozet made his promise, he was unaware that a sinister passenger was on its way to Rockfish Gap. It was silent and invisible, and it traveled fast.

Mystery Graves

Irish workers called it the "choleray." A coffin maker on the west side of Rockfish Gap called it "cholery." However they pronounced cholera, the disease was usually a killer. No one understood what caused it or how it spread.

Scientists know now that tainted water spreads cholera. People become ill when they drink or wash with water contaminated by human waste containing the bacteria. Some cholera sufferers recover after a mild bout of diarrhea, while others lose a quart of water every hour from acute diarrhea and vomiting. Death soon follows.

Cholera was no stranger to the Harrington and Sullivan families. They had seen it on the Berehaven Peninsula back in Ireland. When cholera rampaged there, symptoms came on so fast that people often died before anyone realized how sick they were. The Irish on Berehaven never asked for a doctor—they thought doctors would poison them. The Irish at the Blue Ridge Tunnel felt the same way. Railroad workers with an ache or pain would rather visit a local woman who lived near the tracks and treated them with herbal remedies made from the roots of wildflowers such as Indian Pink.

But no wildflower could cure cholera. Sufferers at the Blue Ridge Tunnel needed to replace bodily fluids immediately, and only a solution of

Vibrio cholera bacteria. *Courtesy of Dartmouth College.*

water, salt and sugar infused directly in a vein with a hollow needle could do that. Modern doctors call this intravenous therapy, but nineteenth-century doctors knew nothing about it. And so the people died, though Father Downey nursed as many as possible.

It all began at the east side shanties in the last week of July 1854. The weather was hotter than usual that month. Young Daniel Harrington's father, Daniel Harrington Sr., was a forty-five-year-old header. He suffered through the heat in his final hours and died on Tuesday. Crozet remembered him as a "sober and valuable man."

The fickle cholera ignored Daniel Sr.'s son, young Daniel, but claimed Daniel Sullivan, twenty-two, on Wednesday. Showing no mercy, it slipped over to Jeremiah Harrington's shanty next. His wife, child and mother-in-law died on Thursday.

Old Downey, seventy, and his wife became ill that same Thursday. He died on Friday, just as his wife seemed to have recovered. By Saturday, she was gone, too. Young Downey, their son, attended his father's funeral on Sunday.

THE CHOLERA EPIDEMIC

Oysters in the Chesapeake Bay may have contained the bacteria that started the outbreak. More than two hundred people died in Richmond in June. The disease then moved to Scottsville, where twenty-five victims died in June and July. It quickly jumped up to the Blue Ridge Tunnel shanties in July and August. People in Staunton were dying of cholera by September.

From the "Virginia Blue Ridge Railroad Datasets," Mary E. Lyons, 2009–13.

He was taken sick on his way back to the shanties and died on Monday.

The overseer removed the slaves from the work area when the epidemic began. They probably returned to their plantation quarters at the bottom of the mountain and waited for the outbreak to subside. Almost all the east side Irish men stopped work on the tunnel. Two fled to the west side. The bacteria hitchhiked with them.

As cholera stalked the west side shanties, it skipped Michael and Catherine Harrington and their five-month-old son, John Patrick. It spared their toddler, Margaret Jane, and the Sullivan family. But two McCarthy boys who were employed on the west side of the tunnel died. They were seven and nine years old. The epidemic claimed at least thirty-three Irish in all. And young Daniel Harrington Jr. had lost his father. Someone kindly increased the boy's daily pay to $0.87½ cents. The raise lasted through the end of the year.

In Catherine Harrington's hometown of Bantry in County Cork, people were so afraid of cholera that some refused to bury the dead. The same may have happened at the Blue Ridge Tunnel. No one knows where the July cholera victims on the mountain are buried. To prevent the spread of the disease, friends or family members may have burned the wood-sided shanties with the dead inside.

The August and September victims lie in unmarked graves in Thornrose Cemetery in Staunton, Virginia. The exact location of those graves is unknown.

5

1855–56

Cholera almost crushed the Irish spirit that summer of 1854. Claudius Crozet was sympathetic, but the loss of life meant that the tunnel was even more behind schedule and over cost. He planned to bargain with local slaveholders in December. He was now paying $1.12 a day for each slave's labor. If he could convince them to lease the men for $1 a day, he could lower Irish wages to the prestrike level of 1853.

Crozet's attitude toward the Irish was at all times contradictory. He complained that the Irish took two days off work when a "mere child," as he put it, died, yet he also admired the pluck of the workers. "Let justice be done, at least," he wrote in a letter to a Richmond newspaper, "to the hard, bold and honest working men, who, drenched to the skin, are exposing themselves fearlessly under such impending danger."

Crozet's admiration evaporated as he pursued his plan, which meant that daily pay for young Daniel Harrington Jr. would drop back to $0.54. Though still a boy, Daniel was old enough to wear a man's shoes. One pair of $3.50 work boots would cost him more than seven days pay. So what? Crozet seemed to say. Keeping costs down was paramount. If the Irish didn't like the lower wages, they could leave.

Some did leave. Mark and Anna Sullivan had two children now—Mary and her infant brother, Eugene. Fifteen people in the Sullivan clan had died in the past four years. The high death rate may have frightened Mark and Anna. According to a family descendant, they returned to Ireland's Berehaven Peninsula in 1855.

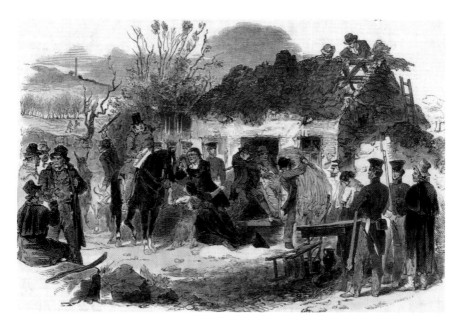

Landlords continued to evict tenants and tumble their cabins for decades after the Great Hunger ended. *From* Illustrated London News, *December 16, 1848.*

A few Irish went north for higher paying jobs, while most tolerated the lower wages and stayed. Then Crozet's plan backfired. The Richmond men told him to avoid using slave labor again.

Now the Irish had the upper seat on the wages seesaw. They went on strike in March. "We are trying to ferret out the ringleaders," Crozet wrote to the board. "I regret that we did not hire Negroes at Christmas."

Crozet was forced to raise wages for some of the men, but he had another trick up his sleeve. He would pay new hires less. Though the worst of the Great Hunger was over in Ireland, people there still struggled for food and shelter. Thousands of hungry Irish immigrants landed on America's shores every week. Crozet knew if he waited long enough, some of them would hear about the tunnel and make their way south, willing to toil for a dollar a day.

Crozet was right, and it didn't take long. More Irish moved to the Blue Ridge Railroad in 1855. They would have heard from other Irish immigrants that steady work was available there. Or perhaps they read about it in port city newspapers after arriving in the United States. By now, all reading eyes in America were on the Blue Ridge Tunnel.

WALL OF WATER

In Massachusetts, newspaper readers anxiously waited for news from Rockfish Gap. The state was building a massive tunnel that would stretch for four miles through the Hoosac Mountain. Failure at the Blue Ridge Tunnel would be a bad omen for the Hoosac project.

People at the southern end of the Mississippi River in New Orleans, Louisiana, eagerly kept up with Blue Ridge Tunnel news. Money was at stake. If Virginia ever finished the race to the Ohio River, more merchants could move goods along the connecting Mississippi River, bringing welcome trade and tourist dollars to the Crescent City.

In Washington, D.C., curious readers learned how Irish workers at the Blue Ridge Railroad might vote in presidential elections. The federal government required that immigrant men live in the United States for five years before they could become citizens and vote. The five-year mark would pass soon for many Irish men. Hundreds of thousands of them could tilt the results of an election. Their opinions mattered. (No American woman could vote in national elections until 1920.)

So readers had developed a hearty appetite for news about the Blue Ridge Tunnel by 1856. When they snapped open their newspapers in August that year, they found a deliciously shocking treat. "Extraordinary Occurrence at the Blue

Water at the east portal of the Blue Ridge Tunnel. *Author's collection.*

TROUBLE AT TWO TUNNELS

The Blue Ridge Tunnel has not averaged over fifty feet per month since its commencement, which is at the rate of one foot per day on each face...At this rate, the Hoosac Tunnel could be finished in 33 years.

From an editorial in the Pittsfield Sun *newspaper, Pittsfield, Massachusetts, March 1854.*

Ridge Tunnel," the headlines blared. "Bursting Out of a Great Water Cavern in the Mountain—Narrow Escape of Workmen—Tunnel Nearly Through"

It seems that when a tunnel worker named Pat Flagan pierced a soft spot in the rock, he opened up a cavern filled with melted snow water. A stream poured out and soon turned to a flood.

The men heard a rumble. It sounded "like the cars," Pat said later. They all dashed for open air as a wall of water ten feet high chased after them. It swept carts and wheelbarrows through the passage as lightly as wheat chaff.

A Staunton newspaper writer witnessed the event. He noticed that the cavern was three hundred feet long. It was so immense, he announced, that surely the tunnel would be finished within the day.

The writer must have chuckled when papers around the country reprinted the article. His story was a hoax, meant to embarrass Claudius Crozet for his snail-like progress at the tunnel. Crozet settled the score two months later. He firmly stated in an October 1856 letter to a Richmond newspaper that the workers were close to boring through the mountain. "The drills from one side to the other," he wrote, "are now heard very plainly."

Trains would run through the tunnel the following spring. America could hardly wait.

TWO INCHES OF DAYLIGHT

Christmas 1856: the winter weather was colder than usual. Pneumonia and tuberculosis, called consumption in those days, were rampant along the railroad. Nine people had died from one or the other that year. Two of them were sisters under the age of two.

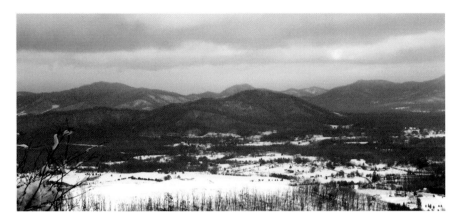

Winter view from Rockfish Gap, Virginia. *Courtesy of Jim Kauffman.*

Irish in shanties on the mountain huddled around their fires and listened to the lonely wind. Smoke curled up through the barrel chimneys as women pulled their shawls tight. Mothers would have held their infant babes close, protecting them from the icy air.

By now, east and west side tunnelers were close to meeting at the center. Claudius Crozet was always annoyed when the Irish took time off work for Catholic Church holy days. This Christmas was no different. Only a smattering of men worked from December 24 through December 26.

The final push began on the twenty-seventh. Men on the west side shouldered double shifts that day. One boy drove himself through fourteen hours of labor.

On December 29, two west side floorers began a grueling twenty-four-hour shift. In a frenzy of work, they attacked the shelf. Headers joined them at dawn on Monday, December 29. Inch by inch, they blew up rock that had stood undisturbed for millions of years.

The scene was the same at the east side. Floorers, headers and blasters worked double eight-hour shifts. When drill bits dulled, boys loaded the rods in a handcar and hopped on. Crank handles on the platform connected with the wheels. As the boys turned the handles, the car rolled along work tracks laid on cleared sections of the tunnel floor.

Blacksmith sheds were located inside the tunnel and just outside the portals. The boys delivered dull bits to waiting smiths who heated them in charcoal fires. The smiths beat the points on an anvil with a hammer until they were sharp, and then the boys cranked back through the tunnel with their cargo of honed drills. They picked up another load, and the process began again. It must have looked like an endless relay race.

An 1850s handcar. The man on the left was a railroad laborer. *Courtesy of Library of Congress.*

Work scene at the Great Bend Tunnel in Virginia, 1870s. The open sheds may have been blacksmith forges. *Courtesy of Library of Congress.*

<div style="border:1px solid">

CONTRACTOR JOHN KELLY'S PURCHASES FOR DECEMBER 1856

- 30,000 feet of fuse
- 75 kegs of powder
- 1,182 bushels of charcoal
- 1 dozen pick handles
- 4¼ dozen hammer handles
- 2 bales of lamp wick
- 22 bars of steel weighing 1,140½ pounds
- ½ dozen oil cans

From a Blue Ridge Railroad account book kept by John Kelly and his partner, John Larguey.

</div>

After six years of hard labor on the tunnel, it's a marvel that the Irish men and boys cared so much about it. But they had wrestled this stubborn mountain with gunpowder and bare hands for six years. Now it was time to finish the job.

Witnesses gathered at the center of the Blue Ridge Tunnel, including John Kelly and Claudius Crozet. They stood by for hours, a long half mile from sunlight. Finally, the deed was done. A drill on the west side pierced the same hole as a drill on the east side. The opening was two inches wide. When one of the older witnesses saw a faint ray of lantern light leak through the hole, the jubilant fellow astonished the others with a few fancy dance steps. They all toasted the historic day—December 29, 1856—with drinks of whiskey and water.

The triumphant Irish threw down their drills and sledgehammers. "We'll do no more work 'til next year!" they joked.

According to one reporter, the Irish men celebrated with a frolic for the rest of the day. No wonder. They had done a superhuman job, and they were justly proud of it.

CHILDREN WHEN THEY GO IN

A two-inch hole through the heart of the mountain was one thing. Widening that hole to the size of a train car was another. The Irish blew up and removed hundreds more feet of rock during the winter of 1857. By March, only two hundred feet remained.

Newspapers around the country announced with relief that trains would finally run through the tunnel in July 1857. The laborers grappled with

DAYLIGHT THROUGH THE MOUNTAINS

Within the last few months, daylight has shown through both the Blue Ridge and the Alleghany mountains. Such were the correct estimates made by Col. Crozet of the Blue Ridge Tunnel, that when the holes were drilled from each side, the error was only a half inch.

From a Greenbrier County, Virginia correspondent to the Nebraskian *newspaper, Omaha, Nebraska, May 1857.*

unforgiving rock day and night, trying to meet the deadline. Sixteen-year-old Daniel Harrington Jr. was among them. Daniel had worked at the tunnel since the age of nine. Hard physical labor can deform growing bones. Most states had no public schools back then, and lack of education can stifle young minds. It's possible that Daniel's boyhood years in the tunnel stunted his physical or mental growth.

One Virginia boy in those days started making railroad ties when he was ten years old. He was "exceedingly

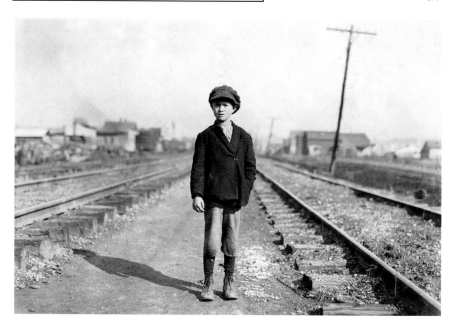

Child laborer, early twentieth century. The boy's name was John Roberts. *Lewis Hines photograph, courtesy of Library of Congress.*

Wagon boy, early twentieth century. Two Irish boys, Barney and Florence McCarthy, were wagoners at the Blue Ridge Tunnel, earning fourteen dollars a month each. *Lewis Hines photograph, courtesy of Library of Congress.*

bright," said someone who knew him at the time. The employer overworked the boy throughout his teen years. At the age of twenty, by now a grown man, he was easily confused and unable to concentrate on a task.

Underground work was especially damaging to youngsters. As one adult miner said, "There are no children working in the mines. They may be children when they go in at 10 or 12 years of age, but a fortnight works that out of them."

In 1938, President Franklin Roosevelt signed a national child labor law that prevented factory and mine employers from hiring children under the age of sixteen. Unfortunately, the law was eighty years too late for Daniel Harrington Jr. and the other fifty-one boys at the Blue Ridge Tunnel. The Great Hunger stole their early childhoods. The tunnel took the rest.

6
1857–59

July 1857 came and went. Again, Claudius Crozet missed a promised deadline. Bricks were part of the problem. The Irish had widened the midpoint of the Blue Ridge Tunnel and raised the ceiling. Now they needed to line three separate ceiling sections with bricks. Only then did they dare remove the timber supports.

Moisture in bricks formed of permeable clay froze and thawed in winter, causing them to crumble. Crozet needed bricks made of water-resistant clay. One of his letters indicates that he used a brick-testing machine to jam a thick iron rod into bricks supplied by two local brickmakers. Inferior ones shattered, while the best withstood more than five thousand pounds of pressure. But the brickmaker charged more, and the four tunnels along the railroad had already required one million bricks. The board in Richmond was reluctant to pay for more.

Jagged edges of rock still poked out from the tunnel walls and ceiling. Though the Irish were chipping them off, the job was only half done. Local newspapers gave Crozet little peace about it. "There exists no prospect of passing through this tunnel for two years to come," one reporter grumbled, "if Crozet can prevent it."

The paper printed Crozet's impatient answer. "It is not quite as easy to cut…through veins of the hardest rock," he huffed, "as to whittle a pine stick." Crozet invented a smart solution to the jutting rocks. Carpenters built a frame the full size of a railroad car. It was ten feet wide and eleven and a half feet high. They pushed this wooden skeleton along

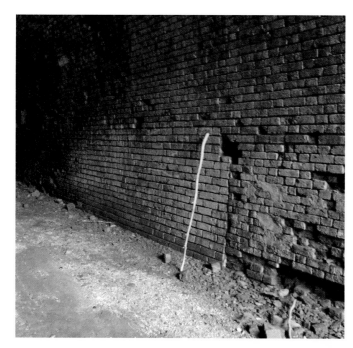

Left: The west portal of the Blue Ridge Tunnel. *Courtesy of Dan Addison Photography.*

Below: A barefoot boy plays with a spiked barrel in a railroad camp, 1862. *Courtesy of Library of Congress.*

Opposite: Center section of the Blue Ridge Tunnel. *Courtesy of Library of Congress.*

the tracks. When the upper corner caught on projecting rocks, the men blasted them off.

The tunnel was still unfinished in October 1857, but Crozet was done with it forever. Bitter and weary of constant criticism, he left Virginia that month to work as an engineer in Washington, D.C. "I am glad," he wrote, "[that] the Board did not insist on my continuing this thankless business."

Michael and Catherine Harrington were also finished with Virginia. Little John Patrick and Margaret Jane had escaped cholera and other diseases, but their parents must have worried about the future. Catherine was expecting her third child, as well. Her brother, John Brennan, had long since left the Blue Ridge Railroad. The Harringtons decided they should leave, too.

They chose Iowa, where farmland was available. If they could buy a few acres there, they'd never have to pay rent to someone like Lord Bantry. A farmhouse in Iowa's wide, open fields might be a safer place for their children than a shanty in a railroad camp. And it might be a more welcoming state for Irish Catholics than Virginia.

BOWEL OF THE EARTH

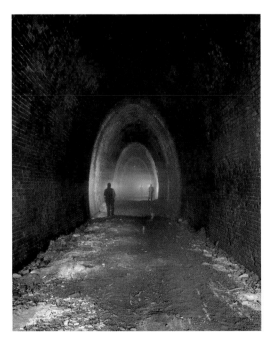

Most Irish who worked on the tunnel had lived in the area since 1850. Seven years later, they were still invisible to local people. Newspapers never printed Irish marriage or birth announcements. They reported sensational deaths such as those from murder or cholera but ignored the deaths of men blown up at the tunnel. When the Irish started voting, though, people noticed.

By 1857, fifty Irishmen living in the shanties had already been to the local county courthouse, sworn allegiance to the United States

IRISHMEN WHO COULD HAVE VOTED IN 1857

James Blewitt
Morris Blewitt
Charles Delay
Dan Donovan
Timothy Driscoll
Charles Duggan
John Fitzgerald
Jerry Hanan
Michael Hurley
Jeremiah Leahy
Florence McCarthy
James Murphy
John Murphy
Dennis O'Brien
John O'Brien
Jeremiah Pharrissy
Daniel Sheehan
Patrick Sullivan
Tim Sullivan
Michael Tobin

From the "Virginia Blue Ridge Railroad Datasets," Mary E. Lyons, 2009–13.

and become American citizens. Most were from County Cork. Two were Sullivan men. When the new citizens voted in an election that summer, the newspaper printed a vicious article:

We understand that at a late hour on Thursday last, the day of election, about fifty Irishmen, followed by the women and children, emerged from the Blue Ridge Tunnel, marched in a body…and cast their votes for the Democratic ticket. These men, having no interest whatever in the community, mere floaters, here today and there tomorrow, utterly ignorant of the issues involved in the election…come up out of the bowel of the earth and overwhelm the intelligent native/born citizens of Augusta. We rejoice that the Blue Ridge Tunnel is near its completion.

The mean words rolled off the Irishmen as easily as rain, thanks to their wives. A recent law stated that an immigrant woman automatically became a citizen when her husband did. Encouraged, no doubt, by wives eager for their own citizenship, twenty more men in the Blue Ridge Railroad area became citizens over the next year. They were Irish Americans now. They were here for good, and they had work to do: finishing the longest mountain railroad tunnel in the world.

A BLAZE OF FIRE

April 1858: the tunnel ceiling needed still more bricks. Rough edges of rock remained on the tunnel walls. An inspector for the Virginia Central Railroad insisted that the men stabilize the bottom of two embankments with more boulders. Extra rock would reinforce the high mounds if heavy rains caused a landslide.

The Blue Ridge Railroad could have been safer, but the people had waited eight years. Summer was coming. Impatient families in eastern Virginia longed to cool off at expensive mountain resorts west of the tunnel as soon as possible. Pig farmers in the western part of Virginia had slabs of bacon to sell east. A train passing through the tunnel could travel up to thirty miles an hour, compared to six on the temporary track. Faster freight cars meant that cows, sheep and hogs often died on the tracks when locomotives hit them, but speed also meant faster profits.

At last, the much-talked-of event took place. The first train through the tunnel made its maiden voyage in April 1858. A passenger who rode the same train a few days later described the experience. "The cars are lighted up," he reported, "and a red light placed on the end of the rear car. The entire distance [of the tunnel] can be seen through from the front or rear."

Sunlight at the end of the tunnel was "brilliant," the passenger remembered. As the train approached the portal, the opening lit up as if it were a "blaze of fire."

Though the words painted a thrilling ride, the tunnel construction had taken too long. It was old, tired news. A Washington, D.C. paper printed only one sentence: "Passenger trains on the Virginia Central Railroad are now running through Blue Ridge Tunnel."

"We hardly know which is the greater bore," yawned a Texas newspaper writer, "the tunnel or the description of it."

A HAPPY PASSENGER

Ann Christian from Richmond, Virginia, wrote that she felt "no sensation of fear or oppression" as she "went under the mountain" on the way to Staunton in 1860. She thought it was "wonderful what industry, perseverance & money *could accomplish."*

Gregg Kimball, American City, Southern Place.

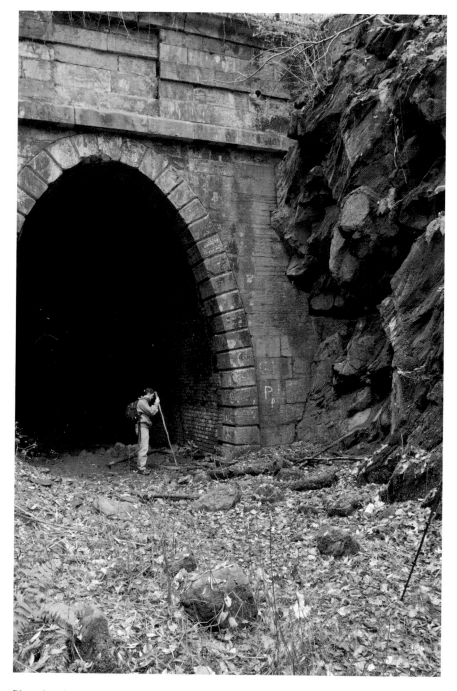

Blasted rock at the approach to the west portal of the Blue Ridge Tunnel. *Courtesy of Dan Addison Photography.*

For Irish workers, the tunnel was a creature yet to be tamed. As obstinate as ever, it fought back. Between scheduled trains, the men continued to shore up the passage with bricks and blast off protruding rock. It was killing work.

Admiration and Delight

Michael Hurly died in the tunnel in January 1859. A header, he was blown to bits by an accidental gunpowder blast. Dan Hurley worked in the tunnel as a header and floorer. He died from a stroke in February 1859. Both were from County Cork. Six more Hurley men who labored in the tunnel were still mourning their kinsmen when a schoolteacher toured the passage with friends in October 1859.

No trains were running that day. The visitors held lanterns as they picked their way along the narrow margin beside the tracks. Far ahead,

Inscription on Michael Hurley's gravestone in Thornrose Cemetery: "Michael Hurley Born in County Cork Ireland Died January 5, 1859." *Author's collection.*

OTHER IRISH DEATHS ALONG THE RAILROAD IN 1859

- Mick Barrett from County Kerry died in an accident at the tunnel.
- Richard Collins, a mason from County Cork, died of dropsy.
- Michael Fallon from County Roscommon died of consumption.
- Jeremiah Hannon, born in County Cork in 1799, died from an unknown wasting disease.

From the "Virginia Blue Ridge Railroad Datasets," Mary E. Lyons, 2009–13.

they saw flashes of light from explosions. They could hear the roar of handcars shuttling back and forth to a blacksmith's forge. When the group reached the center, Irishmen with clanking drills stood on platforms built at different heights against the tunnel walls.

"No one, I think," the teacher wrote in her diary, "could fail to admire the tunnel as he enters, the flinty wall streaming with cool, clear water. It is full of grandeur and elegance and strikes the beholder as the result of Herculean efforts and indefatigable toil. We walked along in admiration and delight."

Let's hope the teacher complimented the Irish workers. Appreciative words might have cheered these unsung heroes who were still risking their lives for slabs of bacon, spoiled tourists and an unfinished race to the Ohio River. Every man deserved a firm handshake and a sincere thank-you.

7

1860–73

Think of eighty-two deserted shanties. Each has a single window. They're perched like one-eyed crows on the steep slopes of a mountain. Empty dwellings were all that was left of the Blue Ridge Tunnel Irish in 1860. Only one worker and his family remained. Most of the people moved on when the Blue Ridge Railroad was finished. Some traveled back to northern states,

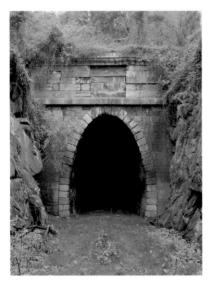

Stone arch at the west portal of the Blue Ridge Tunnel. *Courtesy of Library of Congress.*

while others went to the Midwest. About four hundred Irish put down roots in Staunton, where the Catholic Church remained the spiritual and social heart of their lives.

Daughters of stonemasons, blacksmiths, headers and floorers attended a Catholic school built next to the church. As teens, the girls carried flowers in May Day processions. As women, they carried flowers down the church aisle when they married the sons of railroad workers. Those same daughters and sons then did what immigrant groups have always done in America. They attended high school and college, saved money, bought land, opened businesses or taught school and prospered.

TUNNEL BABIES

Scores of children were born at the Blue Ridge Tunnel. A partial list:

Timothy Callaghan Jr.	Thomas Martain (or Martin)
Savannah Connor	Daniel McCarty
Eliza and Margaret Crowe	Mary Morris
John Driscoll	Julia Murphy
James Hagerty	Ellen Nelligan
Peter Haggerty	John A., Eugenia and Bridget
Mary Hanley	Noonan (or Noon)
John Patrick, Margaret Jane	Dennis O'Brien
and Mary Harrington	Margaret O'Bryan
Catherine, Hannah and	Cornelius Ryan
Johanna Hayes	Robert Sheenan
Baby Hurley 1	Bridget Sullivan
Baby Hurley 2	Catherine Sullivan
Joanna Keefe	Cornelius Sullivan
Cornelius A., Jemie and	Eugene Sullivan
Michael Kelly	Female baby Sullivan
Ellen Lohan	Joanna Sullivan
John Long	John Sullivan
John Lynch	Male baby Sullivan
John M. Maggette	Michael Sullivan
Mary Manley	Thomas Sullivan

From the "Virginia Blue Ridge Railroad Datasets," Mary E. Lyons, 2009–13.

The Rockite urge to fight poverty survived in a benign fashion. Former Irish railroad workers and their sons organized a benevolent society in Staunton. Members collected money for widows or other local Irish who still struggled with poverty. Similar societies blossomed in Irish communities throughout the United States. In New York, they led to the rise of labor unions such as the American Federation of Labor. Every September, millions

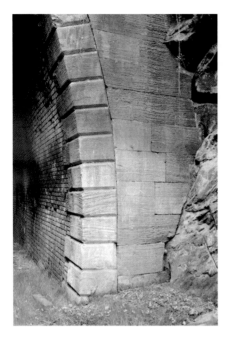

Left: Detailed view of the west portal arch. *Courtesy of Library of Congress.*

Right: A handsome, young nineteenth-century railroad worker. *Courtesy of Library of Congress.*

of American workers celebrate Labor Day by taking the day off. They can thank an Irish American member of the AFL. Congress made Labor Day a national holiday after he suggested the idea.

Hundreds of Blue Ridge Railroad Irish packed up and followed John Kelly toward the Ohio River. By 1860, they had laid almost two hundred miles of track and built four tunnels through the Alleghany Mountains west of the Blue Ridge. The goal of reaching the Ohio River seemed within reach—until the American Civil War began in 1861.

A FAMILY TREE

Historians agree that the Civil War was the result of sectional conflict over slavery. The bloodiest war in American history, it killed more Americans than all other American wars combined. Among the dead were Irish who had worked on the Blue Ridge Railroad. Those who had moved to northern

and midwestern states joined the Union army. They must have felt gratitude toward the nation that had given them refuge from the Great Hunger. So they fought to keep the United States together.

At least twenty-three Irish in the Rockfish Gap area joined the Confederate army. Some signed up shortly after the war began. Others waited until draft laws forced them into service. None owned slaves, yet they fought anyway. In their minds, they were more than Irish Americans. They were Irish Americans who had begun new lives in the South. So they stayed loyal to the region that was now their home.

When the South lost the war in 1865 and slavery ended, a few of the freed African Americans who had worked on the tunnel as slaves continued to live at the eastern base of Rockfish Gap, including Reuben Hailstock, William Spears and blacksmiths Thomas Barns and Henry Groves. Others settled in an area called New Town, just below the Brooksville Tunnel. They lived within sight of the same fields they had involuntarily farmed for slaveholders before the war. Though precise family connections have not been proven yet,

many of their descendants carry the same last names and still reside in New Town or the Rockfish Gap area.

Virginia finally reached the Ohio River in 1873—sort of. During the Civil War, the western part of Virginia split off and became the state of West Virginia. Officially, West Virginia finished the race, not Virginia.

By that time, Irish immigrants who had fled the Great Hunger were on their way to creating the largest branch on America's family tree. More than forty million Irish Americans now live in the United States. Dozens of them are descended from Michael and Catherine Harrington.

Opposite: John Patrick Harrington, a Blue Ridge Tunnel baby born in 1854, and his daughter. *Private collection.*

Left: Margaret Jane Harrington, a Blue Ridge Tunnel baby born in 1851. *Private collection.*

Below: Though many Irish left the area, their handiwork still survives. This hidden culvert runs under the embankment leading to the east portal of the tunnel. *Courtesy of Paul Collinge.*

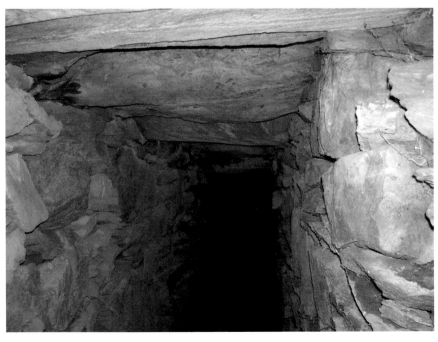

Michael probably never saw the broad, rolling fields of Iowa. His great-grandson thinks he died shortly after leaving Virginia. Catherine arrived in Iowa in 1858. A widow with two small children and a third on the way, she remarried soon after.

Young Daniel Harrington Jr. has disappeared behind a gauzy curtain of time. We can only wish him well from our comfortable twenty-first century seats, 160 years after he traipsed into the dark passage as a nine-year-old lad.

OLD MAN TUNNEL

The Virginia Blue Ridge Tunnel reigned as the longest mountain railroad tunnel in the world until 1875. That year, workers in Massachusetts finally finished the five-mile-long Hoosac Tunnel. Men who labored on the Hoosac in the later construction years could use pneumatic drills and dynamite—new inventions that made the work easier, though not especially safer.

THE BLUE RIDGE TUNNELS

- Estimated cost of the old tunnel: $200,000.
- Actual cost: $488,000.
- Larger locomotives and disintegration of bricks lining the west portal of the old tunnel contributed to the decision to build a replacement.
- Grading of approaches to the new tunnel began in November 1941.
- The new tunnel was completed in April 1944.
- It is lined with concrete.

By 1941, the Blue Ridge Tunnel was too small for modern locomotives. The Chesapeake and Ohio Railroad Company built a taller, wider passage that runs parallel to the old tunnel and is still in use.

Train passengers heading east or west can catch a glimpse of the old portals if they know what they're looking for. But few of them have reason to notice the old Blue Ridge Tunnel as the train speeds by. The civil engineers who visited it in 1976 placed the award plaque at Natural Bridge, a tourist attraction fifty miles away.

Thousands of vehicles cross the peak of the mountain on Interstate 64 every day. The

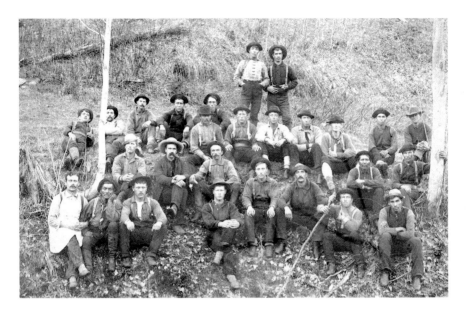

A jaunty group of laborers reporting to work at the Hoosac Tunnel, possibly 1860s. Most workers on the Hoosac were Irish. *Courtesy of North Adams Historical Society.*

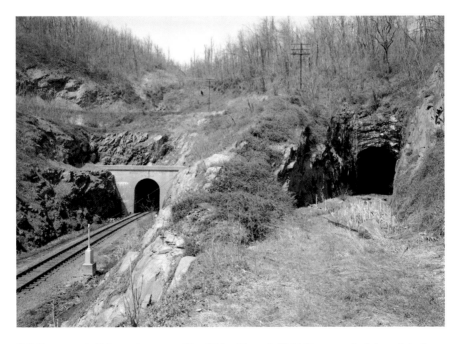

Left: East portal of the replacement Blue Ridge Tunnel. *Right*: East portal of the original Blue Ridge Tunnel. *Courtesy of Library of Congress.*

drivers have no idea that a building project of national importance lies seven hundred feet beneath their wheels. On sunny days, gusts of wind shake cars and eighteen-wheeler trucks as if they were stuffed toys. On cloudy days, rain, fog or snow (or all three at once) can make driving over the summit a knuckle-biting experience. Rock slides and sixty-car pileups are not unusual. Maybe the mountain that the Irish conquered so long ago is still boss after all.

PART II
The Laborers

The Quinn Cemetery

Lost Children of the Blue Ridge Railroad

A version of this article was originally published in the Crozet Gazette, *Crozet, Virginia, April 2011.*

This past year I've visited several abandoned cemeteries in western Albemarle County, Virginia. I've ducked around vines as thick as my wrist and slithered through head-high bramble bushes. Inevitably, the thorns leave scratches, though hours pass before I notice the blood. One of these cemeteries is especially lovely. It's located on a gentle rise next to the Pollak Vineyard and encircled by stunning mountain views. I call it the Quinn Cemetery.

A low stone wall exactly seventy-five feet square defines the space. It's quite likely that the weathered hands of one or more Irish stonemasons erected the wall sometime between 1850 and 1860. During this decade, many hundreds of single men and scores of families moved to the area. They were here to construct the Blue Ridge Tunnel at Rockfish Gap and three sister tunnels in Albemarle County. Concurrently, they built impressive culverts and laid thirty-four miles of connecting tracks for the Blue Ridge Railroad and its partner, the Virginia Central Railroad. Exiles from the Great Hunger raging in Ireland, the Irish settled in for a decade of toil on the tunnels and tracks.

At least twenty-six of these long-forgotten souls are buried in the Quinn Cemetery. Their remains lie beneath roughly rectangular, unmarked fieldstones. Some of the markers are doubles—one short stone directly in front of a taller one, only a few inches away. They suggest to me the childbirth deaths of a mother and child. Some are triples, with one tall stone

Above: Unmarked double stones at the Quinn Cemetery. *Author's collection.*

Left: Inscribed and unmarked stones for Eugene and Mary Quinn, Quinn Cemetery, Albemarle County, Virginia, March 2010. I placed the quince blossoms on the headstone. *Courtesy of Clann Mhór.*

and two short ones. Three stones imply an infectious disease that could have struck unfortunate families with particular fury. Or the multiple markers might follow the Irish custom of burying in vertical graves family members who died at different times.

One solitary inscribed headstone stands in the center of the cemetery. It leans slightly, as if losing the strength to continue its lonely job. Beneath a simple carved cross is this inscription:

> *In memory of EUGENE*
> *Died August 4 1855*
> *Aged 1 year 7 months*
> *Also*
> *MARY*
> *Died August 4 1856*
> *Children of John & Hannah*
> *Quinn.*

A rounded footstone lies about four feet from the head of the grave. The initials "E.Q." and "M.Q." are inscribed on the face. Outside the grave proper is a rectangular, unmarked fieldstone carefully laid flat on the ground. The placement puzzled me until I realized it was probably the original marker for Eugene's grave. Sometime after little Mary tragically died on the first anniversary of her brother's death, the parents or someone else erected the inscribed marker. The plain fieldstone still held a deep meaning, and so it became part of the grave site.

We may never know how little Eugene and Mary died. Children of the Blue Ridge Railroad were struck down by cholera, pneumonia, whooping cough and unknown causes. It's enough to understand that John and Hannah Quinn felt a keening grief when they placed these small bodies in the ground.

And I still wonder where the carved stone came from. Staunton newspapers of the time advertised the services of several marble cutters. The simple Gothic shoulders and carved cross on the Quinn stone match the style of stones for Irish Catholics buried at Thornrose Cemetery in Staunton during the 1850s. At least twenty-five stonemasons worked for the Blue Ridge Railroad. One of them was John Quinn. He might have been skilled enough to hew and inscribe the stone himself.

Work ran out for John Quinn when the first locomotive passed through the Blue Ridge Tunnel in 1858. He and Hannah, along with their seven-year-old son, John Jr., and Edward, her son by a previous marriage, left Albemarle

THE QUINN FAMILY

- Hannora Kelly Cotter was born in Ireland. She was a widow when she married John Quinn in Albemarle County, Virginia, in 1850.

- Edward Cotter was Hannora's son by her first marriage. Born in New York around 1844, he left with John and Hannah when they moved from Albemarle County, Virginia, to Lewis County in what is now West Virginia.

- Edward eventually became a stonecutter like his stepfather.

- Both Edward and his half brother, John Quinn Jr., married in Lewis County and produced many descendants.

From the "Virginia Blue Ridge Railroad Datasets," Mary E. Lyons, 2009–13.

County around this time. One can only imagine their last goodbyes to the babes buried on the hill. Many Irish arrived in the area sitting atop trunks in wagons. I picture the Quinns leaving the same way. Their route was the Staunton Parkersburg Turnpike—a torturous road that winds up and over the Alleghany Mountains—to Weston, in what is now West Virginia.

Construction of the Trans-Allegheny Lunatic Asylum began in Weston the same year that the Blue Ridge Railroad opened for business. According to minutes kept at board of directors meetings, officials wanted Irish stonemasons to build the massive structure. They also wanted skilled artisans to sculpt the bear and wolf heads that gaze with fierce intensity from the gable ends of the hospital.

The next year was a happier one for the family. When Hannah gave birth to a daughter in Weston in 1860, the couple named her Mary. If John worked at the hospital, his employment was steady for the next twenty-one years; construction continued until 1881. By 1880, he owned real estate worth $1,000 and personal property worth $650. It was no fortune, but at least the Quinns possessed a house and possibly enough land for growing food—an opportunity that English policies made impossible when they lived in Ireland.

And what of Mary's deceased siblings? The Quinn Cemetery has been blessed for 150 years, with no development to threaten its peaceful environs. Even deer poachers who have roamed the property for generations seem respectful. Though the hunters leave spent gun shells in the cemetery, I've

seen no vandalism to the gravestones. Perhaps they know that Virginia law imposes up to $25,000 in fines and one to five years in prison for anyone convicted of damaging a historic cemetery.

The Quinn Cemetery is most definitely historic. It's located in a National Historic District, and the Blue Ridge Tunnel is a National Historic Civil Engineering Landmark. Completion of the tunnels and tracks opened up trade between eastern and western Virginia and beyond. This huge public works project represents a pivotal point in Virginia's economic and cultural history. The inscribed stone and unmarked fieldstones at the cemetery are poignant reminders of the high price that workers paid to make the advancement possible.

Someone has recently bulldozed a road around the cemetery and damaged the northwest corner of the wall. Eugene and Mary Quinn need protection. An archaeologist suggests that a high iron fence would prevent further damage to the stone wall and the graves. Wholesale removal of the vines and brambles by yanking them out of the ground may destabilize the stones. The task calls for a more respectful approach that preserves the physical integrity of the graves.

As for me, I wish I could hear the sound of bagpipes at the Quinn Cemetery every Saint Patrick's Day. And every August 4, I'd like to leave a flower at the children's grave. The tributes would acknowledge the unknown dead and the two named children buried there. It's the least we can do for them and for the Irish laborers who enriched Albemarle County and Virginians so long ago.

Buried History

The only inscribed gravestone at the Quinn Cemetery reveals a panorama of transnational, state and local history. Within those brief words are the great Irish famine of 1845–52, the Irish diaspora in the antebellum American South and the mighty Blue Ridge Tunnel—a critical link in America's surge toward fulfilling its ambition of Manifest Destiny. The history of the unmarked fieldstones at the cemetery is much more elusive. Who chose this lonesome spot for these deceased people and when are unknown. One possible answer is worth consideration: the Quinn Cemetery could have been a slave burial ground long before the Irish arrived in 1850.

POSSIBLE ORIGIN OF THE CEMETERY

The Quinn Cemetery is a few miles northeast of Highway 250 (Rockfish Gap Turnpike) and County Road 750 (Old Turnpike Road). The area was a busy place in 1799. That year, James Hays from neighboring Augusta County purchased land surrounding the junction. He divided some of the acreage into forty half-acre parcels and established New York, known now as Little York or Old York. His brother, John, joined the enterprise and ran a drinking establishment in the nascent town.

James Hays and his wife, Mary, held six people in slavery in 1810; John claimed eight people as property that year. Any of the fourteen Hays slaves could have died during the brothers' tenure at New York. If James Hays followed local custom, he, or perhaps the slaves, designated an out-of-the-way burial spot—one that was difficult to farm and some distance from his house. The Quinn Cemetery is about a half mile behind Hays's former dwelling. It sits on a slight rise, as does the slave cemetery at Mount Fair in Brown's Cove, fifteen miles north.

James Hays's vision of a town was only partly realized. A few Pennsylvania German families settled in New York in the early years, and a tan yard, meetinghouse and blacksmith shop were established. Then Hays's daughter, Elizabeth, married Robert Brooks in 1808.

In 1812, Brooks purchased New York lot 31, where he and Elizabeth lived in a one-story frame house. Five years later, he bought the entire New York tract. Slaves held by Brooks may have built the white, two-story house, brick summer kitchen and brick smokehouse that became known as Brooksville Tavern. Brooks ran it as an inn for travelers heading across Rockfish Gap, and New York became known as Brooksville.

Census records list two slaves in Robert Brooks's possession in 1810, eight in 1820 and eight in 1830. It is unknown if the 1820 and 1830 people were the same, or if they were the slaves listed on a deed of trust when Brooks mortgaged them in 1834: Quixol, Gabriel, Homma, Betty, Brener, Lucy, Margaret and Lewis. Brooks must have acquired more slaves within the next two years. When he sold Brooksville to James P. Tyler in 1836, he conveyed Frank, nineteen years old; Fanny; and Eliza and her "future increase," as stated on the deed.

In 1837, James P. Tyler sold the land and its buildings to William Goodwin, a Nelson County resident. The Nelson County line is a mere one mile from the Old York settlement, so it's likely that Goodwin and his eleven slaves were part of the nearby Brooksville community, if not occupants, during his ownership of the land.

In short, at least thirty-six different slaves lived on the New York–Brooksville property in prerailroad days. Any one of them could lie under the mute fieldstones in the Quinn Cemetery. Or the deceased might have been buried without stones, as at the slave burial ground discovered in the University of Virginia cemetery in November 2012. There, according to the *Daily Progress* newspaper in Charlottesville, Virginia, "the nameless graves follow the line of a long-gone fence. They're mostly marked with field stones, if they're marked at all."

And as at the University of Virginia, the slaves might have been buried in layered graves. An article in the *Hook* newspaper in Charlottesville noted that archaeologist Ben Ford "also suspects the grave site was used for a long period of time, as many of the graves are on top of each other."

William Goodwin sold Brooksville to Jonathan Beers in 1840. George Farrow of Fauquier County bought it in 1848. The deed specified 515 acres, the tavern house and town lots. With the arrival of George Farrow, a second chapter opens in the history of the Quinn Cemetery—one that includes more slaves, many hundreds of Irish immigrants and the coming of the railroad.

Possible Slave Burials, 1850–60

Claudius Crozet, chief engineer for the state-owned Blue Ridge Railroad, drew a map of the project shortly after construction began in early 1850. His labeling shows that the old settlement of York retained its name at that point, and five buildings still stood on both sides of the Rockfish Gap Turnpike. Dwelling numbers on the 1850 census indicate that they may have housed Irish immigrant laborers and their families.

George Farrow continued to run the Brooksville house as a tavern and inn during the 1850–60 railroad construction decade. Claudius Crozet, one railroad contractor and two railroad engineers were living there when the census taker knocked on the door in September 1850. By this time, one of the outbuildings was a post office from which Crozet and Irish laborers routinely mailed letters. Located two miles from the east portal of the Blue Ridge Tunnel, one mile south of Brooksville Tunnel and two miles southwest of Greenwood Tunnel, the York-Brooksville area was Midtown, as it were, in the railroad construction zone.

The Quinn Cemetery was at the center of it all. Just off the turnpike at York, a byway called the Old York Road ran north through Farrow's

property. It skirted the Quinn Cemetery by thirty yards. Then it turned east—bisecting structures with stone foundations that are now work buildings in Pollak Vineyard—before heading northeast to a stagecoach stop at Meadowbrook plantation and up to the Greenwood Tunnel. A switchback wagon road peeled off Old York Road, winding up and around the rocky ridge to Brooksville Tunnel, which was lined with bricks. A brick kiln was located just north of George Farrow's property; the wagons hauled bricks from the kiln up to the passage.

Other wagons filled with barrels of gunpowder, steel and fuse arrived regularly via the Scottsville Turnpike (Plank Road), which ended near Brooksville. Movement of laborers and materials along this network of roads placed the cemetery in the midst of an extremely active locale.

One sheet of unsigned, handwritten notes found in the files of the Chesapeake and Ohio Historical Society in Clifton Forge, Virginia, holds a tantalizing clue about the Quinn Cemetery. The notes are dated 1990 and titled "Blue Ridge Railroad." One of them states, "Cemetery location Brooksville Home. Casualties buried there." Indeed, a fenced cemetery is behind the Brooksville house, but its occupants are members of the Farrow family. Though the note taker was obviously unaware of the Quinn Cemetery farther north on the property, the word "casualties" strongly suggests that some of the unmarked stones there are related to railroad deaths.

The first of those casualties may have been an African American child who died in May 1850. Southern newspapers reported the event:

> *A letter has been received in Richmond from Albemarle, giving the details of a shocking event which took place near the Blue Ridge Tunnel a few days ago. A little boy of ten or twelve years of age, the son of Mr. Jas. H. Bagley, being at play with a negro boy of the same age, proposed to show him how the Irishmen at work on the Tunnel blew rock. He accordingly laid a train from the powder stored away in a building used for that purpose, and set fire to it. A tremendous explosion ensued entirely destroying the house, killing the white boy instantly, and injuring the black boy so severely that he died in a few hours.*

The unfortunate Bagley child would have been buried in a family or church cemetery. The Quinn Cemetery, centrally located in the construction area, might have been the final resting place for the African American boy. Wherever he was buried, let's hope he was unconscious during the last hours of his short life.

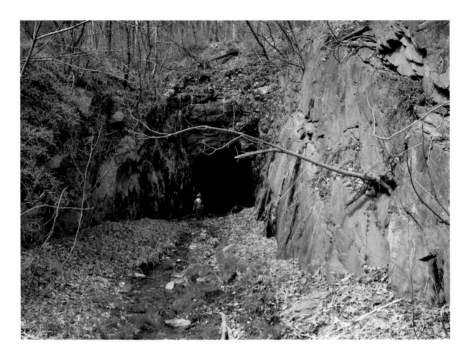

East portal of the Blue Ridge Tunnel. No arch was necessary to support the greenstone at the east portal. *Author's collection.*

This eighteenth-century map shows the four provinces of Ireland. Most Blue Ridge Railroad families were from County Cork, which is in the southernmost province of Munster. *From Wikimedia Commons.*

Above: Late blight on a potato leaf. *Phytophthora infestans* caused the blight. *From Creative Commons.*

Left: Famished children in Caheragh, County Cork, Ireland, search desperately for a healthy potato. *From* Illustrated London News, *February 20, 1847.*

Survivors of the Great Hunger receive a priest's blessing before leaving their homeland. *From* Illustrated London News, *May 10, 1851.*

A soup kitchen in County Cork, Ireland. *From* Illustrated London News, *March 13, 1847.*

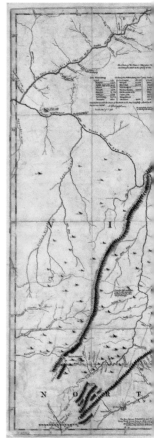

Above: Emigrants arrive at Cork Harbor and board a ship bound for North America. Many Blue Ridge Tunnel workers sailed directly to Baltimore, Maryland. *From* Illustrated London News, *May 10, 1851.*

Right: The planned route of the Virginia Central Railroad to the Ohio River. The blue oval represents the portion that the Blue Ridge Railroad built. *Courtesy of Library of Congress.*

Opposite: The most direct route for Irish traveling to Staunton from western Maryland would have been the Great Valley Road, marked in red on the map. *Fry-Jefferson map, 1751.*

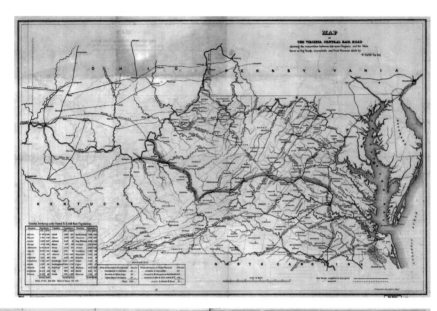

The Fermoy Weir, about four miles southeast of Ballyquane. *From Wikimedia Commons.*

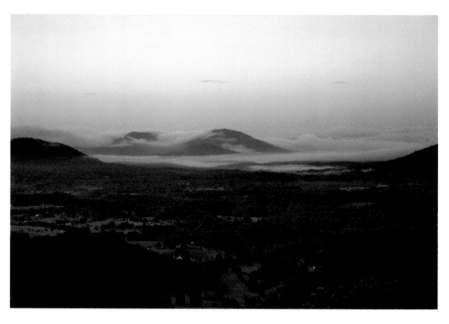

View from Rockfish Gap. *Courtesy of Jim Kauffman.*

Claudius Crozet designed a two-thousand-foot-long siphon that drained water at the rate of sixty gallons per minute from the tunnel. *Author's collection.*

A train steams down the temporary tracks on the west side of Rockfish Gap. Reproduction of an 1857 Edward Beyer painting. *Author's collection.*

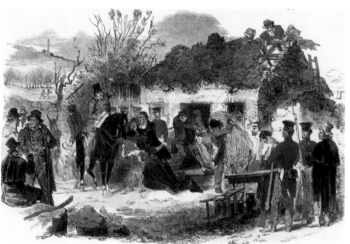

Above: The arrows
show the path of
cholera through
Virginia in the
summer of 1854.
*Courtesy of Library of
Congress.*

Left: Landlords
continued to evict
tenants and tumble
their cabins for
decades after the
Great Hunger ended.
From Illustrated
London News,
December 16, 1848.

The Geology
by
Prof. William B. Rogers.
Chiefly from
the State Survey 1835 '41.
"With later observations in some parts"

EXPLANATIONS.
Railways Completed
do. in Progress
Canals Completed
do. in Progress
County Towns (Courthouses)

EXPLANATION OF COLORS.

Tertiary *covered by Quaternary*
A.B. *Eastern limit of* Lower Tertiary
above tide level.

Upper Jurassic *passing upwards into base of* Cretaceous.

Lower Jurassic *passing down into* Triassic

Great Coal Group.
P.Q. *outcrop of* Pittsburg Coal

Carboniferous Limestone Group.

Lowest Coal Group.

Devonian.

Upper Silurian.

Lower Silurian Cambrian.

Archaean *or Old Metamorphic and Primary including* Huronian *and* Laurentian.

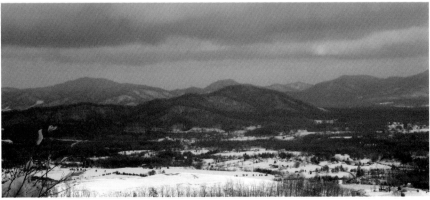

Winter view from Rockfish Gap, Virginia. *Courtesy of Jim Kauffman.*

The west portal of the Blue Ridge Tunnel. *Courtesy of Dan Addison Photography.*

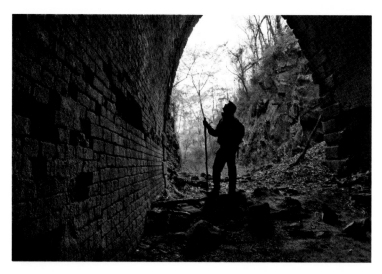

Crumbling bricks at the west portal of the Blue Ridge Tunnel. *Courtesy of Dan Addison Photography.*

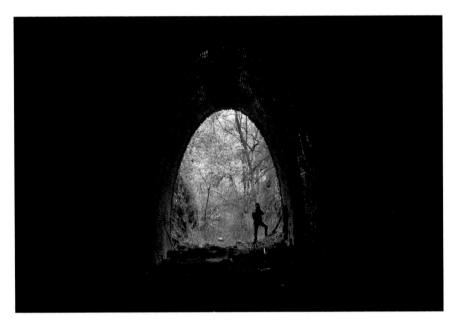

Inside the west portal of the Blue Ridge Tunnel. *Courtesy of Dan Addison Photography.*

Above: Close view of the Quinn footstone. *Courtesy of Clann Mhór.*

Left: Inscribed and unmarked stones for Eugene and Mary Quinn, Quinn Cemetery, Albemarle County, Virginia, March 2010. I placed the quince blossoms on the headstone. *Courtesy of Clann Mhór.*

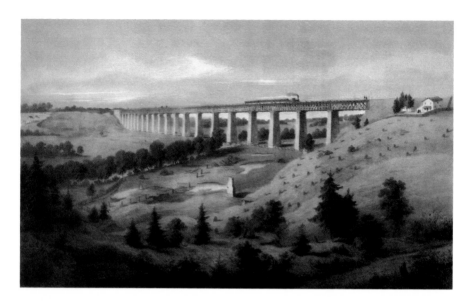

The High Bridge at Farmville. Reproduction of an 1857 Edward Beyer painting. *Author's collection.*

Unmarked double stones at the Quinn Cemetery. *Author's collection.*

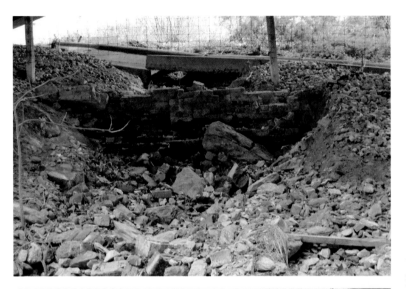

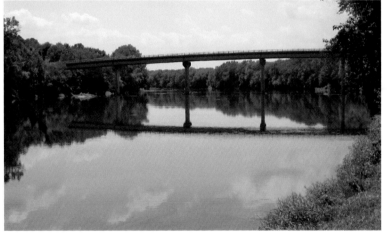

Top: Brick rubble under Interstate 64 is all that remains of Brooksville Tunnel, which was destroyed for the highway construction in the 1970s. *Author's collection.*

Middle: The bridge over the James River at Scottsville. *Courtesy of Billy Hathorn.*

Bottom: Funeral in Skibbereen, County Cork, Ireland. The deceased victim would have been buried in a mass grave at the abbey cemetery. *Drawn by H. Smith for* London Illustrated News, *1847.*

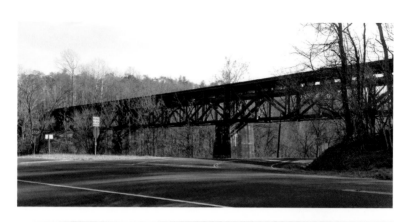

Above: The red circle shows the area known as Ross, home of the Shanahan family. *Courtesy of Library of Congress.*

Opposite, top: Bridge over Mechum's River in Albemarle County, Virginia. General Philip Sheridan's troops destroyed the original bridge during the Civil War. *Author's collection.*

Opposite, middle: Croghan grave near Drumline, County Clare, Ireland. A Croghan descendant in Ireland suggests that the Blue Ridge Croghan family paid for the elaborate stone. *Courtesy of Pat O'Brien.*

Opposite, bottom: Fairhead, County Antrim. *Photo by Frank Donovan, 2005.*

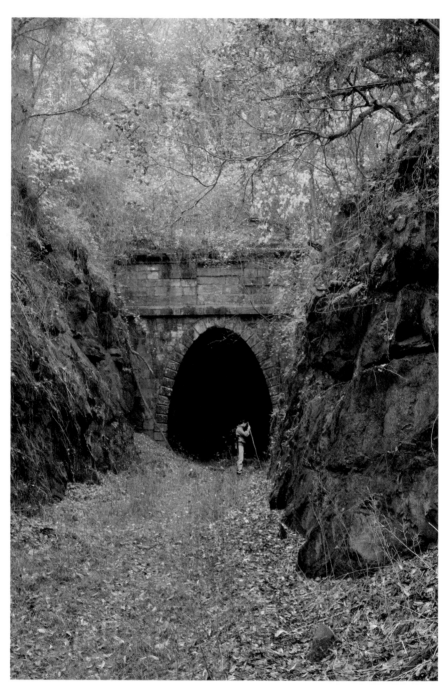

Soft shale at the west portal of the Blue Ridge Tunnel required a supporting limestone arch.
Courtesy of Dan Addison Photography.

I am sorry to say that a most horrible occurrence has stopped the work for two days…Joseph Farrow, one of the foremen of Mr. Sizer, on Sunday, in a drunken state, shot an Irishman, which excited all our laborers of that nation to a great degree…

We hope…the work will be resumed tomorrow… no doubt the circumstance, though bad enough, will be exaggerated in our papers and the Tunnel will be accounted responsible for the occurrence, as it was for the boy who burned himself by playing with powder.

From Claudius Crozet's letter to James Brown, June 18, 1850.

Other possible interments at the Quinn Cemetery include George Farrow's deceased slaves. The 1850 slave schedule lists him as the owner of forty-one people. At least four of them died at Brooksville during the next decade: Betty, age one hundred; Moses, age twelve; Lucy, age ten; and little Georgina, who lived only four months. If the Quinn Cemetery was the traditional resting place for York and Brooksville slaves by this time, the venerable aged lady and the children would have been buried there.

Albemarle County death records indicate that George Farrow and John Mosby co-owned an African American child named Jefferson. No exact date or cause of death is listed, but the child was one year old when he died in Greenwood, two miles east of Brooksville. The Albemarle County 1850 census lists only one person by the name of John Mosby. Sixteen years old that year, he may have been the John Singleton Mosby of later Civil War fame. If Mosby fathered the child, it happened after his release from jail in 1853 for shooting a fellow student at the University of Virginia. Presumably, Jefferson's mother was a Farrow slave, so the boy would have been buried in the Quinn Cemetery.

Finally, death records list Irish contractor John Kelly as the owner of a four-month-old baby named Abraham or Alexander. The child died of teething—an often erroneous nineteenth-century diagnosis that confused teething symptoms with those of disease—in Greenwood, July 1854. Kelly held no slaves in 1850 or 1860; his ownership of this single child is a puzzle.

Contractor for the Greenwood, Brooksville and Blue Ridge Tunnels, Kelly lived in a shanty in what was then known as Kelly's Hollow, located near

the Greenwood and Brooksville Tunnels. His wife lived at a lower elevation in western Albemarle. Occasional conjugal visits with her may not have sufficed for John Kelly, though it's possible that he purchased the infant to free it or to save it from orphanhood if the parents had been sold. Whatever the case, Abraham is another candidate for the Quinn Cemetery roll call.

POSSIBLE IRISH BURIALS, 1850–60

The preceding scenario builds a case for a slave cemetery on the Brooksville plantation. Assuming this is true, the cemetery was integrated after the Irish arrived. Irish deaths in western Albemarle County and in shanties on both sides of the Blue Ridge Tunnel called for expediency, proximity and a funeral with no expense for families living on as little as one dollar a day. The Quinn Cemetery provided all three.

In 1852, an Irish railroad worker named James Higgins, who may have lived in one of the surviving York buildings, murdered his fellow countryman, Timothy Dacy. By this time, the privately owned Thornrose Cemetery in Staunton, Virginia, was open for business. Many Irish workers chose it as a resting place for their loved ones because it was near Saint Francis of Assisi, the recently completed and Irish-built Catholic church in Staunton.

Though Staunton was a long fifteen-mile trip for Irish transporting a body from Albemarle County, a proper Catholic funeral Mass at Saint Francis and graveside prayers by the parish priest, Father Daniel Downey, would have been paramount. The trustees of Thornrose, however, forbade the burial of any person involved in notoriety. Timothy Dacy doesn't appear in Thornrose records, making him a candidate for the much closer Quinn Cemetery. Most of the Irish laborers were floorers earning $1.12½ a day. They could ill afford the $25 fee—the equivalent of $670—for a private, sixteen- by twenty-foot lot at Thornrose Cemetery.

A single grave for someone over the age of ten and not entitled to a burial in a private lot cost five dollars. The charge for deceased under the age of ten was three dollars. A twenty-five-cent charge for a burial permit and staggered fees for digging, filling and sodding the grave were additional. According to a board of trustees meeting in 1853, the fees were "payable in all cases in advance."

The city of Staunton provided what the trustees called "corporation" lots for those who couldn't pay the fees, and many Irish chose them for their

deceased, even if they couldn't afford a headstone. Such was the case for Ellen Hayes from County Cork. Her husband, Edward, worked as a floorer, blacksmith and teamster on the west side of the Blue Ridge Tunnel. He was also a waterman, pumping out the relentless stream that poured down the sloped passage. Edward was toiling at this job in May 1856. Soaking wet and confined for hours inside the chilly tunnel, he contracted pneumonia and died that month. His pregnant wife and one-year-old twin daughters were now on their own.

Ellen's twin daughter Catherine died of pneumonia in June 1856. Mrs. Lyons, a neighbor and midwife at the tunnel who had brought Catherine into the world, reported the death. Both Edward and Catherine were buried at Thornrose, apparently with no headstones. Ellen's baby was born and died that same year of pneumonia, the scourge of shanty housing at the Blue Ridge Tunnel. The widowed mother didn't bury Hannah at Thornrose. The Quinn Cemetery, free and only two miles away, would have been quicker, so less painful, perhaps, for a woman crushed by the loss of her spouse and two children within one year.

Mrs. Lyons had more sad duties in 1856. She reported the death of John Mangle, the infant son of Patrick and Ellen, who died of a cold in January. Michael Kelly, the nine-month-old son of Mike and Ellen Kelly, died from teething in September. Neither was buried at Thornrose. With its growing population of deceased children, the Quinn Cemetery might have been a more comforting choice. It was certainly more affordable.

The Cemetery Wall

And that returns us to the only identifiable deceased in the Quinn Cemetery: Eugene and Mary Quinn. It is unknown who erected their head- and footstones, or exactly when, though the style suggests they were cut and inscribed during the construction decade.

Nor do we know who built the stone wall around the cemetery. If the Quinn Cemetery was originally a slave burial ground, enslaved masons may have constructed the wall, but it totals three hundred linear feet. It's unlikely that slaveholders would have permitted such a labor-intensive task that was of no use to a working plantation. George Farrow's slaves, for instance, produced 1,250 bushels of corn, 800 bushels of oats and 130 bushels of wheat in 1850 alone.

John Quinn, the children's father, worked as a stonemason at the Blue Ridge Tunnel in 1852 and 1855. In the interim years, he probably worked elsewhere along the Blue Ridge Railroad or for the Virginia Central Railroad, which built a temporary track around three tunnels still under construction in 1854. Twenty-five other Irish stonemasons worked for the railroad, as well. As the cemetery filled with Irish graves, any number of these men might have erected the wall for one or both of two reasons.

First, the wall could have defined the enclosed section as suitable for Catholic burials if Father Downey consecrated it by sprinkling holy water and saying the appropriate prayers. Such a scenario assumes the Irish were aware of—but unconcerned about—prior slave burials inside the wall boundary. Fresh from the horrors of the Great Hunger, during which many thousands of victims were dumped from carts in mass graves without coffins, their bare faces covered by soil, the presence of buried slaves in the Quinn Cemetery may have mattered little to the Irish. A dignified resting place for their dead could have been their most pressing concern.

Keeping family members safe from animal or human depredations would have been an equal priority. In *The Graves Are Walking: The Great Famine and the Saga of the Irish People*, author John Kelly describes a woman waiting in a soup line in Skibbereen, County Cork, in 1847: "Near the front, a woman was wailing—but from exhaustion and despair. The mortality in Skibbereen had created such a shortage of burial space, people were digging up each other's dead and burying their own departed in the empty graves. The woman had spent the night guarding her husband's grave."

Second, the wall might have been erected as a racial divider, serving the same purpose as the fence that separated antebellum African American burials from white burials in the University of Virginia cemetery. This scenario assumes the Irish knew of prior slave burials and that those graves lay outside the wall.

Or perhaps Irish and slave burials were spatially separated within the enclosed space. In 2011, I saw a trio of unmarked stones mere inches apart at the southern end of the enclosed wall, about fifteen yards distant from the cluster of graves that surround the Quinn children. More unmarked stones may have been in the same area, hidden beneath the maze of honeysuckle vines and fallen tree limbs. If a distinctly separate cluster of graves were found at the southern end of the cemetery, the discovery would suggest a deliberate division of graves by race.

We cannot know how the Irish railroad workers felt about race. They've left no known memoirs or letters behind that might mention the subject. But

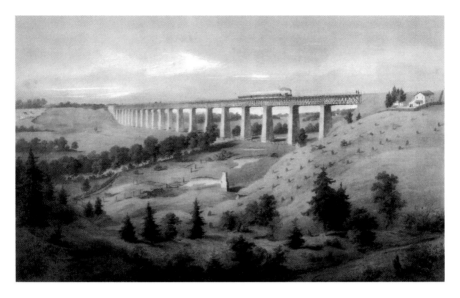

The High Bridge at Farmville. Reproduction of an 1857 Edward Beyer painting. *Author's collection.*

other than one court case that stated a slave was charged with stealing from an Irish man "on the highway," I have found no evidence of racial discord along the Blue Ridge Railroad, though at least four of the contractors used mixed-race crews.

Similar harmony on Virginia's railroad construction routes was not unusual in the 1850s. Historian Melvin Patrick Ely gives two examples from Prince Edward County, Virginia:

> *Soon black railroad workers were also living in shanties and toiling alongside Irishmen, and members of the two groups were visiting each other's little dwellings. The mixing of the two races spilled over from the railroad into other endeavors such as the construction of a new Appomattox River bridge at Farmville. The crew of stonemasons that built the abutments included half a dozen hired slaves, a man simply listed as "Tom, Irishman," and several other whites, at least two of whom were probably Irish.*

Whether such fraternization occurred along the Blue Ridge Railroad, or if it would have led to a shared burial ground, is unknown. Only a primary document, as yet unfound, can establish the truth about the Quinn Cemetery. Meanwhile, its future is as uncertain as its past. It is

A bulldozer damaged the northwest corner of the Quinn Cemetery wall in 2010. *Author's collection.*

unfortunate that the current owners of the land have allowed someone to bulldoze a private road around the perimeter. Any evidence of possible depressions left by deteriorated coffins in unmarked graves just outside the wall has been destroyed.

The *Daily Progress* reported that University of Virginia officials "are debating how best to memorialize the unknowns buried" in the university cemetery. Possible "unknowns" outside the Quinn Cemetery wall will be deprived of any such tribute because their graves may have been swept away. And as it stands now, graves marked with fieldstones inside the wall are also deprived of a memorial, other than the words you are reading now.

I registered the Quinn Cemetery with the Virginia Department of Historic Resources in January 2012. We can only hope that the landowners honor the historic designation and prevent further damage to a powerful symbol of the people whose labor helped build this nation and state.

9

Cholera

Cholera Comes to the Blue Ridge Tunnel

Originally published in the Crozet Gazette, *Crozet, Virginia, September 2010.*

I rish canal workers sang a doleful tune about the "choleray" in the 1830s. A coffin maker in Waynesboro, Virginia, called it "cholery" in the 1850s. Whatever the pronunciation of cholera in those days, it was the scourge of Richmond, Scottsville and Rockfish Gap in the summer of 1854. It seemed to appear out of nowhere during that brutally hot season and then mysteriously vanished.

The cause of cholera is now well known. In 1883, a German scientist named the *Vibrio cholera* organism as the culprit. The bacteria enter the digestive system of victims who drink water contaminated with feces. Or victims eat food harvested from contaminated water or washed in it. Some sufferers recover after a mild bout of diarrhea, but many cases lead to loss of a quart of water every hour from acute watery diarrhea and vomiting. Kidney failure and cardiac arrest soon follow.

Death by cholera was—and is—hideous. No wonder the Staunton *Spectator* and *Republican Vindicator* newspaper editors downplayed the news when cholera appeared in the summer of 1854.

A cholera epidemic in the Augusta County area would have been disastrous for Staunton business owners. By June 1854, hundreds of Richmonders were crossing Rockfish Gap daily on passenger train cars. The train ran on a temporary track that Irish immigrants and enslaved Virginians had recently built for the Blue Ridge and Virginia Central Railroads. It stopped

This nineteenth-century drawing conveys the panic that ensued during a cholera epidemic. *From Wikimedia Commons.*

in Staunton so passengers could dine or spend the night at local hotels before boarding stagecoaches headed west.

Thanks to the temporary track and promised completion of the Blue Ridge Tunnel at Rockfish Gap, as well as three shorter tunnels in Albemarle County, the economy in Staunton and Augusta County was booming. Arrival of a cholera epidemic would have destroyed profits. Dropping revenues would then lead to loss of advertising dollars for the newspapers.

Still, as epidemics erupted across the country, the editors could only put off the news for so long. The *Spectator* printed a brief but ominous announcement on June 28 about cholera in Fayetteville, Tennessee. "There have been seven deaths—of whom three were white persons," the editor reported. "The schools were all broken up, and the inhabitants had fled the place in a panic of fear."

The distant location of the outbreak must have comforted readers—until they read the July 17 issue of the *Vindicator*. Cholera was "daily carrying off a moderate number of persons" in Richmond. The editor calmed his audience, though. "The cases," he wrote, "are principally confined to the dissipated in habit and the careless in diet." In other words, civilized readers had nothing to worry about, especially if they followed Richmond doctors' advice to avoid cucumbers and green corn.

On July 26, the *Spectator* reported worse news from Richmond: "The *Richmond Dispatch* gives the number of burials at one of the city cemeteries

from the 9th to the 17th of July…forty-two had died of cholera. Most of these were colored persons."

Then, the death rate soared. "From a statement made in the *Richmond Enquirer* of Tuesday last," the *Spectator* announced on July 31, "there had been up to that time, 125 deaths from Cholera from the 19th of June, the day the first case occurred." Again, the editor soothed readers. "The disease," he continued, "has greatly abated, if not entirely disappeared." No, not entirely. Richmond physicians later estimated that the final tally was between 200 and 225.

It may be just as well that the true numbers never reached nervous readers in Augusta County because cholera had already reared its frightening head nearby. After Richmond's first case on June 19, cholera struck Scottsville in Albemarle County. As if to reassure readers—and perhaps himself— the *Vindicator* editor noted that "the victims of cholera were persons of intemperate habits, and one of them died in Richmond. No new case of…disease has occurred."

But within a month of the outbreak, twenty-five people would be dead from cholera in Scottsville, a drop-off point for goods transported along the James River and Kanawha Canal. The cruel disease appeared next at the Blue Ridge Tunnel at Rockfish Gap. It landed first on the eastern side in Nelson County on July 24. One week later, it jumped to the western side in Augusta County. Its victims were Irish railroad workers and their families.

Between 1850 and 1860, about three thousand Irish men, women and children moved in and out of crowded shanty housing or equally crowded rental houses during construction of the four tunnels and connecting tracks. This long railroad village began at Ivy Depot in Albemarle County, climbed up the mountain at Rockfish Gap in Nelson County and ended at Staunton in Augusta County. Most of the Irish were exiles from the great famine that raged in Ireland between 1845 and 1852.

The *Spectator* editor already knew that Irish immigrants made good copy. On February 13, 1850, he had run a front-page satire that featured a brogue-ridden Irishman digging for gold in California. "Biddy Darlan," the Irish character wrote, "I've been to the mines, bad luck to 'em. For siven weeks, Biddy, achushla, I sarched the bowels of terry firmer for goold, and all I got was the dissenterry, by rason of workin on an empty stomack."

One and a half million Irish were dying of an "empty stomack" or dysentery during the famine. The editor's insensitivity to their tragedy is noteworthy, especially in light of his announcement in the same issue that Irish laborers had arrived in the city with great fanfare to work on the railroad.

CHOLERA AT THE TUNNEL!

Reverend Dr. Downey, the Catholic priest, has exerted himself both as a temporal and spiritual adviser and is constant in his ministrations to the sick; he endeavors to make his people more cleanly in their persons and houses, and reasons with them against the use of whiskey, which poisons and destroys their bodies, teaching them cleanliness and temperance as well as godliness. We wish him all the success of Father Mathew and trust that his parishoners [sic] may soon be freed from the fatal disease now prevailing there.

From the Charlottesville Jeffersonian, *quoted in the Staunton* Vindicator, *August 1854. Born in County Cork, Father Mathew led a pro-temperance movement in Ireland and the United States in the 1830s and 1840s. It is doubtful that the* Jeffersonian *editor would have risked a visit to the tunnel during the cholera epidemic. Lacking knowledge of what Father Downey actually said to his ailing flock, the editor superimposed Father Mathew's exhortations onto the local priest.*

So when cholera struck Blue Ridge tunnel workers in 1854, the editors' perspective toward the Irish was well in place. Recycling a *Vindicator* announcement, the August 9 issue of the *Spectator* ran a column entitled "Cholera at the Tunnel." It reported that fourteen cases of cholera were "confined to the six or eight shantees situated on the ravine running from near the top of the mountain at Rockfish to the Eastern mouth of the Tunnel—a distance of sixty to a hundred yards—and is hence attributed to some local cause."

The text gave readers a geographical reason to believe they were safe: Tennessee, Richmond, Scottsville, Rockfish Gap. According to the paper, only "away" people could die of cholera. Race or foreign birth also seemed to shield readers. Cholera victims in Virginia were "colored persons" or Irish living in "shantees."

Virginians were not alone in their bigotry toward what they thought of as the lower class. As millions of immigrant laborers arrived in the 1850s, American newspapers dosed readers with editorials, cartoons and articles that were contemptuous of the newcomers, especially the Irish. Irish laborers, in the main, constructed the

roads, canals, bridges and railroads that became the arteries of nineteenth-century American commerce. But as scholar Kevin Kenny notes in *Making the Irish American*, "The American Irish in the period 1845 to 1870 were clearly the least successful and the most exploited of all European Americans."

Cholera decimated entire families on the eastern side of the Blue Ridge Tunnel. The Irish workers often frustrated Claudius Crozet, chief engineer for the project. Earlier, in 1853, he had complained that the men took two days off for a funeral when someone died, even a "mere child." Still, Crozet was the only person to honor the dead Irish by naming them publicly. In a July 31 letter to the editor of the *Jeffersonian Republican* newspaper in nearby Charlottesville, he listed a few of the victims. Their burial places are still unknown:

> *Daniel Harrington, a sober and valuable man, aged about 45. Old Downey, probably 70 years old; Cain Holland 20; Dan'l Sullivan 22. Jeremiah Harrington's wife, her child and her mother. The wife of old Downey had recovered, but relapsed on Saturday and died on that day. Yesterday young Downey attended the funeral of his father, and on his way back was taken sick and was himself buried to-day. Another Harrington also died in a few hours—in all 11 in about a week. The men of the east side have generally scattered and fled, otherwise the disease would take more victims of course.*

Crozet later noted that hired slaves working in the tunnel area weren't susceptible to cholera. It was a silly conclusion. Obviously many African Americans were dying of the disease in Richmond. Blue Ridge Tunnel payroll records show that the slaves and the overseer escaped illness because they stopped work and probably left the area between August 1 and August 14.

By the time the *Spectator* and *Vindicator* editors reprinted Crozet's July 31 letter, cholera had traveled to shanties farther east toward the Blue Ridge Tunnel. It's easy to imagine progression of the disease along the line. The tunnel slopes downhill from west to east, which made water flowing from mountain springs a perennial problem during construction. The men sloshed in water for multiple eight-hour shifts as they drilled, blasted and hauled away stone. After they relieved themselves in outhouses or the woods, they had no way to wash their hands. Contamination of water in the tunnel was inevitable.

Workers who fled the eastern side in Nelson County probably sought refuge with friends or family on the western side in Augusta County. More contamination occurred there, causing an "awful fatality," as Crozet put it in

a September 1 letter. Among the dead were Michael McCarty, Pat Crowley, Mrs. Crowley, Pat Harnett, Mrs. Holleran, James and Joseph Haggerty, ten-year-old Peter Haggerty, Mrs. E.J. Duvall, William Newman, Edward Walsh and John Driscoll, an infant. In all, at least thirty-six Irish died of cholera at the Blue Ridge Tunnel.

The Center for Disease Control says that two factors must be present for a cholera epidemic: a significant breakdown in water, sanitation and hygiene infrastructures and the presence of *Vibrio cholera*. We've seen how easily cholera could have contaminated water at the Blue Ridge Tunnel. No one in those days was aware of infectious bacteria, and few realized the importance of a sterile environment. Family members who nursed dying relatives wouldn't have known to wash their hands or contaminated surfaces. Unchecked, *Vibrio cholera* rampaged through the tunnel area.

But how did the bacteria arrive at the tunnel to begin with? Newspapers of the time often blamed outbreaks on newly arrived Irish immigrants. It's true that thousands of people in Ireland died of cholera during the great famine. Evicted by English or Anglo-Irish landlords, many took refuge in ditches along the road. They had no food or shelter, much less a sanitary infrastructure. More immigrants died of cholera on ships that brought them to America.

According to Blue Ridge Railroad payroll records, no new Irish workers arrived at the tunnel in the weeks prior to or during the cholera outbreak. New immigrants didn't bring cholera to the tunnel, but the movement of people, and possibly oysters, did. Scientists now know that the cholera bacteria can easily contaminate plankton in estuaries. Recent research says that 1 percent of oysters and other shellfish bathed in this poisonous stew become a vehicle for spreading cholera.

Though nineteenth-century doctors were ignorant of the science behind oyster contamination, they recognized the link. Baltimore papers announced forty cholera deaths in July due to oysters from Chesapeake Bay tributaries. In late September, the *Gazette* in Alexandria, Virginia, reported the presence of cholera in oysters from the bay.

Raw oysters were a popular alternative to meat in summer. Three Staunton merchants ran weekly advertisements for the delicacy during the sweltering summer and early fall months of 1854. One was William R. Smith, who opened an "Eating & Oyster Saloon" where he sold oysters by the dish for twenty-five cents.

Following the trail, cholera began in Richmond on June 19, 1854. It moved to Scottsville on June 24 and landed at the Blue Ridge Tunnel around July 24. Meanwhile, oysters from Chesapeake Bay estuaries would have

arrived in Staunton via two routes. The first was by boat up the James River to Richmond and then by express train to the temporary Staunton Depot, where merchants picked up deliveries. "Our citizens are now supplied, daily, with these low-land luxuries by the Central [Railroad] Cars," the *Spectator* proudly announced. "Oysters sell here for $1.50 per gallon."

Oysters also surely arrived via the James River and Kanawha Canal—a traveler on the canal in 1835 remembered that the boat carried "fish of the very best, both salt and fresh." A Blue Ridge Railroad account book shows that canal boats from Richmond brought staples such as coffee and salt for tunnel workers in 1854. The boats also delivered sundry goods for track and tunnel construction. Wagoners would meet boats at the Scottsville landing to load foodstuffs, kegs of blasting powder and tools. From Scottsville, they followed the Staunton Scottsville Turnpike to the Rockfish Gap Turnpike and then took the Stagecoach Road to the Blue Ridge Tunnel and unloaded goods.

We can rule out oyster consumption as the source of cholera for the tunnel workers. Oysters were beyond the budget of laborers paid at most $1.87½ per day for often deadly work. But more than two hundred people died of cholera in Richmond that summer. One of them might have been an unlucky canal boatman who ate an oyster destined for Staunton. Though not all oysters are contaminated with cholera, it takes only one bad oyster and one case of cholera to start an outbreak. Now infected, the boatman could have contaminated a town pump handle in Scottsville.

Symptoms start anywhere from a few hours up to five days after ingestion of the bacteria, so it's impossible to identify the exact point of transmission. But picture this scenario: an infected wagoner leaves Scottsville, feeling queasy. He reaches the Stagecoach Road in Nelson County. A line of shanties perches on the hillside just below. He stops, and a few Irishmen help him unload goods from the wagon.

It's thirsty work. The wagoner reaches for the tin dipper that rests in the workers' water bucket, takes a long gulp and drops the dipper back in the bucket. The lethal cholera is now deposited on the dipper handle and in the bucket, waiting for its Irish prey. Then, the wagoner continues across the mountain to deliver oysters in Staunton.

We'll never know who purchased and ate oysters in Staunton, but we do know that Abraham Venable, the Staunton jailer, died of cholera on August 8. The August 30 issue of the *Spectator* furiously denied rumors that sixteen people had died of cholera in the city, though the paper reported sudden deaths almost every week. "Some people delight in exciting the alarm of

persons at a distance," the editor fumed, "by misrepresenting facts." He was especially insulted by the Charlottesville *Jeffersonian* editor's claim that "whiskey and filth" caused cholera in Staunton.

It's plausible that cholera led to some or all of the following deaths between July and September 1854: Thomas Tinsley of Richmond died suddenly while staying at Mountain Top Inn at Rockfish Gap, where the hotel served "capital fare," according to the Spectator; Roseann Crickard in Staunton died from what official death records called "inflammation of the bowels"; after Reverend Garber died of flux in New Hope, the *Spectator* reported "dysentery has been prevailing to a fearful extent in the neighborhood of New Hope, in this county. A number of deaths have occurred"; and Peter Livick, who lived three miles from Staunton, died of dysentery, along with four of his children.

Dysentery is highly infectious, and the symptoms are the same as those of cholera. To add to the confusion, the unpredictable severity of cholera's symptoms confounded nineteenth-century doctors. Flux, inflammation of the bowels and dysentery might actually have been deaths from cholera—the invisible killer that arrived and then disappeared that dreadful summer of 1854.

FROM SKIBBEREEN TO STAUNTON

A version of this article was published in the 2014 Augusta County Historical Society Bulletin.

Skibbereen, County Cork, Ireland, 1846: a deadly potato blight has cursed the country two years in a row. Potato plants lie rotten in the fields. The people are dying from starvation and disease. Most are too weak to help themselves or one another. One visitor to Skibbereen reports that a "terrible apathy hangs over the poor…they sullenly await their doom with indifference and without fear…Death is in every hovel; disease and famine, its dread precursors, have fastened on the young and old, the strong and feeble, the mother and the infant."

The English government requires that local landlords set up soup kitchens, but the huge cauldrons of broth are inadequate for the crisis. Near Skibbereen, a witness sees five hundred people waiting for a meal of soup: "Fever, dysentery and starvation stare you in the face everywhere—children of 10 and 9 years old, I had mistaken for decrepit old women, their faces wrinkled, their bodies bent and distorted with pain, their eyes looking like those of a corpse."

The Skibbereen Callaghans

- Bridget Callaghan: widowed mother
- Mary Callaghan: Bridget's eldest daughter
- Names unknown: Bridget's two younger daughters
- Thomas, John and Denis Callaghan: Bridget's sons
- Michael Callaghan: Bridget's nephew
- Mary Ann Marmion: Bridget's adopted daughter

At the house of widow Bridget Callaghan, two children are dying of cholera. Often mislabeled as dysentery in those days, cholera is caused by the presence of *Vibrio cholera* bacteria in contaminated water. It is the ghoulish companion of people afflicted by natural or man-made disasters.

Bridget's eldest daughter, Mary, is sixteen. She is a probable witness to the massive diarrhea and vomiting that bring on her younger sisters' rapid deaths. The Callaghan boys are likely present, too: Thomas, the eldest son; John, fourteen; and five-year-old Denis. Their seven-year-old cousin, Michael Callaghan, lives within a quarter of a mile. He is well aware that cholera has struck down the girls. The distress that these surviving children experience from seeing their young relatives die is unimaginable.

At best, the bodies of the Callaghan girls are laid to proper rest in coffins. More likely, they lie in a large plot of consecrated land behind the entrance gate to the defunct Franciscan Abbey. By December 1846, the Skibbereen Irish are expiring in such horrific numbers that no coffins can be found. Eventually, eight to ten thousand nameless victims will be buried without coffins in the Abbey field.

The ruthless famine—the Great Hunger—creates countless orphans. At some point, Bridget takes in a child named Mary Ann Marmion. As cousin Michael later recalled, "She was an adopted child. Her parents put her with old Mrs. Callaghan, Denis's mother, to be raised by her, and was to pay her so much a month, but the paying soon stopped, but Mrs. Callaghan had become so attached to the child and kept her."

Not every cholera victim perishes. If Bridget and the other children are taken ill, they all recover. Three members of this particular Callaghan family will end up at the Virginia Blue Ridge Tunnel. Numerous themes common to Irish famine immigrants run through their story.

Funeral in Skibbereen, County Cork, Ireland. The deceased victim would have been buried in a mass grave at the abbey cemetery. *Drawn by H. Smith for* London Illustrated News, *1847.*

First, their forced exile represents all the Irish who built the famed tunnel, its three sister tunnels and thirty-four miles of connecting tracks in the counties of Albemarle, Nelson and Augusta. Second, Bridget's eldest daughter, Mary, offers a rare glimpse of women's history. Nineteenth-century Irish immigrant women are rarely visible in historical records, aside from censuses. Yet we know from letters sent to and from Ireland that the majority of them found jobs in America and sent money back to family members for ship passage, thus saving countless lives. Last, the famine caused a constellation of trauma symptoms that lasted for decades and ruptured families, as the history of the Callaghans will reveal.

Some historians mark 1850 as the end of the Great Hunger in Ireland, but the growing number of evictions by landlords during and after the famine years only increased the people's suffering. In 1851, the country was still reeling from what some have called ethnic cleansing by callous officials in the English government. That year, Bridget Callaghan found the means—perhaps by selling her last cow or pig—to buy passage on a ship to America for her daughter, Mary.

Now twenty-one years old, Mary ended up in Binghamton, New York. Like most young Irish immigrant women back then, she probably worked as a servant. Whatever the job, she saved every possible penny so she could send money to her mother. Her marriage to Irish-born Cornelius O'Connell sometime in the 1850s may have helped her provide additional funds.

Thomas Callaghan escaped Ireland next. John Callaghan followed in 1852. Then, as cousin Michael remembered, "There was considerable

correspondence as to what they would do with the girl, Mary Marman [*sic*]." Bridget's natural daughter may have balked at spending her hard-earned wages on the abandoned child's passage money. In any case, Bridget prevailed. She, Mary Marmion and fourteen-year-old Denis Callaghan left Ireland for New York in 1854. Mary Callaghan O'Connell paid their way.

Mary Ann Marmion lived with Bridget Callaghan—possibly in Binghamton—until the young woman married and moved out of state. Meanwhile, the Callaghan sons needed employment. The Blue Ridge Tunnel was well known among Irish immigrants, especially those from mining districts in County Cork. John and Denis migrated south to Rockfish Gap for steady work.

Still a boy, Denis worked on the east side of the tunnel from June 1856 through February 1857. After he turned sixteen in March, he was considered a man. His wages rose from $1.00 to $1.12½ a day. The paymaster listed his job as "floorer"—someone who cleared rock debris from the tunnel floor after blasters set off dangerous explosions of black gunpowder.

The tunnel was almost complete in 1857. Though some blasting and brickwork remained, the Blue Ridge Railroad, by now taken over by the Virginia Central Railroad, no longer needed hundreds of men working at each portal. Around this time, Denis and John followed railroad work west to Covington, Virginia. Their mother, Bridget, went with them.

What happened to the family during the Civil War years is unknown, but Denis managed to do well for himself. By 1870, he was back in Staunton with John and Bridget. He worked as a teamster for the railroad and owned $2,700 in real estate.

Land, land. The English government had usurped Irish land for centuries, forcing the people to rent it from English or Anglo-Irish landlords. Buying land was paramount for Irish immigrants in America. Denis's personal estate was worth only $250 in 1870, but he owned property. That was all that mattered—until Annie came along.

A recent immigrant from Ireland, Annie married Denis in 1871. They had their first of seven children in 1872. Denis became a naturalized citizen that same year. No doubt, Annie nudged him toward the decision. After all, we can hear her thinking, their American daughter should have an American father. Annie renounced Queen Victoria and swore allegiance to the United States in 1880. Now she, too, was an American citizen.

Though Denis and Annie were bilingual, neither could read or write. This was not unusual for Irish immigrants from a rural area with no nearby school and whose mother tongue was Gaelic. But like other Irish tunnel workers who settled permanently in the area, the couple insisted that their

Left: "Bridget Callaghan A native of Co Cork Ireland Died Nov. 6, 1888 Aged 96 years. May she rest in peace Amen." *Author's collection.*

Right: "John Callaghan A native of Co Cork Ireland Died May 26 1894 Aged 63 years May he rest in peace." *Author's collection.*

children learn to read and write and acquire a skilled trade. Four of them joined the city's middle class as a barber, plumber, railroader and teacher. For the Callaghan family, the horrors of the famine would have seemed like a bad dream by the 1880s, best forgotten and never mentioned.

Yet the years of the Great Hunger must have been a topic of conversation when John visited Mary in Binghamton in 1884. Surely the siblings spoke of their deceased younger sisters, if only for a few painful moments. Cousin Michael Callaghan was also present at the 1884 reunion. He had immigrated fifteen years earlier. A cart man in Binghamton, his business assets consisted of a single cart and one horse. "That is my way of living," he said later, "and has been for years."

Though it couldn't have been much of a living, at least Michael resided next to his cousin, Mary—another common theme in the lives of Irish famine immigrants. They tended to cluster near each other in the same neighborhood. Physical proximity offered the comfort of a familiar culture to fresh arrivals, making it easier for them to start over in a strange urban environment.

Matriarch Bridget Callaghan died in 1888. She was buried at Thornrose Cemetery. Her son John died six years later. Denis purchased a fine set of

burial clothes and an expensive casket for his brother's stately funeral. He provided cigars and whiskey for a traditional Irish wake and hired dignified black carriages for the family's ride to Thornrose. It was a sorrowful day, but more trouble lay ahead.

John had owned four pieces of property on which stood five houses. Their total value was $2,000. One lot was on Montgomery Street, and three were on Middlebrook Avenue. Unmarried, he left no will; the court appointed Denis as administrator of his estate. For some reason, Denis refused to give his natural sister, Mary, her share.

We can only guess why. Denis wasn't desperate for money. He was well employed as a railroad contractor in 1900, and he and Annie owned their home on Stuart Street. Census data invariably listed occupations for his mother, spouse and sister as "wife," "housewife" or "keeping house." It must have been difficult for Denis to view a female relative as his equal, and dividing the estate meant he would have to sell land—anathema for an Irish immigrant.

Finally, Mary Ann Marmion may have made a claim to part of the inheritance. According to a direct Marmion descendant, Mary Callaghan O'Connell was "greedy" and thought the adopted Mary Ann was not entitled to a share of John's estate. If this is true, Denis might have held some affection for his adopted sister and resisted a fifty-fifty split that would have excluded her. One of his direct descendants feels sure that he would have "stood up" for Mary Ann Marmion, though we have no proof that he did so.

Mary Callaghan O'Connell observed a respectful year of mourning after John's death. Then she sued Denis in 1895. Reminiscent of the *Jarndyce v. Jarndyce* suit in Charles Dickens's novel *Bleak House*, the case lasted for eight years. During this time, Denis received rent from occupants of the five houses.

In 1898, Mary Callaghan O'Connell sent cousin Michael to Staunton. He testified in court that her older brother Thomas had died some years earlier, leaving no heirs. He also stated that Mary was Denis's only lawful sister and had paid for her entire family's passage to America. "I remember when they left as well as if it was yesterday," Michael told the lawyers.

Though Denis refused to budge, the long feud came to a legal end at last. In January 1903, Mary Callaghan O'Connell accepted $1,000 as payment for one of the lots, and Annie paid the costs of the lawsuit. When Mary agreed to "release all claims she may have against Denis Callaghan," the court declared the case was an "ended cause."

Familial arguments over inheritance are common. What's surprising about the Callaghan case is that, in eight years of court records, no one ever mentioned the Great Hunger. Michael talked of his cousins' death from

cholera but not of the mass burials in his town. He described how Mary Ann Marmion became an adopted child but omitted the possibility that her parents could no longer feed her or might have perished from starvation after leaving her with Bridget. He never forgot the day his Callaghan relatives left Skibbereen, yet he could not speak of the calamity that caused their departure.

Mary Callaghan O'Connell, via Michael, conveyed to the court that she had paid her family's way to America but not that she had saved them from inescapable poverty and possibly death. And the lawyers' insistent questioning of Michael implies that Denis, who was not present at his cousin's testimony, was denying—silently, in absentia—his blood relationship to Mary: the very sister with whom he had witnessed, side by side, the horrors of the famine.

Loss, grief and displacement resonate beneath the contentious surface of the Callaghan case. Such muting of dark emotion was customary among Irish famine immigrants. As Peter Quinn writes in *Looking for Jimmy: A Search for Irish America*, "Out of all the millions who have endured deprivation and brutalizing poverty, out of all the families pulverized by punishing degrees of want, how many memoirs are there? How many detailed renderings of the conditions of the destitute—of broken hopes, lives, communities—do we have from the hands of those who suffered these events?…Dead children are not such stuff as dreams are made of. Or mass graves. Or tuberculosis, cholera, and typhoid. Or illiteracy and rude physical labor."

The Irish packed more than a few material belongings in their bags when they crossed the Atlantic. They brought suppressed memories of the greatest humanitarian disaster of the nineteenth century. Emotional numbing is one symptom of trauma. Reluctance to talk about the traumatic event is another, along with anger. All can lead to the collapse of family relationships, as we have seen with Denis and his sister Mary.

Though we can never know exactly what happened in the Callaghan family, the court case strongly hints that the Great Hunger and forced immigration haunted them for life. The family's true, tragic inheritance was a need to obliterate the past and possess land at any cost, even if that meant a bitter battle waged against flesh-and-blood kin.

Symbols and Signs

The House of Ninety-nine

More Callaghans

Written in May 2012 with the research assistance of Margaret Ryther.

Hundreds of Irish famine immigrants poured into Albemarle County, Virginia, in 1850. Desperate for employment, they came to work on the Blue Ridge Railroad–Virginia Central Railroad project. The plan called for construction of four tunnels, including the Blue Ridge Tunnel, and connecting tracks from Ivy to Staunton. The endeavor would provide a speedy link between eastern and western Virginia for the first time in history.

Some of the Irish worked for the Virginia Central Railroad, while others toiled for the Blue Ridge Railroad. Many hopped from one employer to the other during the construction decade. They and their families—about three thousand people—were part of a long railroad village that stretched for thirty-four miles through the counties of Albemarle, Nelson and Augusta between 1850 and 1860.

Discovering the whereabouts of the Irish in their extended trackside community is a daunting job. I've been particularly puzzled by the site of a dwelling in Albemarle County that I call the House of Ninety-nine. Thanks to *The Court Doth Order* by researcher Sam Towler and other records, I now have a plausible theory for the location of this barracks-like building.

Imagine a week in late September 1850. It's census time. John Winn, the enumerator, is riding around the Ivy–Mechum's River neighborhood. The area is rural. Winn rides in circles, so to speak, as he travels across the countryside from one farmhouse to another. This is Mountain Plain Church territory; at least twenty of the families that Winn enumerates are members of the congregation. Their church is near the intersection of what is now Highways 250 and 240.

The area is also Virginia Central Railroad territory, where the Irish are feverishly grading land for tracks that will connect Ivy with Mechum's River at the intersection. Winn ends the enumeration day of Thursday, September 19, at William Graves's residence. It stands on a narrow promontory overlooking the same spot.

Graves, by all accounts an honest, careful businessman, is the proprietor of a dry goods store on the promontory. He and his family live in a two-story house that he has recently expanded. Now doubled in size, it also serves as a tavern and inn for stagecoach passengers. The building stands on the promontory just south of the planned tracks.

On the next two enumeration days, John Winn visits farmhouses in the same neighborhood. He saves the hardest work for last: counting Irish who live near the proposed railroad. For that, he needs a long weekend's rest. On Monday, September 23, Winn resumes his job and finishes the day by listing fifty-four Irish men, women and children in fourteen different dwellings. These may be hastily constructed shanties within a quarter of a mile of the line. Then he reaches the House of Ninety-nine. He's very near where he ended his travels last Thursday.

The task is easy at first. Winn writes the names of the Desmonds: a father, mother and three daughters who compose the only complete family living in the house. Simple. But the hour is late, and we can almost see Winn shake his weary head. There's not enough time or energy left to list the other Irish in the house.

The census taker returns to the House of Ninety-nine the next day. Most or all of the men are at work, making his job even more difficult. Mrs. Desmond would have been at home. While her nine-year-old daughter, Catherine, minded seven-year-old Mary and three-year-old Jane, the harried woman would have provided the remaining ninety-four names. Winn struggles with some of the surname spellings. Maybe he has trouble understanding Mrs. Desmond's lilting Irish accent, though he manages to write the last name of Dennis Callaghan correctly. The enumeration consumes the entire day and part of the next.

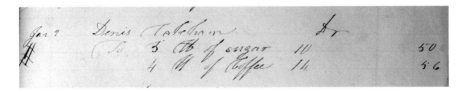

General store ledger page from January 2, 1852. Denis Callaghan, here spelled Calehan, purchased three pounds of sugar and four pounds of coffee. *Courtesy of Clann Mhór.*

Dennis Callaghan, who fled Ireland at the height of the famine, arrived in the United States around 1847. He probably left family members behind in Ireland, hoping he could find work and send them money for eventual passage to America. At least seven more Callaghan men and two boys worked on the Blue Ridge Tunnel between 1852 and 1860. Some may have been from Dennis's clan in Ireland.

Grading land between Ivy and Mechum's was complete by November 1850. Laying the rails began in 1851, and the bridge over Mechum's River was complete in 1852. That year, Dennis Callaghan was a frequent customer at the Wallace general store in Greenwood. Centrally located on the eastern side of the construction project, the store was a major purveyor of supplies for the Blue Ridge and Virginia Central Railroads.

As Margaret Ryther—a William Graves descendant—points out, the dry goods store at Mechum's River furnished items such as sheeting, blankets and mattresses (hair stuffed and corn shuck) necessary for a barracks full of workmen. Graves also sold large quantities of fabric suitable for work clothes—drill, denim and Osnaburg, a heavy muslin. In contrast, the Wallace store offered luxury goods such as overcoats and fine cashmere pants that local planters purchased for themselves. Primarily, though, the Wallace store specialized in bulk amounts of food. It was the equivalent of a big box superstore, and this meant shopping trips for Dennis Callaghan.

The Wallace store issued Dennis a passbook number that allowed him to charge foodstuffs to the Virginia Central Railroad. In January 1852, he bought 102 pounds of beef, 21 pounds of fish, 10 pounds of sugar, 14 pounds of coffee, 0.5 pound of tea and 1 gallon of molasses—in other words, enough fare for ninety-nine people. In April, he charged a whopping 402 pounds of beef to the railroad. Presumably he hauled these items back to the House of Ninety-nine in the Mechum's neighborhood, and the cost was deducted from the residents' pay at the rate of one dollar a week for board. But where exactly was the House of Ninety-nine?

When the Virginia Central Railroad condemned more than two acres on Graves's property to make way for the tracks, the deed noted a "house for hands." Knowing that the need for workers' housing would be great, the Virginia Central Railroad may have built the structure when railroad construction began. It stood on the same promontory as Graves's house but on the north side of the railroad line.

If the men were stacked in bunk beds, it's quite possible that this dormitory was the House of Ninety-nine. A separate space for the Desmond family within the building or attached to it, perhaps with a kitchen and eating area for the men, would have been necessary.

It makes sense that the House of Ninety-nine was at Mechum's River. The spot was a nexus of railroad activity in the early 1850s. Grading land, laying tracks and building the bridge required scores of laborers. Construction of a wooden engine house and a turntable forty-two feet in diameter were also underway.

And, as the real estate folks say, location is everything. William Graves saw financial opportunity for his tavern and dry goods store. In a July 1852 letter to the board of public works in Richmond, he argued for building a depot at Mechum's and won. By October of the following year, a large clapboard depot was complete at Mechum's River.

With plenty of work still available at Mechum's, Dennis Callaghan would have seen William Graves on a regular basis. Certainly he knew him well enough to ask a special favor. On August 2, 1852, William Graves and John T. Antrim, a merchant who lived near Mechum's River, stood as witnesses for Dennis when he applied for U.S. citizenship.

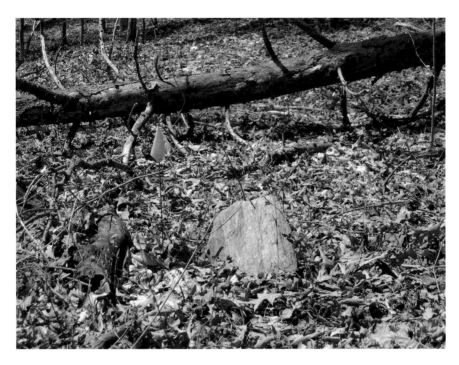

Above: Unmarked gravestones in a cemetery one mile west of Mechum's River Bridge. Irish workers, enslaved African Americans or both could be buried here. *Author's collection.*

Right: A rare image of William Graves. *Private collection.*

On the same day, Dennis's housemate, Jeremiah Callaghan, declared his intention to become a citizen. The four men would have traveled together to the Albemarle County Courthouse in Charlottesville. Receiving one's first papers, as the declarations were called, required no witnesses. Jeremiah had to prove only that he had been in the country for three years. The nature of the proof is unknown. It might have been as simple as a sworn statement, or maybe evidence of previous work in the country was needed.

Citizenship required the first papers and two more years of residency. Dennis showed his first papers document to the magistrate, while William Graves and John Antrim vouched for his character and residence in Albemarle for the previous two years.

The historical record is threadbare on positive interactions between the settled citizens of Albemarle County and workers on the Virginia Central Railroad–Blue Ridge Railroad project. The Irish Catholic immigrants had landed in a predominately Protestant country and state. Those near Mechum's River had no nearby Catholic Church for regular spiritual or cultural sustenance. The closest was in Staunton, twenty-six miles distant.

The secretive Know-Nothing Party, composed of virulent anti-Catholic members, was on the rise nationally and in Virginia. It was especially strong in Staunton, where it routinely posted hostile notices and held its gubernatorial convention in 1854. Life could not have been easy for Irish Catholics living along the railroad during the 1850s. Citizenship records provide a rare glimpse of local support for men such as Dennis Callaghan. It's a poignant moment to think about—enterprising William Graves helps a hardworking immigrant gain the privileges and duties of American citizenship.

All the signs, especially Dennis Callaghan's association with William Graves, point to one answer. Until a primary document surfaces that proves otherwise, we can assume the House of Ninety-nine stood at the Mechum's River Bridge and depot—a spot that trains still pass every day, 160 years after railroad workers lived in the "house for hands."

FROM DRUMLINE TO THE BLUE RIDGE

Originally published in the Clare Champion *newspaper, County Clare, Ireland, June 2012.*

In August 2010, a *Clare Champion* article informed readers of my search for descendants of the Crohan (also Croghan) family who worked on the mile-

long Virginia Blue Ridge Tunnel. The train tunnel—along with three shorter tunnels and thirty-four miles of connecting tracks—was a dangerous, ten-year public works project built between 1850 and 1860. The entire endeavor took the lives of more than two hundred Irish famine immigrants. About one hundred were Blue Ridge Tunnel workers or family members living in shanties near each portal.

When the article appeared, I had only a few clues about the Blue Ridge Croghans. One was an inscription on Hannora Croghan's gravestone at Thornrose Cemetery in Staunton, Virginia, at the western end of the railroad project. It states that she was from Drumline, County Clare. I assumed this meant the civil parish of Drumline.

From the U.S. census, I also knew that Hannora's sons, Daniel and Thomas, were living with her near the Blue Ridge Tunnel in 1850. The three Croghans resided in the same dwelling as Peter Crowe; his wife, Mary; and their children. The structure was very near the west portal of the tunnel.

The Croghan and Crowe families would have lived together in a rented farmhouse or hastily built shanty—a typical situation during the construction decade. Irish families along the Blue Ridge Railroad often doubled or tripled up in cramped quarters. In one case, ninety-nine people lived in the same dwelling.

Thanks to a surviving two-page payroll, I also knew that Peter Crowe helped build a major viaduct and adjacent culvert on the west side of the Blue Ridge Tunnel. Identified as a mason on the payroll, he was the first worker listed and paid more than other listed masons, hinting that he was a master at his craft. Daniel and Thomas Croghan were on the same payroll. They must have been Peter's apprentices; Daniel was listed as a laborer on the 1850 U.S. census but gave his occupation as stonemason on a later one.

The response after the *Champion* article appeared was immediate and gratifying. Two Irish readers—Flan Enright and Pat O'Brien—were already familiar with historical records related to Croghans in Drumline parish. With their research information in hand, I tried to connect the Drumline Croghans with the Blue Ridge Croghans. After months of drawing descendant charts (I wore out five erasers), I couldn't answer the question or make a definitive link.

One item was a particular puzzle. The 1860 census told me that Hannora's son Daniel was married by that year, and he and his wife, Ellen, were living in Staunton, Virginia. The widowed Hannora still lived with Peter Crowe and his family. I wondered why she wasn't living with her son.

Payroll for viaduct project on the Blue Ridge Railroad. Lines two, nine and fifteen list Peter Crowe, Thomas Croghan and Daniel Croghan, respectively. *Author's collection.*

Happily, two vital clues surfaced as I completed research for a book about the Blue Ridge Tunnel at the Virginia Center for the Humanities in the fall of 2011. First, the 1870 U.S. census listed Mary Croghan as Peter Crowe's wife. Hannora was not just living with friends in 1860. She was living with her married daughter, Mary Croghan Crowe.

Next, I discovered an 1851 advertisement in the "Missing Friends" column of the *Boston Pilot* newspaper. The ad, mailed from a post office located along the Blue Ridge Railroad, stated that Daniel Croghan was searching for his brother, John. Identified as a blacksmith in the ad, John was from the *townland* of Drumline as well as the civil parish of Drumline. This small but crucial detail considerably narrowed my search.

John eventually found his way to the Blue Ridge Tunnel area, as did a possible relative named Timothy. An 1852 ledger for the Wallace general store near the construction shows that Daniel, Thomas, John and Timothy (also written as Thady and Teddy) Croghan bought gunpowder, flax thread, boots, smoking pipes and numerous plugs of tobacco while working on the railroad.

Last winter, I reached out to my Clare research partners, informing them that the Blue Ridge Croghans were from Drumline townland. The result has been a fascinating ride in a time machine. It begins with Peter Crowe.

On a windy February day, I drove up to the Blue Ridge Mountains and examined what I call the Crowe-Croghan culvert. It's one hundred feet

MISSING FRIENDS

The *Boston Pilot*, a Catholic newspaper, published more than forty thousand "Missing Friends" advertisements between 1831 and 1920. Historian Ruth-Ann Harris compiled the advertisements in print form. They are now online in a searchable database sponsored by Boston College.

"The Irish had such a different way of life back home [that] they were bound to have an awful time of it in America," Dr. Harris told the *Boston Globe* in 1986. "And many of them did."

long, eight feet high and six feet wide—a "stupendous" structure, according to the railroad's chief engineer in 1850. The universal Masonic symbols of a T-square ruler and open compass are inscribed on the keystone.

I shared photos of the culvert with my Clare contacts. It turns out that a family of stonemasons well known for their stonework lived in Drumline townland in the nineteenth century. Their last name was Crowe. Surely, Peter Crowe, who married a Drumline Croghan, was from Drumline, too. And it's likely he was related to "Black Johnny" Crowe, a mason from Drumline who helped build the Bunratty Castle Bridge in 1804.

Though I've been unable to locate letters between the Drumline and Blue Ridge Croghan families, I've found something better. I've touched the graceful arches and finely fitted stones of the culvert and noticed the same handiwork in online photos of the Bunratty Bridge. Both are a tribute to skills that passed down through generations in Ireland, endured the famine and survived a three-thousand-mile Atlantic crossing.

The Masonic symbols on the culvert keystone are as important as Mayan hieroglyphs carved on limestone or cuneiform symbols stamped in a Mesopotamian clay tablet. Like these priceless antiquities, the inscribed keystone holds a story of Irish artistry that has outlasted paper and ink. Told on stone, it will outlast us all.

Irish Families

FLOWERS OF THE FAIREST: THREE DAUGHTERS

Bring flowers of the fairest
Bring blossoms of the rarest
From garden and woodside
And hillside and dale.

Elenora Hurley

While the Blue Ridge Tunnel was slowly coming to life between 1850 and 1860, the people who begat it carried on with their own sorrows and joys—all within the shadow of the passage. The Hurley clan, possibly from Clonakilty in County Cork, is a typical example.

The Hurleys arrived at the Blue Ridge Railroad in the early 1850s and lived in shanties at the Blue Ridge Tunnel during the construction decade. Seven Hurley men labored steadily in the tunnel as floorers, headers, carpenters and crew bosses through the early months of 1857. When work slowed, some moved west to adjoining Alleghany County, while Michael, a header, stuck it out at the tunnel.

At least two Hurley children were born at the Blue Ridge Tunnel, and several Hurley marriages took place there. Tragically, Michael Hurley was killed by a blast of blowing rock in an 1858 explosion. He left behind his

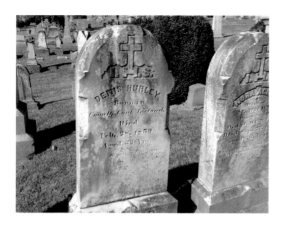

"Denis Hurley Born in County Cork, Ireland Died Feb. 28. 1859." *Author's collection.*

wife, Hannah, and their three-year-old child. (Hannah remarried three years later.)

By 1859, six different Hurley families, including Denis, Julia and their four daughters, had left the shanties and were living elsewhere in Augusta County. Denis may have worked for the Virginia Central Railroad as it proceeded west. The nature of his job is unknown; he died in February 1859.

Denis's death left his wife and daughters to fend for themselves. To support her children, Julia ran a boardinghouse. Her older daughters would have helped with the tiresome chores of cleaning, washing, cooking and serving meals to the five Irish laborers who lived in the house.

Julia's middle daughter, Elenora, was fourteen in 1868. By then, the girl had already lived through the loss of her father and the frightening chaos of the Civil War, including the Battle of the Piedmont in Augusta County. A May Day procession at Saint Francis of Assisi Church in Staunton, Virginia, that year must have been a cheerful change for her.

The Staunton *Spectator* reported the event:

> *Both Protestants and Catholics crowded the church grounds for the ceremony. Prof. A.J. Turner composed the music. Miss Mary Nelligan was selected queen, and surrounded by a court. She led the procession into church, where she crowned a statue of the Virgin Mary. The pastor explained to the congregation that "the ceremony of crowning the statue was not, as some suppose, a superstitious act, but only the carrying out of a simple instinct of the heart, in thus paying a tribute of respect and affection for one who occupied so intimate a relation to the God-Man." Religious services followed.*

We can almost see Elenora that Sunday in May. Older and perhaps taller than the younger girls in the procession, she's at the back of the line as it winds through the yard and around to the front of the church. She wears a twisted wreath of blossoms on her head. A phalanx of Hurley relatives casts loving smiles her way. After entering the church, the girls begin singing a traditional Catholic May Day hymn such as "Bring Flowers of the Fairest." Let us pause and share one of Elenora's last childhood moments with her. It will not last for long.

By 1870, sixteen-year-old Elenora was working as a domestic servant in Staunton. Sometime in her early adult years, she married Michael H. Cox, an Irish widower with a small son for whom she cared as if he were her own. The little family lived in Julia's boardinghouse; Eleanor would have helped her mother run the business.

We can only hope that Elenora was content during her brief marriage. She died in 1882 and was buried with deceased members of the Cox family in Thornrose Cemetery. Her grieving mother chose a gravestone that matched the one for her husband, Denis Hurley:

Nora Agnes
Wife of M.H. Cox
Daughter of D. & J. Hurley
Died Sep. 27. 1882.
Aged 26 years
A devoted wife & mother
and affectionate daughter & sister

Mary Nelligan Scherer

Twenty-six girls in all participated in the 1868 May Day ceremony. Students at Saint Francis Female Academy, they were taught by the Sisters of Charity. No doubt, it was one of these nuns who selected eighteen-year-old Mary Nelligan to be Queen of the Court. Mary probably carried a wreath of roses, the traditional flower for a May Day crowning. Let's watch the scene inside Saint Francis. While Mary places the crown on the head of a statue of Mary, her parents, David and Bridget, look on from a pew. Her siblings—Margaret, Patrick, Ellen and David—are probably sitting next to them.

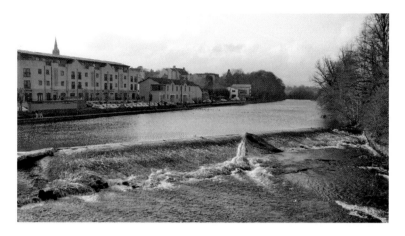

The Fermoy Weir, about four miles southeast of Ballyquane. *From Wikimedia Commons.*

The Nelligan parents are from Ballyquane, Ireland, a tiny townland in east County Cork. Less than five miles from the village of Fermoy, Ballyquane was devastated by the Great Hunger twenty years earlier. The Fermoy workhouse was built to house eight hundred people. Used as a last resort by dying victims of starvation and disease during the famine, it held 2,294 people in 1847.

"A pestilential fever is now raging through the house," wrote a witness, "every room of which is so crowded as to render it impossible to separate the sick from the healthy…By reason of this overcrowding of the house, the supply of bedding is so short as to render it necessary to place 4 or 5 in many of the beds, & on this day 30 children laboring under disease were found in 3 beds."

Rather than die in the Fermoy workhouse, the Nelligans fled Ballyquane and immigrated to America. A blacksmith by trade, David worked at the west portal of the Blue Ridge Tunnel until March 1857. Now, in 1868, he is still a blacksmith, though his earnings are meager, and he owns no real estate. His sons will have to help him support the family. In two years, David, at age ten, will be a laborer, and sixteen-year-old Patrick will learn blacksmithing by his father's side.

Magdalen Scherer, the daughter of immigrants from Baden, Germany, is also part of the May Day court. Her brother, a young man named Joseph, may be sitting in a pew with their parents. Perhaps this is the day that Joseph gives Mary Nelligan a second look. About five years later, he and Mary will marry—a melding of two European cultures united by the same religion.

The couple will have two daughters: Lena, born in 1874, and Mary, a child in the womb when her father died at the age of twenty-one in 1875.

To support her family, the widowed Mary and her daughters lived with her parents. She worked as a dressmaker. Home sewing machines weren't available yet; Mary Nelligan Scherer sewed thousands of stitches for each dress by hand. Like their townland in Ireland, the Nelligan family never fully recovered from the economic effects of the Great Hunger.

Mary's mother, Bridget, died of tuberculosis in 1881. Her father died of the same cause in 1889. Both were buried at Thornrose Cemetery in Staunton, Virginia. Perhaps Mary Nelligan Scherer, the eldest of their children still living in the house, chose the words that mark their gravestone:

OUR FATHER AND
MOTHER
May they rest in peace.

Maggie O'Donnell

Maggie O'Donnell was seven years old when she participated in the May Day procession. At that age, children in the Catholic Church receive the sacrament of First Communion. Traditionally the girls wear white dresses, and the boys wear suits that are often white. The group ceremony usually occurs during Mass on a Sunday in spring. Most likely, Maggie had already received her First Communion and was wearing her white dress for the May Day ceremony.

Maggie's mother, Jane Mateer O'Donnell from County Antrim in Ireland, would have felt deeply proud as she watched her youngest child walk in the procession, but it would have been a bittersweet occasion, too. Maggie was born in 1861—the same year her father died from wounds received in the Civil War at the First Battle of Bull Run at Manassas, Virginia.

Church and civil marriage records show that Jane married Patrick O'Donnell in 1850—the first year of construction of the Blue Ridge Railroad. Patrick was a blacksmith for the project. Though his name doesn't appear on any Blue Ridge Tunnel payroll, he probably worked elsewhere along the line, or perhaps a local merchant who provided services to the Blue Ridge Tunnel contractors hired and paid him for his work.

Patrick must have been sorely missed at the May Day procession, but Maggie's remaining family would have been present. Her grandmother, Jane Mateer, was probably beaming from the sidelines while her grandchild proceeded toward the church in the pretty white dress. The little girl's uncle,

William Mateer, and aunt, Ellen Mateer Quinlan, would have been watching, too, along with three siblings.

Finally, John O'Donnell might have been with the family at the May Day ceremony. John, five feet, six inches tall with brown eyes and dark hair, was working for the Virginia Central Railroad in 1852. He was granted citizenship in 1856, which means he had been in the United States for at least five years, or since 1851—around the time that Patrick O'Donnell would have earned enough money on the railroad to send passage money to him. Like Patrick, his kinsman, John O'Donnell fought for the Confederacy in the American Civil War.

Whoever was present in the O'Donnell family that Sunday in May 1868, the newspaper's benign coverage of the event was a precursor of things to come, as Irish Catholic immigrants blended into American society while maintaining the religion of their homeland. Elenora, Mary and Maggie show us how this

SOME IRISH TUNNEL WORKER FAMILIES WHO SETTLED IN STAUNTON

Callaghan
Cribben
Croghan
Crowe
Dineen
Fallon
Hounihan
Hurley
Kelly
Kennedy
Mateer
McCarthy
Moran
Murphy
Nelligan
O'Brien
O'Connor
O'Donnell
Sullivan
Tobin
Waters
Wright

From the "Virginia Blue Ridge Railroad Datasets," Mary E. Lyons, 2009–13.

played out for the daughters of Blue Ridge Tunnel laborers. American-born, they grew up during the anguish of the Civil War—a common denominator that softened anti-Catholic and anti-immigrant sentiment in the defeated South.

Protestant residents of Staunton well knew that John O'Donnell had fought for their cause, while Patrick O'Donnell gave his life, leaving little

Maggie a fatherless child. The sacrifice of Irish Catholic families could not be ignored. In 1857, a Staunton newspaper editor wrote that Irish men at the Blue Ridge Tunnel were "utterly ignorant." By 1868, such rhetoric was winding down in the city. It was a positive sign that Protestants at the May Day celebration were willing to hear the pastor allay their anxieties about the supposed Catholic worship of icons.

Yet even as the girls were fitting in as Irish Catholics, they were fenced in by gender. Though educated at the Saint Francis Female Academy, their employment choices were minimal. A post–Civil War first-generation Irish daughter in Staunton could be a servant, take in washing or marry. If widowed, she could operate a boardinghouse or work as a seamstress. With a needle or pot in one hand and a toddler in the other, these young women ran their households while caring for worn-out, aging parents who had survived a disaster of enormous proportion.

Daughters such as Eleanor, Mary and Maggie were a cultural and economic bridge between Ireland and America. Their meager earnings created a way station on the long and difficult pilgrimage their families had begun in search of economic security. The journey took a new path when their grown children established businesses in Staunton, became teachers or clerks and purchased their own homes—in other words, achieved a modest version of the American Dream.

TWO COUSINS, TWO CONTINENTS

Originally published in Rosscarbery Past and Present *14, Rosscarbery, County Cork, Rosscarbery and District History Society, 2012.*

It is Thursday morning, January 21, 1830. Cornelius and Bridget Shanahan are scurrying through the winter weather with their newborn son, Denis Shanahan. Their destination is the Catholic Church chapel at the head of Ross Harbor. Located in the coastal town of Rosscarbery, County Cork, Ireland, the chapel is plain on the outside, though a commentator of the time writes that the interior is "chaste and complete."

William Shanahan, known as Uncle Billy, is the male sponsor, or godfather, for Denis's baptism. No doubt a relative, he lives in Curraheen, a townland one-third of a mile south of Rosscarbery. He and Jeremiah Shanahan Sr., also from Curraheen and very likely another relative, rent adjacent fields owned by Lord and Lady Carbery of the Freke family.

As the priest trickles holy water over little Denis's forehead, he intones Latin words that welcome the child to the Catholic community: *Ego te baptizo in nomine Patris, et Filii, et Spiritu Sanctus* ("I baptize thee in the name of the Father, the Son and the Holy Spirit").

Eighty-three years later, three priests concelebrated a Requiem High Mass for Denis Shanahan at Saint Francis of Assisi Catholic Church in Staunton, Virginia. While candles sputtered and the sharp scent of incense wafted through the church, a choir sang the Latin words of a bleak medieval poem: *Dies erae, dies illa, solvet saeclum infavilla* ("Day of wrath and doom impending").

The Latin phrases that ushered Denis Shanahan in and out of his earthly days represent more than his religious faith. Spoken on two continents over a span of eight decades, they encircled a life forever changed by the Great Hunger and emigration. They also symbolize the Shanahans who remained in Curraheen—farmers who attended Sunday Mass at the Catholic chapel and baptized their children there.

William and Jeremiah Shanahan were middle-class farmers by the standards of the day. William worked seven acres, while Jeremiah grew his crops on nine. Their required tithes to the Church of Ireland financed expansion of the local cathedral in 1830, but apparently Cornelius Shanahan paid no agricultural tithes. He was a shipbuilder, as was his father before him and his father-in-law, Thomas Dempsey.

Cornelius and Bridget had two more children in short order. Mary was born in 1832. (Ellen Shanahan, sister of Jeremiah and William, was her godmother.) Michael, the youngest of the family, arrived in 1835. Denis, Mary and Michael probably attended the National School near the Catholic chapel. In summer, they may have spent their playtime at the inner harbor, climbing twelve-foot-high sand ridges and catching silver eels. Market fairs held in August, September and December would have been a treat.

Exactly where Cornelius and Bridget lived with their family in Rosscarbery is unknown, but the town was home to 1,522 souls by the time Denis was seven years old. One of the 252 dwellings that stood on four small streets that radiated from the town square may have housed the shipbuilder and his wife and children.

Establishing family relationships in mid-nineteenth-century Ireland can be difficult. If William and Jeremiah Sr. were Denis's relatives, then Jeremiah's son, born in 1840, was also related to Denis. Named Jeremiah, the child was five years old when the Great Hunger began in 1845 and twelve when the worst was over in 1852. Denis was fifteen when it began and old enough to carry emotional scars from it for the rest of his life. He later

said that the suffering he had witnessed or heard about in those awful days threw a shadow over his entire life.

The Great Hunger sent the two boys down very different roads. One remained in Ireland and carried on the family tradition of farming the hilly, arable fields of Curraheen. The other chose a path that led him across the ocean and through six southern states and one midwestern state in America.

We can only imagine from historical accounts of the Great Hunger what horrors Denis might have seen during those years. But we can be certain that during Sunday sermons, he heard the priest condemn Mrs. Townsend, wife of the Church of Ireland minister. At Derry House, their residence, she performed a strange ministry amounting to religious extortion. An English minister who visited the Townsends in 1847 wrote the following:

> *A company of poor were standing outside the gate in quiet order. Within, at two or three yards distance, [was] a venerable lady of the family with a large basket in her right hand and a volume in her left, from which she was impressively reading to the little congregation. It was the Book of God, the New Testament. Her daily custom was first to dispense in this manner a portion of the bread of life to those who were accustomed to a famine of the words of the Lord and then bestow upon them some of the bread that perisheth.*

Rosscarbery is located midway between Skibbereen and Clonakilty—two West Cork towns devastated by the Great Hunger. Anxious to leave this hunger war zone and the heartless bribery practiced by people like Mrs. Townsend, Denis tried to convince his father that the family should immigrate to America. Gifted with mathematical skills he would later use at the Virginia Blue Ridge Tunnel, he knew he could secure a job with the government in England or Ireland. But he had already developed a lifelong disgust for the English and their part in the famine. To America he and the family must go.

We can never know how Cornelius Shanahan felt about leaving his homeland. He died at the young age of forty-five in 1848. The famine, with its infectious partners of cholera and fever, was a great equalizer. It killed laborers who tilled small patches of land, so-called strong farmers with substantial acreage and skilled artisans such as Cornelius. However he died, widows abounded in Rosscarbery during the Great Hunger. Bridget Shanahan was among them.

Denis Shanahan and his mother made a momentous decision soon after Cornelius's death. Sometime in the fall of 1848, they traveled to Cork Harbor, where stormy weather delayed their passage for six weeks. Finally,

Passenger list for the *General Scott*, with the Shanahans on lines six, seven, eight and nine. Apparently the ship sailed to New York first and then to Maryland. *Author's collection.*

the captain of a small, two-masted brig called the *General Scott* declared that the seas were safe enough for departure, and the Shanahans were on their way across the Atlantic.

Denis worked as a ship carpenter on the journey. Shipbuilding skills he would have picked up from his father served him in good stead now. His pay could offset the cost of four ship tickets, and as a crew member, he could secure sleeping quarters above deck for his family rather than the miserable steerage below.

The *General Scott* landed in Baltimore, Maryland, on February 5, 1849. The Shanahans remained in the city for a time. All would have spoken both English and Irish, and all surely found comfort in an urban area populated by thousands of Irish immigrants who shared a common language and religion.

Mary, seventeen when she arrived, eventually married William O'Callaghan at St. Patrick's Church in Baltimore, while nineteen-year-old Denis soon found work on the Baltimore and Ohio Railroad in nearby Sykesville, Maryland. It's likely that young Michael went along with his older brother; railroad companies routinely hired boys well under the age of sixteen in those days.

Denis's first railroad job was with Irish contractor John Kelly, who hired him as a bookkeeper. The position didn't last long. In December 1850, Kelly agreed to build the Greenwood and Brooksville Tunnels in Albemarle County, Virginia,

for the state-owned Blue Ridge Railroad. Two months later, Kelly agreed to construct a third, spectacular passage: the Virginia Blue Ridge Tunnel.

Denis and Michael Shanahan, along with other men who had worked for John Kelly on the B&O, moved to the Blue Ridge Mountains of Central Virginia in 1850. Denis's first job for the Blue Ridge Railroad is not known, but it's logical that he would have kept Kelly's books again.

By September 1850, Denis and Michael were living in an Albemarle County barracks that housed ninety-four Irish railroad workers and an Irish family of five. It was census time. The enumerator, overwhelmed by the unfamiliar Irish surnames, erroneously wrote "Denis Ahanahan" and "Michael Ahanahan" on his form. (Griffith's Valuation, an Irish census substitute for the 1850s, lists no one by the name of Ahanahan in all of Ireland.) And, as was quite common for the census back then, the enumerator miscalculated Denis's birth year by ten years.

Extant payrolls for the Blue Ridge Tunnel begin in April 1852, two years after work began on the structure. They show that Michael worked as a floorer on the west side of the Blue Ridge Tunnel in 1852. But his presence in the house of ninety-nine Irish in 1850 indicates that he may have labored in the tunnel or one of its sister passages from the start.

A floorer's task was clearing rock debris from the tunnel floor after a blast. It was hard, manual labor, twelve hours a day, six days a week, for an average of one dollar a day. Michael once tried his hand at blacksmithing. By choice or command, he returned to flooring the next month. The grueling job caught up with him eventually. After years of breathing rock dust in the confined space of the tunnel, he disappeared from the payroll in 1855.

Exposure to high levels of silica released from rock blasting causes accelerated silicosis. The progressive disease increases the risk for tuberculosis, or consumption, as doctors called it back then. Accelerated silicosis can develop within five years after exposure. This matches the probable time—1850 to 1855—that young Michael worked in a tunnel. His death from consumption in 1863 strongly suggests that he suffered from silicosis, making him one of hundreds of Irish on the Blue Ridge Railroad whose expendable lives increased trade and prosperity for the citizens of Virginia.

Meanwhile, death and disease continued back in Rosscarbery. A mere fourteen families—all tenants on Lady Carbery's land—were living in Curraheen in 1852, the last brutal year of the Great Hunger.

William and Jeremiah Shanahan Sr. were spared. That year, William paid a mandatory tithe of six pounds and twelve shillings to the Church of Ireland. The money permitted him the use of a house, outbuildings and

seven acres. Jeremiah Sr. was charged nine pounds for his house and nine acres—holdings he would later pass on to his son and namesake, Jeremiah Jr.

While the Shanahans were maintaining their status as middle-class farmers in Curraheen, Denis's mathematical talent was becoming apparent to contractor John Kelly in Virginia. Though only one-quarter of the length of the almost one-mile-long Blue Ridge Tunnel, the Brooksville Tunnel proved to be the most dangerous for Irish workers on the Blue Ridge Railroad.

Rock at the east portal of Brooksville Tunnel was hard enough to stand without the support of an arch. Rock at the west portal was so friable that a huge earth slide and cavity developed in 1855. Daylight could be seen 140 feet above the tunnel floor. "We can hear the rocks falling from an unknown height upon the timbers under which the men are at work," wrote chief engineer Claudius Crozet, "with a rumbling noise resembling that of distant thunder."

John Kelly was impressed by twenty-five-year-old Denis's ideas for solving the construction crisis at the Brooksville Tunnel. After it was completed, Claudius Crozet urged Denis to turn his attention to the mammoth Blue Ridge Tunnel, still under construction a few miles west of Brooksville. And so began Denis Shanahan's career as a civil engineer.

The year 1856 was a turning point for Denis. First, he married a young Irish American woman named Annie Marie Lyons Larguey. Fatherhood soon followed. Denis and Ann named the child Cornelius, adhering to the somewhat typical Irish custom of naming a firstborn son after the father's father.

Then, Irish workers bored through the Blue Ridge Tunnel on December 29, 1856. Though more blasting with volatile black gunpowder was required to complete the passage—and more Irish men were blown up while doing it—Denis's skills were no longer needed. With two years of engineering experience under his belt, he moved to the mountains of north Georgia in 1857 to work on yet another project called the Blue Ridge Tunnel.

When government funding for the Georgia tunnel ran out, Denis returned to Virginia. He ended up in Covington, where railroad construction was advancing west in the state's huge push to reach the Ohio River and exploit the trade potential of the Mississippi River Basin.

Denis's work on the Mud Tunnel near Covington was interrupted by the onset of the American Civil War in 1861. He owned no slaves in 1860 or at any other time as far as we know, but his loyalty to the region he now called home must have been deep, indeed. He joined the Confederate army, serving as a quartermaster and building fortifications at Williamsburg, Virginia.

After the war, Denis returned to more engineering work in Covington, North Carolina, Ohio and Kentucky. His last move was back to Covington. While Denis and Annie were producing nine children during these years, his kinfolk in Curraheen—Jeremiah Jr. and his wife, Julia O'Callahan Shanahan—were producing eleven offspring. It is unknown if Denis ever returned to Rosscarbery to visit his relatives, if the Curraheen and Virginia Shanahans corresponded over the decades or if the Great Hunger severed their familial ties forever.

Still, the two Shanahan lines preserved their mutual ancestry in various ways. Both Denis and Jeremiah continued a lineage of family first names. The Virginia Shanahans named their children Denis, Cornelius, Mary, Michael and William through at least two generations. The Curraheen Shanahans passed on the names of Denis and Michael. Denis remains a favored name in both families to this day, handed down as if it were an heirloom.

Engineer Denis Shanahan and farmer Jeremiah Shanahan Jr. both prospered within the context of their time and place. The 1901 and 1911 Irish censuses show Jeremiah and his family living in Curraheen in a six-room house with a slate, tile or iron roof; six windows across the front; and four outbuildings for horses, cows, pigs and chickens. This was Class 2 housing, exceeded only by Class 1 mansions. Denis Shanahan's modest Greek Revival house in Covington was solidly middle class. It featured two stories, two chimneys, four windows across the front and covered porches on the first and second floors.

As the fathers went, so went the sons. Cornelius, Denis's firstborn, worked as a railroad contractor. John J. became a civil engineer in West Virginia. In Curraheen, Jeremiah's son Denis took over his father's acreage.

After decades of protest and reform, Irish tenants were finally allowed to purchase their land from landlords beginning in 1903; 75 percent succeeded by 1914. The Shanahans of Curraheen were among them; Guy's Postal Directory of 1914 listed young Denis as a "landholder." After Denis married and moved out of the ancestral home, the holdings went to his brother Peter Shanahan and then to Peter's son.

Both the elder Denis in America and his kinsman Jeremiah in Ireland retained their Catholic religion and survived well into old age. Regrettably, Denis didn't pass on the language of his ancestors to his children. Neither did Jeremiah. Only Jeremiah's daughter Julia spoke Irish.

One last piece of data provides a moving finish to this dual family history. On May 27, 1921, two of Jeremiah's grown children arrived at Ellis Island, New York. What happened to twenty-one-year-old Michael and twenty-six-year-old Nellie Shanahan after they stepped off the ship with wobbly sea legs

THE SHANAHAN FAMILIES

- Cornelius Shanahan + Bridget Dempsey
 Denis Shanahan + Annie Lyons Larguey
 Denis A., Mary, Ignatius, Denis F., Michael,
 William and John J.
 Mary Shanahan + William O'Callaghan
 Michael Shanahan
- Jeremiah Shanahan + Johanna O'Mahoney
 Jeremiah Shanahan + Julia O'Callaghan
 Denis, Hannah, Peter, Mary, Julia, Kate,
 Ellen (Nellie), Jeremiah, Michael, Margaret
 and John
- Other Shanahans in Rosscarbery, 1852:
 William, Andrew, Mary, Ellen, John

is lost to us now. Let's hope that a Shanahan relative was waiting to greet the brother and sister and that housing and employment had been arranged for them.

Michael and Nellie became two invisible threads in the vast fabric of America—a country with mountains pierced by tunnels that Irish immigrants such as the Shanahans built and died for in the nineteenth century.

Note: The famed Irish Republican hero, Jeremiah O'Donovan Rossa, was born in Rosscarbery in 1831. Since Rossa was just one year younger than Denis Shanahan, the two boys must have attended the same school and may have been related. As Rossa stated in his memoir, *Rossa's Recollections*, "Jerrie Shanahan is my second cousin, and my godfather."

Was this the same Jeremiah Shanahan Sr. of Curraheen who was related to engineer Denis Shanahan? The connection is surely there, though I have found no absolute proof. The lack of evidence hardly matters. Jeremiah O'Donovan and Denis and Jeremiah Shanahan were sons of Ross and sons of Ireland. Each had a resilient spirit that flourished, whatever they chose as their life's work and wherever they lived.

Epilogue

C ompletion of the Blue Ridge Tunnel was a significant moment in America's relentless march to link east and west. But until recently, the men and boys who built it have been forgotten.

A plan to open a rail-to-trail hiking path through the Blue Ridge Tunnel is in the works and may instill the laborers in the public memory. Yet some Irish Americans wonder what the men who died in the tunnel would say about the trail if they could speak for themselves. Would they say their place of violent death was hallowed ground that should be left in peace? Or would they be proud that Americans could see the magnificent work that cost them their lives?

Almost everyone who visits the tunnel claims they can feel the presence of the workers who built it. You can experience the same thing. Simply close your eyes and let yourself travel seven hundred feet under the mountaintop.

Your oil lamp burns high. Then it sputters and barely lights the gloom ahead. Fearsome noises echo off the low ceiling. Swirls of smoke drift around you like grieving ghosts.

Taste the bitter fumes of blasted gunpowder in your mouth. Listen to the shouts of panicked Irishmen as pieces of the tunnel ceiling come crashing down. Picture African American blacksmiths as they pound red-hot metal or the muscled backs of men heaving lengths of rail in place.

Almost two hundred people died during the construction of the Blue Ridge Railroad, including twelve men who were blown up in the Blue Ridge Tunnel—about one for every four hundred feet. To feel their presence, all you need is imagination and, most of all, memory.

Appendix I

Deaths Along the Blue Ridge Railroad
1850–60

1. William Ahern, 35
2. Cath Ambrose, 32
3. Mick Barratt, 23
4. Richard Barrett, 36
5. John Barry, 35
6. Mrs. Mary Barry, 35
7. Richard Barry, 30
8. John Bowen, 25
9. James Bowler, 56
10. Mrs. Burks, age unknown
11. Patrick Burns, 12
12. Don Calden, age unknown
13. Rosella Carroll, infant
14. Daniel Collins, 39
15. John Collins, 35
16. Julia Collins, 22
17. Julia Collins, 36
18. Mary A. Collins, 2
19. Michael Collins, 35
20. Richard Collins, 53
21. Michael Connel, 27
22. Thomas Connell, 30
23. Dan Conovan, 54
24. John Cotterin, 28
25. Roseanna Crickard, 2
26. Catharine Crowley, 30
27. Mrs. Crowley, age unknown
28. Patrick Crowley, 25
29. Dennis Dacey, 30
30. Ellen Daily, age unknown
31. Deasy, age unknown
32. John Delaney, 50
33. John Delay, 56
34. John DeSea, 56
35. Francis Devine, 36
36. Thomas Devine, age unknown
37. Dillon daughter, 8
38. Johanna Dillon, age unknown
39. Peter Dillon, 33
40. Mrs. Donivan, age unknown
41. Daniel Donnovan, 35
42. Johanna Donovan, 10
43. Mary Donovan, 35
44. Dennis Doray, age unknown
45. Hugh Doughtery, 71
46. James Dowler, 50
47. Old Downey, age unknown
48. Downey's son, age unknown
49. Downey's wife, age unknown
50. John Driscol, infant
51. Mary Driscol, 50
52. Morgan Driscol, 36
53. Mrs. Duvall, age unknown
54. Michael Fallon, 24
55. Peter Fife, age unknown
56. Simon Fitzgerald, 30
57. Joseph Fitzpatrick, 28
58. John Foley, infant
59. Michael Gary, age unknown
60. Andrew Griffin, 21
61. Morris Griffin, 24
62. Payton Hagan, age unknown
63. James Hagarty, 44
64. Joseph Hagarty, 10
65. Peter Hagarty, 2
66. James Hagerty, 10
67. Joseph Haggerty, 63
68. Hamilton child, age unknown
69. Mrs. Jeremiah Hamilton, age unknown
70. Jeremiah Hannon, 60
71. Patrick Harnett, age unknown
72. Daniel Harrington, 43
73. Michael Harrington, 30
74. Catharine Hayes, 1
75. Edward Hayes, 39
76. Patrick Hayes, 36

77. Hannah Hays, infant
78. Patrick Hays, age unknown
79. William Hilhouse, 70
80. Cain Holland, 20
81. Mrs. Holleran, age unknown
82. Patrick Holleran, 2
83. John Honofan, 32
84. Mary Hoolern, 26
85. Dan Hurley, 36
86. Dennis Hurley, 33
87. Michael Hurley, 32
88. Unidentified Irish child
89. Unidentified Irish man
90. Jerry, age unknown, enslaved
91. Johnny, 10, enslaved
92. Daniel Kalalan, 16
93. Dan Keefe, 20
94. James Keefe, age unknown
95. Johanna Keefe, 1
96. Michael Kelly, 1
97. Ann Kennedy, 10
98. Patrick Kilhar, 67
99. Peter Kirwin, 27
100. Denis Lacey, 20
101. Patrick Larguey, age unkown
102. James Larguey, child
103. Margaret Lawler, 20
104. Thomas Lawler, 27
105. Redmond Levin, infant
106. Dan Lynch, 27
107. Catherine Mahaney, 80
108. Daniel Mahaney, 27
109. Thomas Mahaney, 20
110. John Mahoney, 38
111. Thomas Mahoney, 67
112. Martin Maligan, age unknown
113. James Malone, age unknown
114. John Mangle, infant

115. Joseph Marrow, age unknown
116. Franklin McCarthy, 9
117. McCarthy child
118. McCarthy infant
119. James McCarthy, 8
120. John McCarthy, 24
121. John McCarthy, 23
122. Barry McCarty, 20
123. James McCarty, 24
124. John McCarty, age unknown
125. John McCarty, 56
126. Michael McCarty, age unknown
127. Mrs. McCarty, age unknown
128. Michael McDemarrow, child
129. Alexander McKenna, 19
130. James McKenna, 22
131. Patrick McNallis, 44
132. Don Mohana, age unknown
133. Mrs. Mohany, age unknown
134. Joseph Moriarity, 30
135. William Mullen, age unknown
136. Johanna Murphy, 23
137. John Nonan, 20
138. Bridget Nunan, 4
139. O'Brian child
140. William O'Brian, age unknown
141. William O'Brien, 58
142. James O'Brien, 30
143. Dan O'Conner, 55
144. Joseph O'Brien, 30
145. O'Briant child
146. Mrs. O'Briant, age unknown
147. William O'Brien, 26
148. O'Connor child
149. Dennis O'Connor, 40
150. Kitty Powers, 26
151. Eugene Quinn, 1
152. Mary Quinn, age unknown

153. John Radford, 15
154. Ragan child
155. Johanna Reardon, age unknown
156. Tim Regan, 20
157. John Roach, 2 months
158. Rogan child
159. William Rotche, 35
160. John Ryan, 79
161. Owen Ryan, 22
162. Tim Sheay, 36
163. Mary Sheridan, 28
164. Baby Sullivan, 2
165. Baby Sullivan, 3
166. Cornelius Sullivan, 43
167. Cornelius Sullivan, 21
168. Cornelius Sullivan, 40
169. Dan Sullivan, 24
170. Dan Sullivan, 30
171. Dan Sullivan, 40
172. Dan Sullivan, 22
173. Dennis Sullivan Jr., age unknown
174. Elizabeth Sullivan, age unknown
175. James Sullivan, 22
176. Mary Sullivan, 10
177. Patrick Sullivan, 8
178. Timothy Sullivan, 5
179. Sullivan child
180. William Sullivan, 50
181. Thomas, age unknown, enslaved
182. Michael Vance, age unknown
183. Edmond Wallace, 34
184. Edward Wallace, 40
185. James Wallace, 4
186. Edward Walsh, 20
187. Alexander Watson, 32
188. William, 26, enslaved
189. Garrett Wright, 55

Appendix II

Where Did They Come From?

Hundreds of Irish families lived and worked along the Blue Ridge
Railroad–Virginia Central Railroad project. The civil parish or
townland of origin in Ireland is known for the following eighty. Like other
Irish immigrants, they were on—as Jeremiah O'Donovan Rossa wrote in
Rossa's Recollections—"a tramp through the world."

JOHN ABBET was from the townland of Butlerstown in the civil parish of
Kilburne, County Waterford. In 1855, he was working on the Greenwood
Tunnel, the easternmost of four tunnels built for the Blue Ridge Railroad
between 1850 and 1860.

On December 1, 1855, John posted an ad in the *Boston Pilot* newspaper for his
brother-in-law, PIERCE KELLY, who arrived in America in 1852 and first settled in
New Haven, Connecticut. John Abbet's contact person at Greenwood was John
Kelly, the Irishman who was contractor for three of the four tunnels.

THREE AMBROSE BROTHERS—Michael, Thomas and John—were from the
townland of Cannawee in the civil parish of Kilmoe, County Cork. James
and Patrick may have been brothers or cousins. Catherine might have been
their sister and Pate their father.

Michael left Ireland in 1840. His first job was building the Doe Gully
Tunnel for the Baltimore and Ohio Railroad in western Maryland. His
brother John advertised in 1847 for his whereabouts from Cumberland,
Maryland—a B&O railroad construction site west of Doe Gully.

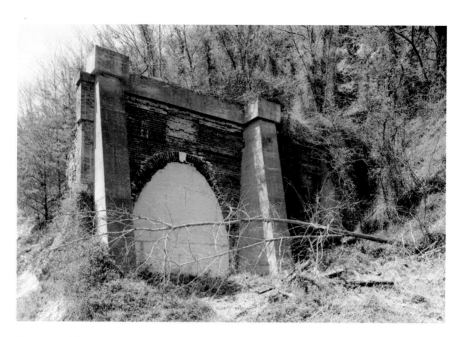

Greenwood Tunnel was closed in 1954. *Courtesy of Library of Congress.*

By 1850, Michael and Patrick were living in Albemarle County, Virginia, where the Virginia Central Railroad was building the easternmost section of the Blue Ridge Railroad project. Their dwelling was a barracks-like structure that housed ninety-nine Irish. Michael's wife, Johanna, lived in a nearby dwelling with six-year-old Thomas and four-year-old Margaret. Catherine (also C.M. or Cath) lived very near them with Pate. Meanwhile, John and James worked elsewhere in the county, probably as farm laborers.

A general store ledger book shows that John was working for the Virginia Central Railroad by 1852. The following year, Catherine Ambrose died of pneumonia and was buried at Thornrose Cemetery in Staunton, Virginia—the westernmost point of the Blue Ridge Railroad–Virginia Central Railroad partnership.

Patrick Ambrose worked as a header and a floorer in the Blue Ridge Tunnel for a few months in 1853 but may have switched to easier, safer work along the tracks. Both he and John declared their intention to become U.S. citizens that year. By 1860, Michael, Johanna, Thomas and Margaret were living in Alleghany County, Virginia, where the Virginia Central Railroad was continuing its push west to the Ohio River.

Denis Bolen, son of Cornelius Bolen, was born in Dublin around 1827. A stonemason, he lived in Augusta County, Virginia, in the 1850s and likely worked on the Blue Ridge Railroad–Virginia Central Railroad project. Denis declared his intention to become a U.S. citizen in 1852, indicating that he had been a resident in the country for at least three years. He obtained full citizenship in 1856.

In 1862, Denis married Bridget McCarthy, a member of the large McCarthy clan in Staunton that worked on the railroad construction. Denis died in 1864 and was buried at Thornrose Cemetery in Staunton. Now a widow on her own, Bridget became a retail liquor dealer in Staunton shortly after the American Civil War ended in 1865. By 1880, she was also running a boardinghouse. She died in 1895 and is buried at Thornrose.

John Bolster was from the townland of Emlagh in County Tipperary. He may have emigrated around 1848. His brother, Richard, arrived in April 1849.

After completing the required three years of residency in the United States, John declared his intention to become a U.S. citizen. The declaration was made in Staunton, Virginia—the westernmost point of the Blue Ridge Railroad–Virginia Central Railroad project—on December 22, 1851.

Richard's first work location after arrival was Virginia, indicating that he joined his brother at the Blue Ridge Railroad. He then moved on, and the brothers lost touch. Still in Staunton, John advertised in the *Boston Pilot* newspaper in April 1855 for the whereabouts of Richard.

John and Catherine Brennan were from Bantry in County Cork. Brother and sister, they left Ireland in 1846. Catherine married Michael Harrington, who was probably from the Berehaven Peninsula, sometime before 1850. That year, they were living in shanty housing near the west portal of the Blue Ridge Tunnel in Augusta County, Virginia. Michael and his brother-in-law, John Brennan, worked at the tunnel. John was a floorer; Michael was both a floorer and a header.

Catherine and Michael had two children during these years. In 1857, Catherine, by now pregnant again, moved to Iowa, but Michael disappeared from the public record around that time and may have died. The fate of John Brennan, Catherine's brother, is unknown.

Edward Burke was from the townland of Adare in County Limerick. His parents were Ellen and Edward Burke. Born around 1830, young Edward was living in Staunton, Virginia, in 1860, just after the Blue Ridge Railroad

was completed. That year, he worked as a drayman and boarded in a house with eighteen people, including Michael Burke, also a drayman. Many of the residents were Irish who had helped build the railroad and remained in the area.

By the end of the decade, Edward was in the livery business, and his personal estate was worth $4,000. His wife, Mary E. Burke, lived with him, along with two small children: Thomas W., three years old, and Mary, one year old. Apparently Edward's mother, Ellen, moved to Staunton during these years.

Edward was still keeping a livery stable in 1880. In August 1883, Ellen died. Her gravestone at Thornrose Cemetery in Staunton reads, "Our Mother." Edward died in March 1896 and was also buried at Thornrose Cemetery.

YOUNG PATRICK BURNS was from Tralee in County Kerry. He was only twelve years old when he died in Staunton, Virginia—the westernmost point of the Blue Ridge Railroad–Virginia Central Railroad project. Records at Thornrose Cemetery in Staunton state that flux was the cause of death. Child laborers were common along the Blue Ridge Railroad; Patrick may have been one of them.

Patrick's death record also states that his mother was Betsy Burns. Apparently she was deceased or living elsewhere when her son died. Patrick's gravestone at Thornrose is inscribed with the words, "OUR BROTHER PATRICK BURNS Native of Tralee County Kerry Ireland Died July 23 1855 Aged 12 years."

Patrick's siblings could not afford to purchase a burial plot for the boy. He was buried in a corporation lot, meaning that the incorporated City of Staunton donated the plot. The donor for the gravestone is unknown.

JOHN CASEY was from the townland of Castletown in County Cork. Probably a shanty resident at one of the portals of the Blue Ridge Tunnel, he worked as a floorer and header in the passage from October 1854 through August 1856. His sister, Mary, lived in Staunton, Virginia, at the westernmost end of the Blue Ridge Railroad project.

John's next location was Baltimore, Maryland, where he possibly worked for the Baltimore and Ohio Railroad. On April 18, 1864, as Civil War skirmishes and battles grew closer to Staunton, Mary Casey fled to Pennsylvania with a woman named MRS. MEADE. Mary's companion was probably Margaret Mead, an Irish woman living in Staunton. Writing from Ashland, Pennsylvania, Mary advertised for her brother's whereabouts in the *Boston Pilot* newspaper in July 1864.

MICHAEL CASEY was from the civil parish of Kildorrey in County Cork. He may have left from Liverpool in November 1852 on the ship *Western World*, arriving in New York City. He worked as a header and floorer at the Blue Ridge Tunnel from November 1853 until February 1855.

While living at the tunnel in April 1853, Michael advertised for his sister, Ellen. In June 1853, he went to the Augusta County, Virginia courthouse in Staunton and declared his intention to become a U.S. citizen.

MICHAEL CLEARY was from the townland of Stonehall in the civil parish of Clonloghan, County Clare. In 1850, he lived in a barracks-like dwelling that housed ninety-nine Irish in Albemarle County, Virginia—the easternmost point of the Blue Ridge Railroad–Virginia Central Railroad project.

In 1852, Michael was working on the railroad at or near Mechum's River in Albemarle. In February of that year, he advertised in the *Boston Pilot* newspaper for the whereabouts of his brother, Patrick.

DANIEL COLLINS was from the civil parish of Abbeyfeale in County Limerick. He may have emigrated with his brother, William, in 1850, leaving from Cork and arriving in Boston, Massachusetts, in February of that year.

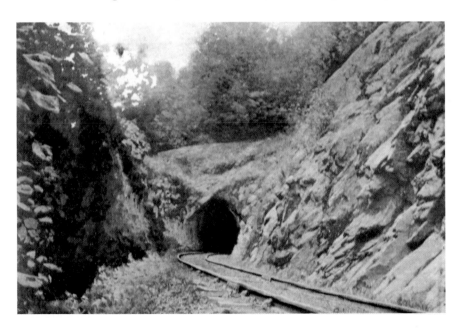

A rare photograph of Brooksville Tunnel, one of four that Irish workers built for the Blue Ridge Railroad. *Author's collection.*

By February 1851, Daniel was living near Brooksville, a hamlet in Albemarle County, Virginia. He was probably working on the Brooksville Tunnel, one of four built for the Blue Ridge Railroad–Virginia Central Railroad project between 1850 and 1860.

Daniel placed a want ad in the *Boston Pilot* newspaper for the whereabouts of William on February 22, 1851. One William Collins in the Blue Ridge Railroad area enlisted as a Confederate soldier in August 1861, shortly after the American Civil War began. He died of disease during the war. It is unknown if he was Daniel's brother.

JEREMIAH COLLINS was from the townland of Woodfield in the civil parish of Ross, Rosscarbery, County Cork. In 1850, he was living in Augusta County, Virginia, and probably worked for the Blue Ridge Railroad. In November 1851, his brother, Timothy, advertised for his whereabouts. Timothy was living in Springfield, Massachusetts, at the time.

JULIA COLLINS was from Berehaven. Though we don't know her maiden name, we know from her obituary that she came to America when she was an infant. Born around 1818, she died in 1851 of tuberculosis. She was the wife of Cornelius Collins, a stonemason who worked for the Blue Ridge Railroad. Their daughter, Mary, is buried with her. At least four Collins families from County Cork lived along the railroad between 1850 and 1860.

DANIEL AND DENNIS CONNEL were from the civil parish of Clonfert in the poor-law union of Kanturk, County Cork. Dennis left Ireland in February 1846 and arrived in New York City. We don't know if the brothers traveled together on the voyage.

In July 1852, Daniel was living in Staunton, Virginia, and likely laying tracks for the Blue Ridge Railroad project. That month, he advertised for his brother, Dennis, in the *Boston Pilot* newspaper. Dennis had also arrived in New York City in February 1846 and then moved to Wooster, Ohio.

JOHN CONNOR was from the townland of Clontaff in the civil parish of Myross, County Cork. He arrived in Boston in 1856. By July of that year, he was working as a floorer in the Blue Ridge Tunnel.

On January 1, 1859, his brother Michael advertised for his whereabouts in the *Boston Pilot* newspaper. Michael also posted an ad for their brother, Robert, on the same day.

Four brothers with the last name of CONNORS—William, Robert, John and Michael—were from the townland of Glantane in the civil parish of Kilshannig, County Cork. Glantane was about nine miles from the Dromach coal mine.

Michael Connors worked steadily as a floorer and header in the Blue Ridge Tunnel from 1852 until 1857. In 1853, his brother John advertised for him in the *Boston Pilot* newspaper. Michael must have seen the ad and written to John, who then joined him at the Blue Ridge Tunnel. John worked in the tunnel in 1856 and 1857.

The four brothers lost each other during the American Civil War years, 1861–65. In 1866, John was trying to find Michael and Robert. In 1867, Robert was trying to find William.

THE CROWLEY SIBLINGS—Ellen, Jeremiah and Patrick—were from the townland of Boherboy, now spelled Boherbue. Ellen may have been the first to leave Ireland. She emigrated in 1848 or 1849, arriving in Boston, Massachusetts.

Jeremiah probably left next. He ended up as a laborer at the Paw Paw Tunnel in Maryland in 1849, the Pape Tunnel in Virginia in 1851 and the Blue Ridge Tunnel between 1852 and 1857. In 1849 and 1852, he advertised for Ellen's whereabouts in the *Boston Pilot* newspaper.

Patrick Crowley worked steadily as a floorer and crew boss at the Blue Ridge Tunnel from 1852 to 1857. He then moved to Pekins, Nebraska. Jeremiah migrated to Buffalo, Virginia (now West Virginia), and was there in 1860. He lost track of Patrick and advertised for him in February of that year.

Meanwhile, Ellen, married by now to a man named MAHONEY, was looking for both brothers. Writing from Foxboro, Massachusetts, she advertised for their whereabouts in January 1857. Let's hope that this family eventually reunited.

PETER CRICKARD, son of Michael and Sarah Crickard, was from the townland of Downpatrick in County Down. He and his wife, Rose, were part of the tiny Irish Catholic community that lived in Staunton, Virginia, two decades before Great Hunger exiles arrived to build the Blue Ridge Railroad.

Already experienced with road building, Peter was a subcontractor for Section 7 of the Virginia Central Railroad west of Staunton. Called the Covington Extension, this construction occurred simultaneously with construction of the Blue Ridge Railroad.

Peter was one of the few native Irish in Staunton to hold slaves. In 1850, five unnamed African Americans between the ages of one and nineteen

were listed as his property. After his death in 1856, his wife or other heirs sold or freed them. No Crickards in Staunton held slaves in 1860.

James Crickard, also from Downpatrick, was Peter's brother and a master shoemaker in Staunton. He reported Peter's death and perhaps ordered the stone for his grave at Thornrose Cemetery in Staunton. It reads, "A hospitable, kind and open hearted Irishman."

James and his wife, Mary, lost their two-year-old daughter, Roseanna, when a cholera epidemic struck the Blue Ridge Tunnel and Staunton in July 1854. The child was not buried at Thornrose. She may be one of many cholera victims, including laborers at the Blue Ridge Tunnel, whose grave sites are unknown.

DANIEL AND THOMAS DALY were from Ballymartle in County Cork. Their first work site in America may have been in Cincinnati, Ohio. Daniel Daly worked steadily at the Blue Ridge Tunnel as a floorer from 1852 through 1857. Thomas Daly worked at the tunnel from 1852 until early 1853 and then probably left the area. In 1855, Daniel advertised for his whereabouts in the *Boston Pilot* newspaper. John and Tim Daly were stonecutters for the Blue Ridge Tunnel. It is not known if they were related to Daniel and Thomas Daly.

BRIAN, EDMOND, PATRICK AND WILLIAM DEE may have been from the parish of Gammondsfield (Kilsheelan) on the Waterford-Tipperary border. In 1852, they were all working on the Virginia Central Railroad in Albemarle County, Virginia—the easternmost section of the Blue Ridge Railroad project.

The Dee men would have built embankments, laid tracks or constructed depots along the proposed railroad route. Meanwhile, other Irish laborers and enslaved men were building the Blue Ridge Tunnel through the mountain at Rockfish Gap, a few miles west. The broad shoulders of the mountain would have been visible to the Dee men as they worked, reminding them of Slievenamon Mountain near home in Tipperary.

JOHANA DENAHEE (also Denaghy) was from the parish of Manister in County Limerick. The wife of Mathew Denaghy, she died in February 1861 and was buried in Thornrose Cemetery in Staunton, Virginia—the westernmost point of the Blue Ridge Railroad–Virginia Central Railroad project.

Her gravestone states that she was "buried by her children." Though no other records have been found for the Denahee family, they were obviously

part of the Irish community that formed in Staunton during construction of the Blue Ridge Railroad.

JOHN DONOVAN was from the townland of Templederry in north Tipperary. After emigrating, he worked first in Albemarle County, Virginia—the easternmost county in the three-county construction of the Blue Ridge Railroad.

His mother, Hannah, advertised for him in the newspaper in July 1855. She was living in Baltimore, Maryland, when she placed the ad. Baltimore was often the port of entry for Irish immigrants who worked on American railroads. Hannah's ad stated that her son was from Castleotway, implying that the Donovan family had been tenants on the Otway estate.

PATRICK DUGGAN was possibly from the townland of Grenagh in the poor-law union of Cork. He worked as a floorer and header in the Blue Ridge Tunnel from 1855 until March 1857.

While working at the tunnel in 1856, Patrick advertised for the whereabouts of his brother-in-law, DENNIS CALLAGHAN from Grenagh. Other Duggan men who labored in the tunnel were Charles, Daniel, John and Tim.

EDWARD (also Edmond) FAHEY was from the townland of Ballyhandle in the poor-law union of Bandon, County Cork. In February 1853, his father, B. Fahey, advertised for his whereabouts in the *Boston Pilot*. The ad stated that Augusta County was Edward's first location after arriving in the United States. Edward probably was working somewhere along the Blue Ridge Railroad project at the time of the advertisement. We know for certain that he was a floorer in the Blue Ridge Tunnel in July and August 1853.

THOMAS AND ANN HANLEY FALLON may have emigrated from the Strokestown area of County Roscommon. The couple settled in Staunton, Virginia, near the Blue Ridge Railroad–Virginia Central Railroad project, around 1851. Three of their sons, all born in Ireland, fought for the Confederacy in the American Civil War.

Thomas was killed at the Battle of Piedmont near Staunton. James, whose enlistment record stated that he was born in "Roscommon Co. Langford," was captured at the battle of Gettysburg and imprisoned at Fort Delaware in 1863. John was captured in 1864 and imprisoned at Camp Chase, Ohio. Both John and James were released at the end of the war and returned to Staunton. James died in 1866. John established a florist business that his eldest son, John, carried on.

Thomas, John and Patrick Flynn were from the townland of Ballyclough in the civil parish of Kilworth, about ten miles from the Lisnacon and Dromagh coal mines. Their parents were Maurice and Honoree Flynn. In early 1852, Thomas was working on tracks near the Brooksville Tunnel, a few miles east of the Blue Ridge Tunnel. In May of that year, he advertised for his brothers, Patrick and John, in the *Boston Pilot* newspaper. That same month, he began work as a header at the Blue Ridge Tunnel.

Thomas married widow Ellen Wallace at the tunnel in January 1854. He continued employment there until the cholera epidemic began in July. He then disappeared from the payroll and probably worked elsewhere along the Blue Ridge Railroad. Thomas was still living in the area when his brothers, John and Patrick, migrated south in 1856 to work as floorers in the tunnel. John Flynn endured the grueling, backbreaking labor for two months. Patrick stuck it out for four months.

Richard Fraley (also Frawley) was from the townland of Ennis in County Clare. In 1854, he was living in Staunton, Virginia. In November 1854, Richard advertised in the *Boston Pilot* newspaper for the whereabouts of Bridget, John, Martin and Thomas Frawley. Richard's contact was John B. Scherer, a German Catholic immigrant who was a member of Saint Francis of Assisi Church in Staunton.

No other records have been found for Richard. We can only hope that his family read and responded to the ad and that he joined them wherever they were.

Bridget Gannon was from the townland of Donoughmore, less than a mile from present-day Limerick City. She died in 1872 and was buried with two infants at Thornrose Cemetery in Staunton, Virginia. Her gravestone is inscribed with these mysterious words: "40 years old. The official husband James Gannon has erected this monument."

One James Gannon from Ireland was living in Staunton in 1850. A laborer, he probably laid tracks for the railroad. He was working as a gardener at the Deaf, Dumb and Blind Institution, as it was called, in 1870. A widower by 1880, he was still employed as a gardener. It is unknown if he was the "official husband" of Bridget Gannon.

Patrick Glynn was from Boghill townland in the civil parish of Kilfenora, County Clare. In 1851, he was working at Mechum's River in Albemarle County, Virginia—the easternmost county of the Blue Ridge Railroad—

Murty Hays. If so, they could be an example of chain migration, by which Irish workers who arrived first in America sent money back to relatives in Ireland for their passage to America.

TIMOTHY HEALY was from the townland of Cashel in St. John the Baptist Catholic Parish in County Tipperary. He may have arrived in New York City in 1848 with his sister, Margaret.

Timothy worked on the Blue Ridge Railroad project at the beginning of its construction in March 1850. That month, he was living near Brooksville in Albemarle County, Virginia. Construction of the Brooksville Tunnel and the much longer Blue Ridge Tunnel a few miles west had just gotten underway when he posted an advertisement for the whereabouts of Margaret in the *Boston Pilot* newspaper on March 9.

PATRICK HURBART was from the parish of Youghal, County Cork. His first location after arrival in America was Brooksville, a few miles east of the Blue Ridge Tunnel. He probably worked on the Brooksville Tunnel or laid connecting tracks nearby. In November 1852, his wife, Margaret, advertised for him in the *Boston Pilot*. She was living in Townshend, Vermont, at the time.

EDWARD JOYCE was from the civil parish of Youghal and Youghal townland in County Cork. In 1852, he was working sixteen miles west of the Blue Ridge Railroad–Virginia Central Railroad project in Buffalo Gap, Augusta County. Laying tracks for this "Covington Extension," as it was called, was concurrent with construction of the Blue Ridge Railroad–Virginia Central Railroad project as the railroad pushed west toward the Ohio River.

Edward advertised for the whereabouts of his brother-in-law, THOMAS GAIRY, in September 1852. In 1853, he married ELLEN SULLIVAN in Staunton, Virginia. Records for 1860 indicate that the couple may have moved to Tunnelton, Virginia (now West Virginia), where Edward labored on the railroad. By this time, they had an eight-month-old daughter named Margareth.

DANIEL KEEFE was from the civil parish of Knockavilly, about five miles from Bandon, County Cork. He worked as a floorer in the Blue Ridge Tunnel from October 1853 until March 1854.

Likely a shanty resident near one of the portals, thirty-year-old Daniel died of pleurisy at the tunnel on March 23. His gravestone states that he was the brother of James and Cornelius Keefe.

JOHN KEEFE (also Keeffe) and MARY DONOVAN KEEFE were from the townland of Tallow in County Waterford. They were married at the Irish-built Saint Francis of Assisi Church in Staunton, Virginia, in 1852. John worked as a floorer and crew boss in the Blue Ridge Tunnel between 1852 and 1856.

Johanna Keefe was John and Mary's daughter. Born on February 17, 1853, she died on May 5, 1854, at the age of thirteen months. Her gravestone at Thornrose Cemetery in Staunton is inscribed with the words, "Born on the Blue Ridge."

MICHAEL LONG was from the townland of Leamcon in the civil parish of Skull, County Cork. In 1854, he was working on the Brooksville Tunnel, one of three sister tunnels built within a few miles of the mammoth Blue Ridge Tunnel. In January of that year, he advertised in the *Boston Pilot* newspaper for the whereabouts of his brothers, William and Patrick Long.

WILLIAM, JAMES, PHILIP, MARY AND JOHANNA MACKEY were from Payfield (or Peatfield) in the civil parish of Lysgood-Aghada in County Cork. They were the children of JOHN AND JULIA FITZGERALD MACKEY.

According to James, he and William worked on the "Blue Ridge Mountain" (Blue Ridge Tunnel) in 1856. The brothers were separated when William moved to New York in 1857.

James fought in the Civil War. His siblings placed an advertisement for his whereabouts in the *Boston Pilot* in 1864 and 1865, but he later said, "I, Being in the Union Army Did Not See It Perhaps." He was living in Elliota, Minnesota, when he advertised for his brother William in 1867.

DANIEL MAHANEY was from the civil parish of Ballymartle in County Cork. He was probably living at the Blue Ridge Tunnel when he died in June 1853. His cousin Thomas was also from Ballymartle and died at the tunnel in August 1854.

Though Thornrose Cemetery records in Staunton, Virginia, state that Thomas died of a sunstroke, he may have been a victim of the cholera outbreak that struck the tunnel area in summer 1854. Daniel and Thomas are buried side by side at Thornrose. Their kinsmen, Patrick and Michael Mahaney, may have paid for the gravestones. Mrs. Catherine Mahaney, born around 1774 in County Cork, died of a stroke in June 1854. She is also buried at Thornrose Cemetery and might have been related to the Mahaney men.

ELIZABETH MAHONEY was from Tralee. Born around 1821, she was the wife of Thomas Mahoney, also from County Kerry. By 1852, Thomas was laboring in the Blue Ridge Tunnel. His eleven-year-old son, Thomas J., may have worked in the tunnel as a tool bearer.

The family settled in Staunton, Virginia, at the western end of the Blue Ridge Railroad–Virginia Central Railroad project. Thomas died in 1879. Thomas J. died in 1884. Elizabeth, who outlived her husband and son, died in 1889. Though her gravestone says "Our Mother," we don't know the names of her other children.

BATT MALONEY was from an unidentified townland in the civil parish of Drumline, County Clare, Ireland. In 1850, he was living in Albemarle County, Virginia. Family members who lived with Batt included Jeremiah, born in 1817; John, born in 1820; and two children born in Ireland: eight-year-old Ann and four-year-old Daniel.

In 1852, Batt was working for the Virginia Central Railroad in Albemarle. That year, he advertised in the *Boston Pilot* newspaper for the whereabouts of his brother, Thomas, and Thomas's wife, MARY NASH MALONEY. The ad stated that the couple had left from Limerick in July 1850, arriving in Quebec, Canada, in August. Batt was located in Brooksville, Albemarle County, when he posted the ad. This hamlet was very near construction of the Brooksville Tunnel, one of four tunnels built for the Blue Ridge Railroad–Virginia Central Railroad project.

THE MATEER FAMILY was from County Antrim, possibly the townland of Antrim. Family members included Jane, born around 1810; Jane, her daughter; William, her son; and Ellen, probably a niece. They all lived in Staunton, Virginia, in the 1850s—the construction decade for the Blue Ridge Railroad–Virginia Central Railroad project.

The younger Jane Mateer married blacksmith Patrick O'Donnell at Saint Francis of Assisi Church in Staunton in 1850. Ellen Mateer married DANIEL QUINLAN in 1856. She listed her father as Maurice on the marriage record. William Mateer, a blacksmith, married Mary Kilkelly in 1862. He listed his father as William. Ellen and Daniel remained in Staunton, as did Jane and Patrick O'Donnell. Their descendants still live there today.

MICHAEL MCALLAN was from the civil parish of Feakle in County Clare. He may have emigrated with his brother, John, from Liverpool, England, in October 1851. Their ship, the *Albert Gallitin*, arrived in New York City in November.

In 1852, Michael was working near Mechum's River in Albemarle County, Virginia. That year, he advertised for the whereabouts of John, who had been living in Albany, New York, in December 1851.

Pat McCarthy was from the civil parish of Creagh near Skibbereen in County Cork. He worked on the Blue Ridge Tunnel from 1854 through August 1856. In 1856, he also worked near the Greenwood Tunnel, one of three sister tunnels built at the same time as the Blue Ridge Tunnel.

In 1854, Pat advertised for the whereabouts of his brother Jeremiah, who had arrived in America in 1842 and first lived in Hallowell, Maine. In 1856, Pat also advertised for his brother John, who arrived in 1846 and first lived in Kirkwood, New York, on the Erie Canal. We don't know if the McCarthy brothers were ever reunited.

Alexander, Bernard and James McKenna were brothers from County Derry. Only a few sad details are known about them. In the summer of 1854, they were likely working somewhere along the tracks of the Blue Ridge Railroad–Virginia Central Railroad project. That summer, cholera crept up the James River from the Chesapeake Bay area to the Blue Ridge Tunnel.

By September and October, the brutal disease had reached Staunton in Augusta County. Alexander died in Staunton in September 1854. James died eleven days later on October 4. The closeness of the dates suggests that both young men were victims of contagious cholera. Their grieving brother, Bernard, erected a stone over their graves at Thornrose Cemetery in Staunton.

Patrick McNamara was from County Roscommon, possibly the Newtown area near the County Longford border. Born in 1804, he declared his intention to become a U.S. citizen in 1844 in Staunton, Virginia. This means he had been in the country for at least three years, or since 1841.

Residents of Patrick's household in Staunton in 1850 included Catherine, born in 1770. She may have been his mother. John, a blacksmith born around 1800, might have been a brother. Youngsters living in the house were Daniel, John, William and Patrick, all born in Ireland. Patrick married Ellen (also Eleanor) McClure at the Catholic Church in Staunton in 1850. Four daughters were born to them. Only one, Bettie, survived to adulthood.

Patrick became the first sexton for Thornrose Cemetery, which opened in Staunton around 1850. He held the position for more than three decades and would have overseen the burials of many Irish workers and their

family members. Also a policeman for the cemetery, he—and presumably his family—lived in a residence on the grounds. A handwritten, framed tribute to Patrick survives in Staunton. It's dated 1888 and includes scores of signatures, including those of Irish Americans from the Kivlighan and Croghan families:

> *The undersigned friends of Mr. Patrick McNamara of Staunton, Va., recognizing the uprightness, industry and usefulness which have characterized his long and busy life and desiring to testify that personal friendship and sincere respect for his sterling worth, beg leave to tender him on this, his Eighty-third Birthday, the accompanying purse as a token of their regard for him, with the hope that it may in some degree pay tribute to his personal comfort, and with the further wish that his useful and honorable life may in the kindness of Providence be prolonged many years.*

One James McNamara was working along the Blue Ridge Railroad in 1852, and Dennis McNamara declared his intention to become a citizen in 1856. It is unknown if they were related to Patrick.

THOMAS MEAD was from Ballybricken in County Limerick. He might have emigrated with his cousin MARY BARRY. She left from Liverpool, England, in 1854 and arrived in New York City in September of that year.

In 1855, Thomas advertised for Mary's whereabouts in the *Boston Pilot* newspaper. At the time he placed the ad, he was living in Staunton, Virginia.

Thomas may have been related to John and Margaret Mead and their daughter, Margaret. She was born in Ireland in 1850. That same year, the family was living very near construction of the Blue Ridge Railroad in Albemarle County, Virginia. This means that Margaret was an infant when she crossed the Atlantic and traveled up to the Blue Ridge Mountains with her parents.

THE MORAN FAMILY was from Reenconnell on the Dingle peninsula in County Kerry. Patrick, born around 1800, emigrated in 1847. His possible sons, Dennis, James and John, may have been with him. Patrick's first location was Iowa.

By 1851, Dennis was living in Staunton, Virginia—the westernmost point of the Blue Ridge Railroad–Virginia Central Railroad project. He was confirmed at Saint Francis of Assisi Church in Staunton that year.

In 1852, James was laboring on the same railroad project in Albemarle County, Virginia. James declared his intention to become a U.S. citizen in 1854. He received full citizenship in 1857. John Moran was living in the area by 1858. That year, he and Denis received full citizenship on the same day. Like so many of the Irish who came to build the four tunnels and thirty-four miles of connecting tracks, the Moran family settled in Staunton.

In 1860, the Moran household included John; Dennis; eight-year-old Catherine, born in Staunton; sixty-year-old Patrick; and sixty-nine-year-old Catherine. John Moran enlisted in the Confederate Staunton Light Artillery Regiment shortly after the American Civil War began in 1861.

THREE LABORERS NAMED DANIEL MURPHY, including a boy, were employed at the Blue Ridge Tunnel. They worked as floorers, headers, blasters, bosses and watermen from 1852 until early 1857. One of them was Daniel Murphy from the civil parish of Kilofin in County Clare. He may have emigrated with his brother, Peter, arriving in Canada in 1851.

This same Daniel Murphy was living in Staunton in early 1857, just as work was winding down at the tunnel. On January 17, he advertised for Peter's whereabouts in the *Boston Pilot* newspaper. Peter had worked in Canada in 1851, then New Hampshire. His last location, as far as Daniel knew, was Haverhill, Massachusetts, in 1853.

JEREMIAH MURPHY was from the civil parish of Skull in County Cork. He left Wales in April 1852 and arrived in New York one month later. His next location was Baltimore, Maryland, where he likely worked for the Baltimore and Ohio Railroad. That same year, he migrated south to labor on the Brooksville Tunnel. In October 1852, he advertised from Brooksville for his friend Denis Sullivan, who had left Wales with him.

MARGARET MURRAY was born around 1790. She was from the civil parish of Killashee and townland of Fisherstown in County Longford. In 1850, she was living in Staunton, Virginia. Eight more Murray family members lived with Margaret: Martin, born around 1810, and his wife, Sarah; Mary and Michael, both born around 1820; and four children born in Virginia in 1846, 1847, 1848 and 1850. Martin and Michael, listed as laborers on the 1850 census, declared their intentions to become U.S. citizens in 1855. Martin received full citizenship in 1858.

By 1860, the family was no longer jammed together in one house. Martin and Sarah lived in a separate residence, while Margaret, Mary

and Michael lived in another. The 1860 U.S. census indicates that Margaret (also Peggy) was a widow. The following year, she advertised in the *Boston Pilot* newspaper for the whereabouts of her son, Thomas. He had departed Ireland for Michigan in 1849. His first work location was Philadelphia that same year. His second location was Michigan in 1860.

It is unknown if Margaret ever found Thomas. She died from unknown causes in 1869 and was buried at Thornrose Cemetery in Staunton, probably without a gravestone. It is also unknown if she was related to four Murray men who worked as floorers and blacksmiths in the Blue Ridge Tunnel: Dennis, John, Timothy and another Timothy.

MICHAEL, THOMAS AND MAURICE NELAN were from the townland of Ballinicrene in the civil parish of Killarney, County Kerry. Apparently the brothers emigrated together, arriving in Quebec in 1849. Their first location after arrival was Vermont.

In 1852, Michael was working on the Blue Ridge Railroad project at Mechum's River in Albemarle County, Virginia. By this time, he had lost touch with his brothers. On February 14 of that year, he advertised in the *Boston Pilot* newspaper for their whereabouts.

BRIDGET NELLIGAN; her husband, David; and his possible brother, Dennis, were from the townland of Ballyquane (also Bally Quane) near Fermoy in the civil parish of Dunmahon, County Cork. David and Dennis both worked in the Blue Ridge Tunnel. David was a blacksmith on the west side from the beginning of the project until spring of 1857. Dennis was a floorer for a few months in 1856.

Bridget and David had six children: Margaret, Mary Ann, Patrick, Ellen, David and Thomas. At least one of them, Ellen, was born at the Blue Ridge Tunnel.

By 1870, Dennis was working as a gardener in Staunton, Virginia, at the Institution for the Deaf, Dumb and Blind. Bridget died of tuberculosis in 1881. Her husband, David, died in 1889, also of tuberculosis.

JOHN NUNAN, whose father was also John Nunan, was from County Limerick. Born around 1830, the younger John met and married MARY KIELY, who emigrated in 1850. The couple ended up in Staunton, Augusta County, Virginia, sometime before 1855. Their first son, also named John, was born that year.

For the next three decades, Mary Kiely kept house in Staunton and gave birth to ten children in all. John worked first as a railroad contractor and

then turned to farming. When the Civil War began, he joined the Augusta County Reserves for the Confederacy. After the war ended, he continued to farm and acquired a distillery license.

John Nunan died in Staunton in 1888. His gravestone at Thornrose Cemetery says he was "born on the Banks of the Shannon, County Limerick." His wife, Mary Kiely, died in 1912.

PATRICK O'LEARY was from the civil parish of Desertmore in the poor-law union of Bandon. In 1852, he was working on the Brooksville Tunnel, a sister tunnel east of the Blue Ridge Tunnel. In March of that year, he advertised in the *Boston Pilot* newspaper for the whereabouts of his sister, Catherine O'Leary O'Brien, and her husband, William O'Brien.

TIMOTHY O'LEARY was from the civil parish of Kilmeene in East Carbery, County Cork. In 1857, he declared his intention for U.S. citizenship in Albemarle County, Virginia, the easternmost county of the Blue Ridge Railroad project. By 1860, Timothy was living in adjoining Augusta County. He resided in a dwelling that housed twelve people, including John and Julia O'Leary.

In 1868, three years after the American Civil War ended, Timothy advertised for his family's whereabouts in the *Boston Pilot* newspaper. Family members mentioned in the ad included his brothers, Jerry and Thomas O'Leary; his sister JOHANNAH MADDIGAN; her husband, Thomas; and another sister, MARY O'LEARY O'BRYAN. All had been living in Keokuck, Iowa.

HENRY PEED was from the civil parish of Ballynoe, County Cork. He was working on the Blue Ridge Railroad near the Brooksville Tunnel in 1852. In July of that year, he advertised for his brother in the *Boston Pilot* newspaper.

BATT (Bartholomew) POWERS was from the townland of Tansk Bridge in the civil parish of Inniscarra, County Cork. He worked on the Greenwood Tunnel, one of three sister tunnels built a few miles east of the Blue Ridge Tunnel, in 1854. On July 1, 1854, he advertised for his son, Batt Powers, in the *Boston Pilot* newspaper.

Other Irish with the last name of Powers who lived and worked at the Blue Ridge Tunnel were Kitty, James, Margaret, Michael, Pat, Randall, Richard, Thomas and William. Kitty died on July 5, 1854. The cause of death was listed as "congestion of the brain."

MARGARET SKANE REARDON (also Riordan) was from the townland of Hog Brook Park and civil parish of Dublin in Dublin County. In 1852, she was living in a shanty at the Blue Ridge Tunnel in Rockfish Gap, Virginia.

Four men with the last name of Riordan worked as floorers in the tunnel during the early years of construction: James, Michael and two Patricks. One of them was Margaret's husband.

In October 1852, Margaret advertised in the *Boston Pilot* newspaper for the whereabouts of her widowed sister, SARAH DAVIS. Margaret may have wanted to let her sister know that she and her husband were moving on for employment elsewhere. Within two months, all but one of the Riordan men had left the tunnel. James continued work for a few months but was gone by April 1853. That same month, the Blue Ridge Railroad men held a long, difficult but successful strike for higher wages.

CATHERINE AND JOHN RIORDAN, sister and brother, were from the townland of Finnetenstown in the civil parish of Adare in County Limerick. Writing from Baltimore, Maryland, Catherine advertised for John in the *Boston Pilot* newspaper in June 1854. The ad stated that his first location after arrival in America was Staunton, Virginia. John probably labored somewhere along the tracks until 1856, when he worked as a floorer in the Blue Ridge Tunnel in June, July and August of that year.

CORNELIUS AND OWEN RYAN were from the civil parish of Newport. Cornelius was working for the Blue Ridge Railroad–Virginia Central Railroad project in 1852. Owen died on February 7, 1853, and was buried in Thornrose Cemetery in Staunton, Virginia. His gravestone reads, "Native of Co Tiperary Parish of Newport, Ireland. Age 28 yrs. Erected by brother Cornelius Ryan."

DANIEL RYAN was from the townland of Carrigal in the civil parish of Burgasbet, County Tipperary. In 1850, he was living in Albemarle County, Virginia.

By early 1857, much of this thirty-four-mile-long project was almost complete, including the Blue Ridge Tunnel at Rockfish Gap. Many Irishmen at the tunnel, including Daniel, worked only one month longer.

Daniel advertised in February for the whereabouts of his brother, John. He might have wanted to let him know that he was moving elsewhere for employment.

JAMES RYAN was from the townland of Glasheen in the civil parish of Clontead, County Cork. After arriving in America, he helped build the Marion and Hammet Railroad in Ohio. He moved next to Kentucky.

In 1852, James was working on the Albemarle County portion of the Blue Ridge Railroad project. He left the area in June 1856. His wife, Mary, advertised for him in the *Boston Pilot* in 1857. She was living in Greenwood, Albemarle County, when she placed the ad.

MICHAEL SCALES was from the civil parish of Killilagh in County Clare. He arrived in New York City in September 1850. In January 1852, he was living in Albemarle County, Virginia, where construction of the three-county Blue Ridge Railroad was underway.

In June 1852, Michael's sister, Catherine Scales, advertised for his whereabouts in the *Boston Pilot* newspaper. She was living in Scituate Harbor, Massachusetts, when she placed the ad.

MICHAEL SCULLY was from Skibbereen, County Cork. He worked as a floorer in the Blue Ridge Tunnel, possibly from the beginning of its construction in 1850. In March 1854, his brother, John, was living in New York City and advertised for his whereabouts.

In the summer of 1854, the cholera epidemic swept through the tunnel area, claiming scores of lives at both portals. When the epidemic began in July, Michael was building an embankment that led to the east portal. He disappeared from the payroll in August and may have fallen victim to cholera. If so, his burial place is unknown.

DENIS SHANAHAN was from Rosscarbery, County Cork. In 1847, his father, Cornelius, died. Denis, his younger brother, Michael, and their mother, BRIDGET DEMPSEY SHANAHAN, left Ireland later that year.

After arriving in Baltimore, Maryland, Denis—and probably Michael—worked for the Baltimore and Ohio Railroad. By 1850, they were living in Virginia and helping to build the Blue Ridge Railroad. Denis worked first at the Brooksville Tunnel, one of three sister tunnels built near the Blue Ridge Tunnel. He then became an engineer for the Blue Ridge Tunnel. Meanwhile, Michael labored in the passage as a floorer from about 1850 until 1855.

By 1857, Denis was living with his wife, Ann Marie Lyons Larguey, at Brooksville Tavern at the eastern base of Rockfish Gap. Brooksville housed engineers and contractors during the Blue Ridge Tunnel construction.

JOHN SHANNIHAN was from the civil parish of Emly in South Tipperary. He emigrated in 1849, arriving in Boston, Massachusetts. His first work location was Middlesex, Vermont, where Irish laborers were building a network of railroads. He then moved to Staunton, Virginia.

In June 1856, Michael Shannihan advertised for the whereabouts of his brother, John, in the *Boston Pilot* newspaper. Michael was located in Cavendish, Vermont, when he placed the ad.

HANNAH SHAY from the civil parish of Kilmurry, County Cork, was married to Jeremiah Shay. The couple lived at Rockfish Gap, probably in shanty housing, for eight or nine years. They then moved to Brown County, Illinois, around 1860. Hannah's sister, MARY DONOVAN, advertised for their whereabouts in the *Boston Pilot* newspaper in 1864.

MCGRATH SULLIVAN was from Castletown on the Berehaven Peninsula, County Cork. He left Ireland in 1851. In 1855, he advertised in the *Boston Pilot* newspaper for the whereabouts of his brother, Murty Sullivan. At the time he placed the ad, McGrath was living in Augusta County on the west side of the Blue Ridge Tunnel. He worked in the tunnel as a floorer and header from March 1854 through April 1856.

Five laborers named JEREMIAH SULLIVAN worked as floorers and headers in the Blue Ridge Tunnel. One was from Glasheen, now a suburb of Cork City, in St. Finbar Parish. In 1850, one Jeremiah Sullivan—perhaps the same Jeremiah from Glasheen—lived near the Blue Ridge Railroad construction in the same dwelling with five more Sullivans: Cornelius, Daniel, Ellen, James and Mary.

JOHANA SULLIVAN was from the townland of Lodge in the civil parish of Hospital, County Limerick. She emigrated in the spring of 1859, arriving in Brooklyn, New York, on May 4. Her sister, MARY SULLIVAN BURNS, advertised for her whereabouts in the *Boston Pilot* newspaper in December of that year. At the time she placed the ad, Mary was living in Albemarle County, Virginia—the easternmost county of the Blue Ridge Railroad–Virginia Central Railroad project.

Mary was probably the wife of Patrick Burns, who placed a second ad for Johana in July 1860. By this time, Mary and Patrick were living in Nelson County, a mountainous county adjacent to Albemarle. Patrick was repairing a railroad in Nelson; other Irish railroad workers lived with the couple and next door to them.

About nine men named JOHN SULLIVAN were associated with the Blue Ridge Railroad project. Five of them worked as floorers or headers in the Blue Ridge Tunnel. One was from the townland of Knock in the civil parish of Kilmeen, County Cork. He worked in Wales from 1851 to 1854, then emigrated on the ship *Emily* and arrived in Boston. In July 1854, he was working on the west side of the Virginia Blue Ridge Tunnel. His sister, Mrs. O'Driscoll, advertised for him in the Irish American newspaper in January 1855.

MARK AND ANNA NEWMAN SULLIVAN shared a dwelling at the Blue Ridge Tunnel with Michael Harrington and his wife, Catherine Brennan Harrington. The Sullivans were from Allihies on the Bearhaven Peninsula. Their first child, Mary, was born there in 1847.

Mark's name does not show up on extant Blue Ridge Tunnel payroll records. He may have worked elsewhere along the Blue Ridge Railroad or on construction of a nearby turnpike. Mark and Anna had two more children while living at the tunnel. They returned to Ireland in 1855.

ELLEN WALLACE was born in the townland of Ballyhooly in County Cork. Her husband, Edward (also Edmond) Wallace, worked at the Blue Ridge Tunnel as a floorer, possibly from the time that construction began in 1850.

Edward, also from County Cork, died from a skull fracture at the tunnel in 1853. Following his death, Ellen married Thomas Flynn at the tunnel in January 1854. Her son, four-year-old James Wallace, died later that same year. She buried him side by side with his father, Edward, at Thornrose Cemetery in Staunton, Virginia.

JOHN WALSH was from the civil parish of Lismore and Mocollop in County Waterford. In 1853, he was working a few miles east of the Blue Ridge Tunnel near the Brooksville Tunnel. The following year, he worked as a floorer in the main Blue Ridge Tunnel. Other laborers at the tunnel with the last name of Walsh were James, Jeremiah, William and Edward.

Edward died during the cholera epidemic at the tunnel in the summer of 1854. That same year, John advertised in the *Boston Pilot* newspaper for the whereabouts of his sister, Mary Walsh. She had departed from Cork in 1846, arriving in Quebec that same year. If Edward was related to John and Mary, John may have been trying to locate his sister and inform her of Edward's death.

CELIA WELCH was born in Dublin around 1834. Her parents were EDWARD AND MARY BURNS WELCH. By 1856, Celia was living in Staunton, Virginia. Early that year, she married JOHN LONNIGAN from County Tipperary. His parents were JOHN LONNIGAN AND MARY HENNESSY. The younger John was a carpenter who helped build a bridge and viaduct for the Blue Ridge Railroad in 1850. The viaduct was located on the west side of Rockfish Gap, Virginia, near the bottom of the three-mile slope.

PATRICK WELCH was from the civil parish of Gallen in County Offaly. He resided in a boardinghouse with other Irish laborers in Augusta County, Virginia, in 1850. All were probably employed by the Virginia Central Railroad, which partnered with the Blue Ridge Railroad to build four tunnels and thirty-four miles of connecting tracks in the 1850s.

Patrick moved northward, following railroad work to Tunnelton in Preston County, Virginia (now West Virginia), around 1858. That year, he advertised in the *Boston Pilot* newspaper for the whereabouts of his brothers, George and Thomas Welch.

JOHN WHOLEHAN (also Wholihan) and his brother, Cornelius, were from Rosscarbery in County Cork. John may have emigrated with Cornelius in 1850. Cornelius was married in Bath, Maine, that year.

John worked as a header and floorer on both sides of the Blue Ridge Tunnel beginning in January 1855. He would have lived in shanty housing at the top of the mountain. In September 1856, he advertised in the *Boston Pilot* newspaper for the whereabouts of Cornelius. John's employment at the tunnel continued through January 1857.

Appendix III
Enslaved Laborers on the Blue Ridge Railroad Tracks

Enslaved	Slaveholder	Slaveholder Location	Date and Length of Lease	Sources
Anderson	J. Yancey	Albemarle County	January 9, 1854–55	Blue Ridge Railroad Records Library of Virginia/1850 Albemarle County census
Armistead	Elizabeth Powell	Mechum's River Depot area, western Albemarle County	January 9, 1854–55	Blue Ridge Railroad Records Library of Virginia/1850 Albemarle County census
Ben	A.D. Mosby (Alfred, father of John Singleton Mosby)	Albemarle County	July 17, 1854–January 7, 1855	Blue Ridge Railroad Records Library of Virginia/1850 Albemarle County census
Bob	Dr. Charles Carter	Charlottesville, Albemarle County	January 9, 1854–55	Blue Ridge Railroad Records Library of Virginia/1850 Albemarle County census

Enslaved	Slaveholder	Slaveholder Location	Date and Length of Lease	Sources
Bob	Thomas W. Williams	Possibly the Williams "Yellow House" slave pen, Washington, D.C.	January 9, 1854–55	Blue Ridge Railroad Records Library of Virginia/ Farrow daybook
Caleb	Andrew Woods	Woodville (now Ivy) area, western Albemarle County	January 9, 1854–55	Blue Ridge Railroad Records Library of Virginia/1850 Albemarle County census
Coy	George W. Kinsolving	Mechum's River Depot area, western Albemarle County	January 9, 1854–55	Blue Ridge Railroad Records Library of Virginia/1850 Albemarle County census
Dabney	Socrates Maupin	professor, University of Virginia, Charlottesville, Albemarle County	January 9, 1854–55	Blue Ridge Railroad Records Library of Virginia/1850 Albemarle County census
Dennis	J. Yancey	Albemarle County	January 9, 1854–55	Blue Ridge Railroad Records Library of Virginia/1850 Albemarle County census
Ellis	A.D. Mosby	Albemarle County	July 17, 1854– January 7, 1855	Blue Ridge Railroad Records Library of Virginia/1850 Albemarle County census

ENSLAVED	SLAVEHOLDER	SLAVEHOLDER LOCATION	DATE AND LENGTH OF LEASE	SOURCES
Fountain	William A. Maupin/Addison Maupin, executor of estate	Albemarle County	January 9, 1854–55	Blue Ridge Railroad Records Library of Virginia/1850 Albemarle County census
George	Hiram Via	Albemarle County	January 9, 1854–55	Blue Ridge Railroad Records Library of Virginia/1850 Albemarle County census
George	Dr. Charles Carter	Charlottesville, Albemarle County	January 9, 1854–55	Blue Ridge Railroad Records Library of Virginia/1850 Albemarle County census
Goliah	Margaret Dawson/ William Graves, her guardian	Mechum's River Depot, western Albemarle County	January 9, 1854–55	Blue Ridge Railroad Records Library of Virginia/1850 Albemarle County census
Henderson	Austin G. Shelton	Mechum's River Depot area, western Albemarle County	January 9, 1854–55	Blue Ridge Railroad Records Library of Virginia/1850 Albemarle County census
Henry	Ira Maupin	Mechum's River Depot area, western Albemarle County	January 9, 1854–55	Blue Ridge Railroad Records Library of Virginia/1850 Albemarle County census

Enslaved	Slaveholder	Slaveholder Location	Date and Length of Lease	Sources
Horace	Thomas W. Williams	Possibly the Williams "Yellow House" slave pen, Washington, D.C.	January 9, 1854–55	Blue Ridge Railroad Records Library of Virginia/ Farrow daybook
Jacob	William Rothwell	Mechum's River Depot area, western Albemarle County	January 9, 1854–55	Blue Ridge Railroad Records Library of Virginia/1850 Albemarle County census
James	Chapman (C.) Maupin	Albemarle County	January 9, 1854–55	Blue Ridge Railroad Records Library of Virginia/1850 Albemarle County census
Jefferson	Th. W. Williams	Possibly the Williams "Yellow House" slave pen, Washington, D.C.	January 9, 1854–55	Blue Ridge Railroad Records Library of Virginia/ Farrow daybook
Jerry	James Garland	Woodville (now Ivy) area, western Albemarle County	January 9, 1854–55	Blue Ridge Railroad Records Library of Virginia/1850 Albemarle County census
Jesse	Peter A. Woods and William H. Jones, trustees	Unknown	January 9, 1854–55	Blue Ridge Railroad Records Library of Virginia/1850 Albemarle County census

ENSLAVED	SLAVEHOLDER	SLAVEHOLDER LOCATION	DATE AND LENGTH OF LEASE	SOURCES
Joe	J. Yancey	Albemarle County	January 9, 1854–55	Blue Ridge Railroad Records Library of Virginia/1850 Albemarle County census
Johnson	Chapman (C.) Maupin	Albemarle County	January 9, 1854–55	Blue Ridge Railroad Records Library of Virginia/1850 Albemarle County census
Lewis	William Graves	Mechum's River Depot area, western Albemarle County	January 9, 1854–55	Blue Ridge Railroad Records Library of Virginia/1850 Albemarle County census
Lewis	William Tilman	Mechum's River Depot area, western Albemarle County	January 9, 1854–55	Blue Ridge Railroad Records Library of Virginia/1850 Albemarle County census
Leuvil	John Woods	Woodville (now Ivy) area, western Albemarle County	January 9, 1854–55	Blue Ridge Railroad Records Library of Virginia/1850 Albemarle County census
Macajah	Andrew M. Woods	Woodville (now Ivy) area, western Albemarle County	January 9, 1854–55	Blue Ridge Railroad Records Library of Virginia/1850 Albemarle County census

Enslaved	Slaveholder	Slaveholder Location	Date and Length of Lease	Sources
Remus	Dr. Charles Carter	Charlottesville, Albemarle County	January 9, 1854–55	Blue Ridge Railroad Records Library of Virginia/1850 Albemarle County census
Romulus	Dr. Charles Carter	Charlottesville, Albemarle County	January 9, 1854–55	Blue Ridge Railroad Records Library of Virginia/1850 Albemarle County census
Scipio	A.D. Mosby	Albemarle County	July 17, 1854–January 7, 1855	Blue Ridge Railroad Records Library of Virginia/1850 Albemarle County census
Tandy	Chapman (C.) Maupin	Albemarle County	January 9, 1854–55	Blue Ridge Railroad Records Library of Virginia/1850 Albemarle County census
Tom	Vienna Fretwell	Mechum's River Depot area, western Albemarle County	January 9, 1854–55	Blue Ridge Railroad Records Library of Virginia/1850 Albemarle County census
Tom	Andrew M. Woods	Woodville (now Ivy) area, western Albemarle County	January 9, 1854–55	Blue Ridge Railroad Records Library of Virginia/1850 Albemarle County census

Enslaved	Slaveholder	Slaveholder Location	Date and Length of Lease	Sources
unnamed	Robert F. Harris	Charlottesville, Albemarle County	January 9, 1854–55	Blue Ridge Railroad Records Library of Virginia/1850 Albemarle County census
unnamed	Ira Maupin	Mechum's River Depot area, western Albemarle County	January 9, 1854–55	Blue Ridge Railroad Records Library of Virginia/1850 Albemarle County census
unnamed boy	James H. Jarman	Mechum's River Depot area, western Albemarle County	January 9, 1854–55	Blue Ridge Railroad Records Library of Virginia
unnamed man	James H. Jarman	Mechum's River Depot area, western Albemarle County	January 9, 1854–55	Blue Ridge Railroad Records Library of Virginia
unnamed man	James H. Jarman	Mechum's River Depot area, western Albemarle County	January 9, 1854–55	Blue Ridge Railroad Records Library of Virginia
Watsin	Overton Tillman	Mechum's River Depot area, western Albemarle County	January 9, 1854–55	Blue Ridge Railroad Records Library of Virginia/1850 Albemarle County census

Bibliographical Essay

RESEARCH FOR PART I

I first became interested in the workers who built the Blue Ridge Tunnel in 2009. It was as if someone had hypnotized me. The more I learned, the more I wanted to know. These heroes had built an engineering landmark that one railroad historian has called a miracle. Surely I could locate trustworthy books and articles about the project. To my surprise, I found only a few recent sources.

I began with a chapter about the Blue Ridge Tunnel in a biography of Claudius Crozet, chief engineer for the project. It didn't say nearly enough about the Irish and enslaved laborers, and it made no mention of women or children. My second source was a dissertation about the Blue Ridge Railroad and its partner, the Virginia Central Railroad. I often referred to the dissertation for statistics on the two companies, but it contains no thoughtful information about laborers who worked for them. Aaron Marrs's book about antebellum railroads offered a fascinating look at southern railroads in general, though the author wrote only two sentences about the Virginia Blue Ridge Railroad.

As my research continued, I became curious about strikes and Irish-versus-Irish conflicts. I learned about the origins of Irish protests in Peter Way's book, which points out similarities in the desperate lives of canal workers and railroad workers. A thesis by Jay Perry and Matthew E. Mason's article were also extremely helpful on this topic. Thanks to James S. Donnelly's article and

book about Captain Rock, I was able to identify Blue Ridge Tunnel workers who would have participated in the Rockite rebellion in Ireland or whose grown children at the tunnel would have been familiar with Rockite methods.

For a deeper understanding of the Irish immigrants' world, I turned to Kevin Kenny. His edited collection of scholarly articles includes Timothy O'Neil's analysis of miner migration. O'Neil uses the frequency of last names to identify Irish miners who left the Berehaven Peninsula in County Cork and migrated to Montana copper mines. By the same method, I realized that Corkonians at the Blue Ridge Railroad had worked in mines, some in copper mines on the Berehaven Peninsula. Like the Montana miners, most of them had Sullivan and Harrington surnames. Advertisements for lost relatives in the *Boston Pilot* newspaper helped me pinpoint other men at the Blue Ridge Railroad who emigrated from Irish mining towns.

The most useful book I read was a collection of scholarly essays edited by J.J. Lee and Marion R. Casey. The articles cover a broad range of Irish American history, including labor, music, sports, religion, race and employment for Irish women.

Oral history played a crucial role in my research. It still seems miraculous that I found Sullivan, Harrington and Croghan descendants who generously shared their stories and photographs.

The bulk of the remaining information came from primary sources. The following are available on the Internet or in databases available to students and faculty at most university research libraries: census returns for the Virginia counties of Albemarle, Nelson and Augusta from 1840, 1850 and 1860, as well as partial 1860 returns for Alleghany County, Virginia; Civil War soldiers' records; birth and baptismal records; and 1850s newspaper articles about the Blue Ridge Tunnel.

I've read the following original documents in person, as scans or on microfilm: 1850 and 1852–57 Blue Ridge Railroad payrolls, Virginia Central Railroad payrolls, the Wallace general store and William Graves general store ledgers, Blue Ridge Railroad ledgers, marriage records, death records, letters from Claudius Crozet, 1850–60 Staunton *Spectator* and *Vindicator* newspapers and gravestone inscriptions. I found scanned copies of 1850s documents on the Internet and abstracts of citizenship records at the Augusta County Historical Society and the public library in Staunton, Virginia. Augusta County chancery court records are available at the Library of Virginia website.

My first thought when examining these thousands of pages was to honor the workers and family members by naming them. I included all Irish adults living along the tracks and in Staunton between 1850 and 1860, along with

their children, whether born in Ireland or America. The list also names enslaved laborers at the Blue Ridge Tunnel, family members for three of these men and the names of enslaved men and boys whose labor the Blue Ridge Railroad leased to finalize tracks. The final list contains about three thousand names, each with one or more pieces of information attached to it.

I divided the massive amount of material I found into four sections: vital statistics, payrolls, ledgers and cholera chronology. I have titled them the "Virginia Blue Ridge Railroad Datasets." But data are only bits of information, and bits do not make a story. As I wrote, I needed to connect the data with what I already knew—a process I repeated many times while visualizing the world of the tunnel workers.

RESEARCH FOR PART II

Lynn Rainville's award-winning article about a slave cemetery in western Albemarle County, Virginia, was of great assistance as I considered the geographic location and layout of the Quinn Cemetery for "Buried History." I also relied on local history books by Edgar Woods and Edward K. Lay for details about Brooksville and Old York. Sam Towler's unpublished notes on the Old York-Brooksville area were key in establishing the location of housing for the Irish and the starting point of the Old York Road. Towler's and Bob Vernon's research helped me identify enslaved African Americans at Brooksville plantation.

Articles in the Staunton *Spectator* and *Vindicator* newspapers provided the chronology for "Cholera Comes to the Blue Ridge Tunnel." The articles reflected on a local level the prevailing national attitude toward Irish immigrants and cholera in the 1850s. Useful medical information came from books by Todd Savitt, Wyndham Blanton and a scientific article about cholera by Reni Martin and Mark Tamplin. George Bagby's book offered a fascinating first-person glimpse of nineteenth-century travel along the James River Canal, which was a major route for transporting construction materials—and probably oysters—to the Blue Ridge Railroad.

John Kelly's book about the Great Hunger was a constant inspiration as I wrote "From Skibbereen to Staunton." The Skibbereen Heritage Centre provided specific information about the Great Hunger in Skibbereen.

The impetus for "The House of Ninety-nine" came from the exciting discovery of the Virginia Central Railroad deed in the William Graves

Papers at the Wisconsin Historical Society in Madison, Wisconsin. Special thanks to Margaret Rhyther for making the Graves Papers available. The deed, combined with data compiled by Sam Towler, my "Virginia Blue Ridge Railroad Datasets" and the pre-1858 membership list for Mountain Plain Church in Albemarle County, Virginia, helped me connect the dots.

Information for "Bring Flowers of the Fairest" came from the "Virginia Blue Ridge Railroad Datasets." Most of my sources for "Two Cousins, Two Continents" are online.

Sometimes I turned off the computer, closed the books and pulled on my hiking boots. I walked the same embankment mentioned in the prologue. I hiked around the old temporary track bed and saw old bricks left from Brooksville Tunnel, one of the three shorter tunnels on the Blue Ridge Railroad.

I've seen both portals of the Blue Ridge Tunnel and shanty foundations near them. I've peered inside large culverts and hopped across railroad tracks—sometimes dashed across because a train was coming.

Every hike filled me with a deep respect for what the men and boys—with family help—accomplished with their embankments, culverts, tracks and tunnels. You've heard the phrase "move heaven and earth." That's exactly what these workers did for ten long years. I tip all of my hats to all of them.

Bibliography

Bagby, George William. *Canal Reminiscences: Recollections of Travel in the Old Days on the James River & Kanawha Canal.* Richmond, VA: West, Johnston & Co., 1879.

Blanton, Wyndham, M.D. *Medicine in Virginia in the Nineteenth Century.* Richmond, VA: Garrett & Massie, 1933.

Blue Ridge Railroad Company Papers. Library of Virginia, Richmond, VA.

Carlyle, Thomas. *Frasier's Magazine for Town and Country* 35. London: James Frasier, 1847.

Census of Ireland, 1901 and 1911.

Chancery Court Records, Staunton City. Index Number 1903-020. Library of Virginia, Richmond, VA.

Coleman, Elizabeth Dabney. "The Story of the Virginia Central Railroad 1850–1860." PhD dissertation, Department of History, University of Virginia, 1957.

Dilts, James D. *The Great Road: The Building of the Baltimore & Ohio, The Nation's First Railroad, 1828–1853.* Stanford, CA: Stanford University Press, 1993.

Donnelly, James S. "Captain Rock: Ideology and Organization in the Irish Agrarian Rebellion of 1821–24." *Éire-Ireland* (Fall/Winter 2007).

———. *Captain Rock: The Irish Agrarian Rebellion of 1821–1824.* Madison: University of Wisconsin Press, 2009.

———. *The Land and the People in Nineteenth Century Cork.* London: Routledge, 1975.

East, John. *Glimpses of Ireland in 1847,* last accessed December 7, 2013. http://www.rosscarbery.ie/history.

Ely, Melvin Patrick. *Israel on the Appomattox: A Southern Experiment in Black Freedom from the 1790s Through the Civil War.* New York: Knopf, 2004.

Gage, Mary, and James E. Gage. *The Art of Splitting Stone: Early Rock Quarrying Methods in Pre-Industrial New England 1630–1825.* 2nd edition. Amesbury, MA: Powwow River Books, 2005.

Giemza, Bryan. *Rethinking the Irish in the American South: Beyond Rounders and Reelers.* Jackson: University of Mississippi Press, 2013.

———. "Turned Inside Out: Black, White, and Irish in the South." *Southern Cultures* (Spring 2012).

Griffith's Valuation of Ireland. http://www.askaboutireland.ie/griffith-valuation/ (accessed July 15, 2012).

Harmon, William E. "Handicaps in Later Years from Child Labor." *Annals of the Academy of Political and Social Science* 33 (March 1909).

Hawke, George. *A History of Waynesboro, Virginia to 1900.* Waynesboro, VA: Waynesboro Historical Commission, 1977.

Holladay, Mary Jane Boggs. *The Journals of Mary Jane Boggs Holladay, 1851–1861.* Special Collections, Small Library, University of Virginia. Typescript. Charlottesville, Virginia: 1970.

Hunter, Robert F., and Edward L. Dooley. *Claudius Crozet: French Engineer in America, 1790–1864.* Charlottesville: University Press of Virginia, 1989.

Kelly, John. *The Graves Are Walking: The Great Famine and the Saga of the Irish People.* New York: Henry Holt, 2012.

Kenny, Kevin. *The American Irish: A History.* New York: Longman, 2000.

———, ed. *New Directions in Irish-American History.* Madison: University of Wisconsin Press, 2003.

Kimball, Gregg. *American City, Southern Place: A Cultural History of Antebellum Richmond.* Athens: University of Georgia Press, 2000.

Lay, K. Edward. *The Architecture of Jefferson Country: Charlottesville and Albemarle County, Virginia.* Charlottesville: University Press of Virginia, 1999.

Lee, J.J., and Marion R. Casey, eds. *Making the Irish American: History and Heritage of the Irish in the United States.* New York: New York University Press, 2006.

Lewis, Samuel. *A Topographical Dictionary of Ireland.* London: S. Lewis & Co., 1837.

Lyons, Mary E. *Feed the Children First: Irish Memories of the Great Hunger.* New York: Atheneum Books for Young Readers, 2002.

———. "Virginia Blue Ridge Railroad Datasets." In *Dark Passage: The Virginia Blue Ridge Tunnel.* Vol. 2, a Multi-Touch® book for the iPad. Charlottesville, VA: Lyons Den Books, 2013.

Marrs, Aaron. *Railroads in the Old South.* Baltimore, MD: Johns Hopkins University Press, 2009.

Mason, Matthew E. "'The Hands Are Disposed to be Turbulent': Unrest among the Irish Trackmen of the Baltimore and Ohio Railroad, 1829–1851." *Labor History* 39 (1998): 253–72.

McIntosh, Robert. *Boys in the Pits: Child Labour in Coal Mines.* Montreal: McGill-Queen's University Press, 2000.

Merrin, Dean. *America Transformed: Engineering and Technology in the Nineteenth Century; Selections from the Historic American Engineering Record.* National Park Service, Washington, D.C.: ASCE Press, 2002.

Murphree, Reni L., and Mark L. Tamplin. "Uptake and Retention of *Vibrio cholerae* in the Eastern Oyster, *Crassostrea virginica*." *Applied and Environmental Microbiology,* October 1991.

Perry, Jay. "Shillelaghs, Shovels, and Secrets: Irish Immigrant Secret Societies and the Building of Indiana Internal Improvements, 1835–1837." Master's thesis, Department of History, Indiana University, 2009.

Peyton, Aquila Johnson. *Diary of Aquila Johnson Peyton, 1859–1861.* Manuscript, Small Library, University of Virginia, Charlottesville, VA.

Putnam, William Lowell. *Great Railroad Tunnels of North America.* Jefferson, NC: McFarland & Co., 2011.

Quinn, Peter. *Looking for Jimmy: A Search for Irish America.* New York: Overlook Press, 2007.

Rainville, Lynn. "An Investigation of an Enslaved Community and Slave Cemetery at Mt. Fair in Brown's Cove, Virginia." *Magazine of Albemarle County History,* 2003.

Rossa, Jeremiah O'Donovan. *Rossa's Recollections 1838 to 1898: Memoirs of an Irish Revolutionary.* Guilford, CT: Lyons Press, 2004.

Rosscarbery Tithe Applotment Extracts, 1830, last accessed December 7, 2013. http://www.failteromhat.com/rosstithe.php.

Savitt, Todd. *Fevers, Agues, and Cures: Medical Life in Old Virginia.* Richmond: Virginia Historical Society, 1990.

Skibbereen Heritage Centre. "Great Famine Commemoration Exhibition." http://www.skibbheritage.com/famine.htm (last accessed December 7, 2013).

Slater, Isaac. *Slater's National Commercial Directory of Ireland.* London: n.p., 1846.

Towler, Sam. *The Court Doth Order.* Athens, GA: New Papyrus Publishing, 2008.

Way, Peter. *Common Laborers: Workers and the Digging of North American Canals, 1780–1860.* Cambridge, UK: Cambridge University Press, 1993.

Williams, R.A. *The Berehaven Copper Mines: Allihies County Cork S.W. Ireland.* Sheffield, England: Northern Mine Research Society, 1991, reprinted 1998.

Woods, Edgar. *Albemarle County in Virginia.* Charlottesville, VA: Michie Company, 1901.

Wyman, Mark. *Immigrants in the Valley: Irish, Germans, and Americans in the Upper Mississippi Country, 1830–1860.* Chicago: Nelson-Hall, 1983.

Index

W

Wallace general store 119, 124
Waynesboro, Virginia 22
Weston, West Virginia 92
West Virginia 82, 92, 139
Wheeling, Virginia 38
widows 80, 111, 135
women
 Blue Ridge Railroad 31
 Corkonian 28
 immigrant daughters 133
 midwife 99
 seamstress 32, 133
 servants 112

Y

York 94
 Crozet's map of 95
 murder 98
 Old York Road 95
York-Brooksville area 95

About the Author

M ary E. Lyons is the author of
nineteen books published by
Scribner, Atheneum, Henry Holt,
Houghton Mifflin and Oxford
University Press. Born and raised in
the American South, she holds dual
Irish-U.S. citizenship, thanks to her
Irish grandfather, Patrick Lyons. A
native of County Donegal, Patrick
was born in 1869, immigrated in
1884 and settled in Atlanta, Georgia,
around 1900. Mary Lyons lives in
Charlottesville, Virginia, with her
husband, Paul.